CARMEN LOMAS GARZA

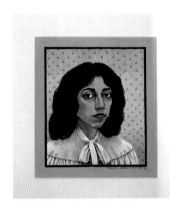

A VER: REVISIONING ART HISTORY

Carmen Lomas Garza, by Constance Cortez (2010)
María Brito, by Juan A. Martínez (2009)
Celia Alvarez Muñoz, by Roberto Tejada (2009)
Yolanda M. López, by Karen Mary Davalos (2008)
Gronk, by Max Benavidez (2007)

A Ver: Revisioning Art History stems from the conviction that individual artists and their coherent bodies of work are the foundation for a truly meaningful and diverse art history. This series explores the cultural, aesthetic, and historical contributions of Chicano, Puerto Rican, Cuban, Dominican, and other U.S. Latino artists. Related educational, archival, and media resources, including downloadable teacher's guides, can be found at the series home page, www.chicano.ucla.edu/research/ArtHistory.html. A Ver . . . Let's see!

Series Editor
Chon A. Noriega, University of California, Los Angeles

Associate Editor
Colin Gunckel, University of Michigan

National Advisory Board
Alejandro Anreus, William Paterson University
Gilberto Cárdenas, University of Notre Dame
Karen Mary Davalos, Loyola Marymount University
Henry C. Estrada, Public Art Division, City of San Antonio
Jennifer A. González, University of California, Santa Cruz
Rita Gonzalez, Los Angeles County Museum of Art
Kellie Jones, Columbia University
Mari Carmen Ramírez, Museum of Fine Arts, Houston
Yasmin Ramírez, Hunter College, City University of New York
Terezita Romo, independent writer and curator, Sacramento

A VER: REVISIONING ART HISTORY

VOLUME 5

CARMEN LOMAS GARZA

CONSTANCE CORTEZ

FOREWORD BY CHON A. NORIEGA

UCLA CHICANO STUDIES RESEARCH CENTER PRESS

LOS ANGELES

2010

CSRC Director: Chon A. Noriega
Senior Editor: Rebecca Frazier
Business Manager: Luz Orozco
Manuscript Editor: Catherine A. Sunshine
Design and Production: William Morosi
Project Coordinator: Ana Guajardo
Research Assistants: Janyce Cardenas, Lauro Cons, Beth Rosenblum, Ariana Rosas
Getty Intern: Nathalie Sánchez

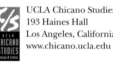

UCLA Chicano Studies Research Center
193 Haines Hall
Los Angeles, California 90095-1544
www.chicano.ucla.edu

Distributed by the University of Minnesota Press
111 Third Avenue South, Suite 290
Minneapolis, Minnesota 55401-2520
www.upress.umn.edu

Front cover: Carmen Lomas Garza, *Prickly Pear/A Little Piece of My Heart*, 1991. Oil and alkyd on wood, 32 × 24 inches. Artist's collection. Photograph by M. Lee Fatherree.

Front flap: Photograph of Carmen Lomas Garza by Bob Hsiang.

Back cover: Carmen Lomas Garza, *Cama para Sueños*, 1985. Gouache on Arches paper, 23 × 17½ inches. Smithsonian American Art Museum, Washington, DC. Reproduced by permission of the Smithsonian American Art Museum, Washington, DC.

Back flap: Photograph of Constance Cortez by Artie Limmer.

Half-title page: Carmen Lomas Garza, *Autoretrato*, 1980. Gouache on paper, 8½ × 7½ inches. Artist's collection. Photograph by Wolfgang Dietze.

Library of Congress Cataloging-in-Publication Data

Cortez, Constance, 1958-
 Carmen Lomas Garza / Constance Cortez ; foreword by Chon A. Noriega.
 p. cm. – (A ver : revisioning art history ; v. 5)
 Includes bibliographical references and index.
 ISBN 978-0-89551-124-9 (cloth : alk. paper) – ISBN 978-0-89551-125-6 (pbk. : alk. paper)
 1. Garza, Carmen Lomas–Criticism and interpretation. 2. Garza, Carmen Lomas. 3. Mexican American artists–Biography. I. Garza, Carmen Lomas. II. Title.
 N6537.G379C67 2010
 709.2–dc22

 2010020380

♾ This book is printed on acid-free paper.

CONTENTS

SUPPORTING INSTITUTIONS

This book is sponsored by
Entravision Communications Corporation

A Ver: Revisioning Art History
is made possible through the generous support
of the following institutions:

The Getty Foundation
The Ford Foundation
The Andy Warhol Foundation for the Visual Arts
The JPMorgan Chase Foundation
The Rockefeller Foundation
The Joan Mitchell Foundation

AFFILIATED INSTITUTIONS

Archives of American Art, Smithsonian Institution • California Ethnic and Multicultural
Archives (CEMA), University of California, Santa Barbara • Centro de Estudios
Puertorriqueños, Hunter College, New York • Cuban Research Institute, Florida
International University • Hispanic Research Center, Arizona State University,
Phoenix • Inter-University Program for Latino Research (IUPLR) • Institute for Latino
Studies, University of Notre Dame • Jersey City Museum • La Plaza de Cultura y
Artes, Los Angeles • Latino Art Museum, Pomona • Latino Museum, Los Angeles •
Los Angeles County Museum of Art • Mexican Cultural Institute, Los Angeles •
Mexican Museum, San Francisco • El Museo del Barrio, New York • Museum of
Fine Arts, Houston • National Association of Latino Arts and Culture (NALAC)

ACKNOWLEDGMENTS

The real meditation is . . . the meditation on one's identity.
Ah, voilà une chose!! You try it. You try finding out why
you're you and not somebody else. And who in the blazes are
you anyhow? Ah, voilà une chose!
—Ezra Pound, letter to Dorothy Shakespear

In fact, now I come to think of it, do we decide questions, at
all? We decide answers, no doubt: but surely the questions
decide us?
—Lewis Carroll, letter to Marion Richards

Over the years, these two quotations, in their enlarged printed
manifestations, have migrated back and forth—from my office
door to the bulletin board inside of my office and back to my
office door again. The Xeroxed pages, tattered through succes-
sive moves, have prompted a variety of responses from my
students, and, in the end, they usually come to the conclusion that
"yeah, they're about identity and choices." I'm pleased that they
notice them but I'm always slightly embarrassed because, in all
honesty, I put up the quotations as reminders to myself. Pound's
sentiment is a challenge to remember how hard it is for those of
us involved in the arts to keep in mind who we are and how it
comes that we are who we are. The Carroll quote, for me, is about
the questions already in place—usually asked by larger-than-life,
more powerful bodies—which force our responses. But it is also
about the questions that we ourselves generate, and whether or
not they are the "right" questions. Implicit in both quotes is the
centrality of both process and journey to our lives. In the present
context, the process of writing has been the vehicle of my journey
over the past few years. And like all journeys, this one has been
enriched and made easier by individuals whom I have met along
the way. Funding for research was greatly enhanced by a Texas
Tech University Internal Research Grant. This allowed me to
travel to libraries in Texas and to visit the Bay Area in California.
I wish to thank Margo Gutiérrez and Michael Hironymous at the
Nettie Lee Benson Latin American Collection at the University
of Texas at Austin for their help in accessing the materials from
the Carmen Lomas Garza Archives. Cecilia Hunter at the South
Texas Archives (Texas A&M Kingsville) helped me negotiate the
holdings of that institution, pointed me in the right direction for

information, and, through conversation, helped me in piecing together the Kingsville of the 1950s and 1960s.

Data for the volume were also obtained through the help of others. Amalia Mesa-Bains clarified information regarding an exhibition held during San Francisco's Galería de la Raza's early days. Janet del Mundo at Children's Book Press (San Francisco) supplied the publication and sales data for Carmen's *Family Pictures*. Sculptor Will Cannings (Texas Tech University) suggested volumes related to metal laser-cutting techniques. My sincerest thanks go to José Angel Gutiérrez for taking time out of his busy schedule to read an early draft of chapter 2 and giving invaluable comments on the manuscript.

At my home institution, Texas Tech's School of Art provided a "captive audien. . ." er . . . forum in which to present my scholarship during the annual Art History Lecture Series. Colleagues who commented on these early words include Joe Arredondo, Kevin Chua, Janis Elliott (two *t*'s), Andrew Martin, Terry Morrow, Brian Steele, Carolyn Tate, *y mi comadre*, Tina Fuentes.

The staff at UCLA's Chicano Studies Research Center Press has been extraordinarily helpful. My thanks to Chon Noriega and Tere Romo for their early readings of my work. I would especially like to thank Colin Gunckel, now Professor Colin Gunckel of the University of Michigan (Go, Colin! Go!), for his close editorial scrutiny of and invaluable help with my manuscript in all of its manifestations.

Finally, my boundless gratitude to Carmen Lomas Garza for her help and professionalism. Over the course of the project, Carmen opened her home and office to me. Her archives—I am still in awe of Carmen's organizational prowess—not only made it possible to reconstruct her extraordinarily rich career with facility but also actually made archival work a pleasure. (Artists, take note.) Throughout the research process, she made herself available via e-mail and over the course of numerous phone conversations. During the writing of the manuscript, she and her husband, Jerry Avila Carpenter, reviewed and commented on all the later drafts. But there is another level on which I owe Carmen my thanks. Like many of the viewers of her work, I see myself in her art. I have re-membered myself and this place I call Tejas. The questions asked by Carmen over the course of her life and the answers revealed in her work seem to me central to the role of art in our lives—to provide resonant imagery that invokes both distinct and shared journeys.

FOREWORD

CHON A. NORIEGA

Carmen Lomas Garza's artwork represents a lifelong project of creating an alternative chronicle of Chicano familial, communal, and cultural practices in South Texas as refracted through personal memory. Her paintings (gouache and alkyd), prints, installations, and paper and metal cutouts challenge official histories, but they do not document racial oppression or violence, or political resistance. Instead, they tell of customs, communal events, local folk heroes, and family history. Their pleasing and deceptively simple appearance bears the weight of violent and exclusionary practices that have had institutional and societal force. This work is the product of Garza's *compromiso,* or commitment, to remember for her community—a project that is by no means finished.

Garza's art takes the form of personal memory within a visual "folk" idiom, suggesting a sharp contrast with a modern art that is understood as a break with the past, with tradition, and with religion. But such a view would be shortsighted, overlooking a significant tributary for American modernism, one that emerges from immigrant and nonwhite communities. The formalist understanding of modernism privileges the Euro-American appropriation of the nonwhite "folk" and "primitive" aesthetic, not its transformation into a modern vernacular. In this respect, Garza's art must be placed in the context of a protracted political struggle over public culture in the United States, a struggle played out *within* American modernism. Garza's aptly titled retrospective, *Carmen Lomas Garza: Pedacito de Mi Corazón* (A Piece of My Heart), provides insight into the public and performative aspects of this process. Organized by the Laguna Gloria Art Museum in Austin, the exhibition opened in the fall of 1991. It then traveled to the El Paso Museum of Art, where it was on display from December 14, 1991, through February 2, 1992.[1]

The exhibition came amid a national shift regarding the role of the museum and the function of art in civil society, one aspect of which was publicly debated in terms of "cultural diversity" versus "artistic quality." What was less frequently reported was

how changes in demographics and funding policies affected the internal structure of the art museum, with the result that the board of trustees, the museum director, and the various curatorial departments came to have different, and often conflicting, constituencies. And this is what happened in El Paso. The previous year, Becky Duvall Reese had been hired as the new director and given a mandate to bring about change for the first time in twenty-five years. The museum was 100 percent municipally funded, yet it was not responsive to the local community, especially the Mexican American community, which made up 70 percent of the local population. Instead, exhibitions and activities at the museum reflected the interests of the city's cultural elite, which oversaw the museum via the El Paso Art Museum Association. Duvall Reese set out to open up the museum to the general public, starting with an exhibition of Mexican colonial art in the permanent collection that was followed in quick succession by three exhibitions of Chicano art: the Garza retrospective; *Chicano and Latino: Parallels and Divergence—One Heritage, Two Paths,* organized by the Daniel Saxon Gallery in Los Angeles; and *Chicano Art: Resistance and Affirmation, 1965–1985.* These exhibitions turned around declining attendance, increasing the number of visitors from a low of twenty people a day to an average of one hundred a day, with the Garza retrospective first setting a record of 6,500 people during its six-week run and *Chicano Art: Resistance and Affirmation* then attracting 4,000 people to the opening alone.

The Garza retrospective became the occasion for a public struggle between the director and the museum association. In a front-page newspaper story published in late January 1992, the president of the association announced that he had taken a personal survey of the popular show and found that no one liked it. "I've asked people to rate the exhibit from one to ten," he told the *El Paso Herald-Post,* "and didn't find a single person who rated it above a one. To me, it's an embarrassment."[2] Off the record, the association complained about the "brown art" and "brown faces" that now filled the museum. Garza responded to the press statements by saying, "There is a strain of racism in that attitude, which is also a form of censorship. I'm not threatened by it. I think it's sad."[3]

Were it to end there, this story would not be that unusual, a sad-but-true tale of thwarted ideals and expressions. But Duvall

Reese and Garza went one step further. If the association had taken the seeming high road of cultural elitism, director and artist would take the low road of engaging political representation. They went to Freddy's Breakfast, where the town's leaders met before city commission sessions. Garza worked the room, talking with the mayor and council members, explaining her work, answering questions, and so on. Soon thereafter the city government moved to legally disenfranchise the association—it continued to exist, but it no longer governed the museum. Today the mayor and the city council appoint an advisory board, and the museum director reports directly to the mayor.

Garza's intervention within the museum, like the politics of memory in her artwork, was a local one. She speaks to a specific place and time, and she speaks for those whose silence and invisibility is presumed to be natural, an assumption that is merely corroborated by public funding for the arts, culture, and civic space. To look at this case strictly in terms of censorship misses the point. It is not just about an abstract concept of "free" expression but also about the platforms from which certain individuals and groups are allowed to speak. It is about the fact that discourse correlates to governance—what is said determines who gets to make the administrative and curatorial decisions that define our public culture, that define what it means to exist in the modern world.

In one of the works produced after the retrospective, Garza offers her own definition, recalling a visit to her grandmother's house when she was about ten or eleven years old. Garza's friend, a teenager, had always wanted to visit the grandmother. In *Una Tarde/One Summer Afternoon* (1993), Garza depicts the moment of revelation in which she learns why her friend had been so interested in the grandmother's house: the boy next door. The friend sits on the bed and leans into the windowsill, and the boy, on the other side of the screen, faces her. The grandmother acts as chaperone, crocheting as she watches the interaction between the two teenagers from a chair opposite the bed, while a young Garza braids the bedspread fringe. Garza has flattened and exaggerated the perspective, organizing the figures along two diagonal lines that intersect at the boy—on the left, from Garza to her friend, and on the right, from the photographs on the dresser to the grandmother. At the bottom center of the painting, underneath the boy, is a cat feeding her

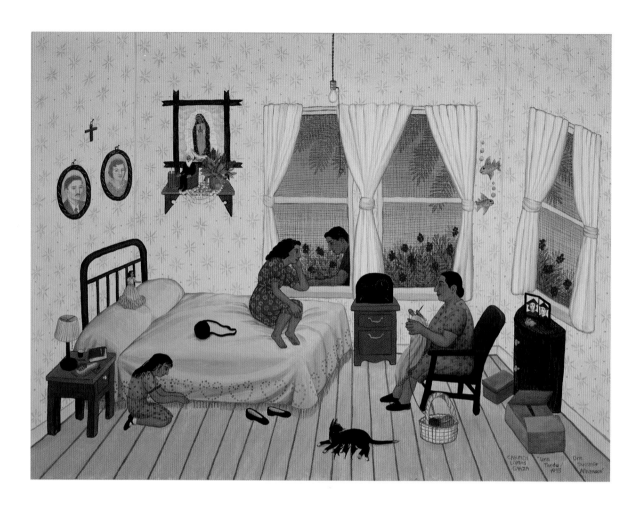

Carmen Lomas Garza, *Una Tarde/One Summer
Afternoon*, 1993. Alkyd on canvas, 24 × 32 inches.
Artist's collection.

Photograph by M. Lee Fatherree.

three kittens. The cats and the boy form a line that leads up to
an exposed lightbulb hanging from the ceiling.

The procreation narrative is at once overdetermined at an
animalistic level (boy plus girl equals kittens) and counterbal-
anced by the cultural and intergenerational framework for
couple formation in the Mexican-descent community of South
Texas. Indeed, the latter adds an interesting dimension to the
grandmother's traditional role as chaperone: the line between
the grandmother and the boy originates at two black-and-white
graduation photographs of, presumably, the grandparents in
their youth. These photographs are echoed by the black-and-
white portraits of the couple as adults that hang over the bed.
Here the composition produces a visual narrative that links folk

tradition, religious belief, and coed education by connecting the graduation photos to the grandmother to the girl on the bed to the married couple above the bed. Similarly, a line runs from the graduation photos to the grandmother to the boy outside the window to a small statuette of Don Pedro Jaramillo, a renowned *curandero,* or faith healer, who died in South Texas in 1907.[4] The statuette sits on a shelf in front of a portrait of the Virgen de Guadalupe and alongside a vase of flowers like those just outside the window.

The grandmother's crocheting serves as a metaphor—or makes the image a "gerund rather than a noun," as Constance Cortez notes about another painting[5]—for how these elements form a cultural logic within the Chicano community. Neither the girl nor the boy belongs to the Garza family; their courtship is governed by a set of communal expectations for education, religious belief, and social hierarchies. Notice how the composition works from the top down: from Catholicism to folklore and parental authority, to youth, to education (as offered by the chaperone and represented by the graduates), to innocence (represented by the artist as a young girl), to reproduction (the cat and kittens). The grandmother's crocheting is echoed by Garza's braiding the fringe of the bedspread. Here we see the young artist being acculturated into the logic of the community, even as her braiding also appears to be a way of distracting herself from the revelation about her friend's motive.

What we see, then, is the visual representation of a "Chicano erotics" structured around religious belief, social expectations, and patriarchal authority, but we also see the self-reflective presence of the artist-as-artist. Garza describes her younger self in the following way: "I'd be braiding and braiding, but I would have to unbraid everything when it was time to go." As with Penelope's weaving in the *Odyssey,* Garza's braiding can be seen as a way of forestalling an unwanted suitor who represents a danger to the community. In the myth, Penelope's suitors threaten the family-as-kingdom; in the painting, the teenage boy upsets Garza's prepubescent understanding of female-male relationships. But Garza's braiding is also a metaphor for the work of the artist, who weaves together the strands of memory, again and again. Each braiding becomes an unbraiding, for with each telling the narrator must forget in order to remember. Each artwork neither repeats the last nor retrieves a pure and unchanging

past; instead, it must create anew. Garza has outdone Penelope, braiding and unbraiding for four decades, not two, creating an alternative chronicle that situates Chicano culture in all its complexity as a dynamic and constituent element of American modernism.

NOTES

1. Carmen Lomas Garza and Amalia Mesa-Bains, *A Piece of My Heart/Pedacito de Mi Corazón: The Art of Carmen Lomas Garza* (New York: New Press, 1991). See also Carmen Lomas Garza, *Family Pictures/Cuadros de Familia* (San Francisco: Children's Book Press, 1990). The exhibition traveled to other sites in Texas and California.

2. Robbie Farley-Villalobos, "Museum President Embarrassed: 'Personal' Survey Shows Public Doesn't Like Current Exhibit," *El Paso Herald-Post*, January 25, 1992, p. A1.

3. Ibid.

4. Ruth Viola Dodson documented the cures in *Don Pedrito Jaramillo: Curandero* (San Antonio: Casa Editorial Lozano, 1934). See also Wilson H. Hudson, ed., *The Healer of Los Olmos and Other Mexican Lore* (Dallas: Southern Methodist University Press, 1951), which reproduces some of Dodson's text.

5. See the chapter titled "A Tejana on the West Coast" in this volume.

A BED FOR DREAMS

Two young girls recline on a rooftop on an early summer evening in South Texas (fig. 1). One points to the open sky above, where clouds drift by and a full moon provides a half light. The girls' mother, unaware of their location, busies herself with preparing their room for a night's slumber. The title of the 1985 painting, *Cama para Sueños* (Bed for Dreams), actually references two beds. One is created by an act of parental love inside of the confines of the safe and light-filled home; the other is the shingle-clad roof on which the children gaze toward their future and its seemingly endless possibilities.

The image was inspired by the childhood memories and imagination of Carmen Lomas Garza, one of the most successful and best-known Chicana artists working in the United States. Garza, who now lives in San Francisco, was born and raised in the small South Texas community of Kingsville.[1] Her extended family had strong roots in the town and ties to the great King Ranch.[2] Carmen was the second of five children of María and Mucio Garza, who nurtured the ambitions of their wide-eyed eldest daughter (fig. 2).[3] Especially important was her mother, to whom Garza dedicated *Cama para Sueños*. Throughout Garza's childhood, her mother set an example by painting watercolors and *lotería tablas* (lottery tablets). The latter were often sold to raise money for the local branch of the American GI Forum, which assisted Latino veterans. It was María who instilled in Carmen and her younger sister, Margarita, or "Margie," the dream of becoming artists.[4]

Today Garza is widely recognized for works that celebrate the everyday activities and traditions of her family and her South Texas Latino community. In her paintings and prints, close relations between family and community are conveyed by the figures' proximity to one another and by private conversations held in domestic interiors and at public celebrations. The imagery is remarkable in that it seemingly challenges the repressive era through which the artist lived while invoking a kind of divine grace through the actions of the canvas's inhabitants. As such, her paintings speak not only to memory but also to hope and tenacity.

Garza's current renown as artist, activist, and the author of four children's books is both temporally and geographically far removed from the dreams that took shape on a rooftop years ago. Then, her world was much smaller, delimited and influenced by Mexico and the Gulf Coast. When the world outside Kingsville is acknowledged in images from Garza's youth, the reference is most often to the borderlands. In *La Feria en Reynosa* (1987, fig. 3), Garza visually recounts a trip she took with friends to a fair in Reynosa, a Mexican border town located across the Rio Grande (Río Bravo) from McAllen, Texas.[5] A barbed-wire fence and two mesquite trees, ubiquitous features of the borderlands, demarcate the fairground's edge. Here, three booths offer a variety of goods brought from Mexico's interior. Dolls, ceramics, embroidered blouses—such items would be taken back to Kingsville as comforting reaffirmations of historic and ongoing cultural ties to Latin America. At the same time, cultural hybridity is evident in the sign on the refreshments booth: "Sodas. Coca Cola, Fresa, Limon: $5.00 pesos." Such code switching, an index of the melding and coexistence of two cultures, is frequently visible in the artist's work.

Although Garza's images are grounded in the realities of the Mexican American community of Texas, their appeal is far broader. Her paintings and prints have been widely collected and are found in the holdings of major museums throughout the United States, including the National Museum of Mexican Art in Chicago, the Oakland Museum of California, and two Smithsonian Institution museums in Washington, DC: the Hirshhorn Museum and Sculpture Garden and the Smithsonian American Art Museum. Garza has received numerous national and regional grants and fellowships, including awards from the National Endowment for the Arts and the California Arts Council. She is also the author of four illustrated children's books. There is even an elementary school named for her, the Carmen Lomas Garza Primary Center in Los Angeles.

While most critics have cheered the celebratory tone of Garza's art, a few have derided the imagery as an attempt to gild the racial conflicts and economic and educational disparities of midcentury Texas.[6] Such critics reveal their lack of familiarity with life in Texas during the 1950s and 1960s, as well as a less than close reading of the artist's work. Many of her paintings deal with events such as illnesses and carry with

Figure 1. Carmen Lomas Garza, *Cama para Sueños*, 1985. Gouache on Arches paper, 23 × 17½ inches. Smithsonian American Art Museum, Washington, DC. Reproduced by permission of the Smithsonian American Art Museum, Washington, DC.

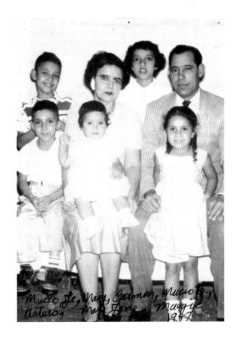

Figure 2. The Garza family, 1957. *Back row, left to right:* Mucio Jr., María, Carmen, Mucio Sr. *Front row, left to right:* Arturo, Mary Jane, Margarita. Photo courtesy of Carmen Lomas Garza.

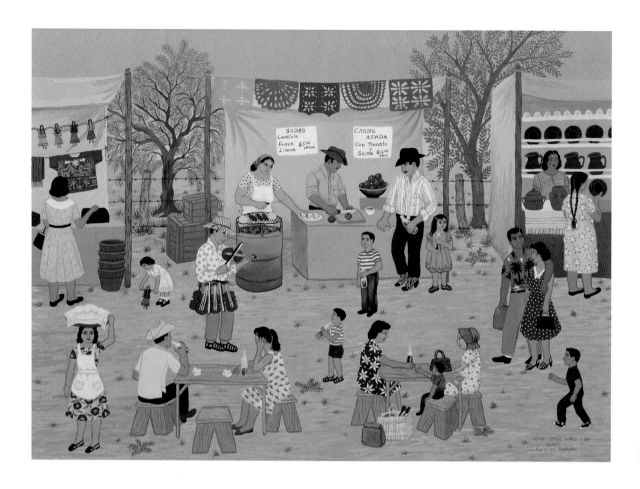

Figure 3. Carmen Lomas Garza, *La Feria en Reynosa*, 1987. Gouache on cotton paper, 20 × 28 inches. Artist's collection.

Photograph by Wolfgang Dietze.

them an undercurrent of childhood anxiety. A case in point is *Hammerhead Shark on Padre Island* (1987, fig. 4). In this beach scene, people gather around a fisherman who has just caught a shark off the pier. Blood pours from the creature's gaping mouth as small children shyly touch or bend over the shark to examine it. Horror mixes with fascination in the faces of the assembled group, sentiments underscored by Garza's written account of the event in her children's book titled *Family Pictures*. In the text accompanying the image, she recalls that "it was scary to see because it [the shark] was big enough to swallow a little kid whole."[7] In the context of this children's volume, then, the image is clearly more Sendak than it is Potter.[8] Here, as in many of Garza's works, the lesson is embedded in the imagery: there are sharks everywhere, even in the places where we play.

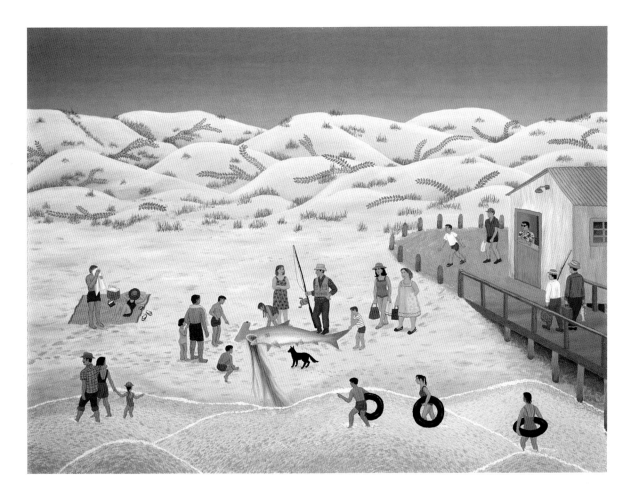

It is true enough that Garza, in her art, chooses to reveal aspects of life around her that reaffirm cultural practice. However, she does so while illustrating the means through which her own identity has been sustained—this despite racial inequities, cultural conflict, and urban pressures. She also reminds us that to dream is to risk. The trees that we climb to see our futures are frequently precarious, and even the perch from which we glimpse possibilities can be steep. In the end, it is the struggle that is important, and that makes the dream all the more powerful when it is realized.

Figure 4. Carmen Lomas Garza, *Hammerhead Shark on Padre Island*, 1987. Oil on canvas, 36 × 48 inches. Artist's collection.

Photograph by Wolfgang Dietze.

POLITICS AND LIFE IN TEJAS
FROM TEJANA TO CHICANA

The midcentury world into which Carmen Lomas Garza was born was marked by ambivalence and contradiction. During the 1950s and early 1960s, Kingsville still operated under the institutionalized racism established in the early decades of the century. Elementary schools were segregated, and the Mexican American population resided principally in the northeast quadrant of the city. Working-class Latinos found employment in agriculture, on the railroad, and in domestic service to the city's white population.[1] Many continued to work on the King Ranch, which functioned as an unofficial overseer to the community.[2]

But the 1950s and 1960s also represented a political watershed for Latinos in Kingsville and throughout Texas. After World War II, Mexican American men who had fought for the United States overseas returned home battle-tested and with a newfound confidence. Their wartime experiences had broadened their vision and their aspirations. Along with the general public, euphoric at the war's end, the returning GIs felt that all things were possible. But the idealism of the veterans was tempered by the reality of their homecoming. Despite their service to their country, the prewar status quo, with its cultural and economic restrictions on Latinos, remained firmly entrenched. The veterans quickly realized that the same tenacity and courage required to win the war would have to be employed to overcome racism and discrimination at home.

It is not surprising that the first significant political gains for Latinos in Texas came through an organization formed by a returning Mexican American veteran, Dr. Héctor P. García.[3] During the war, García had served as an army physician in Europe, where he had been decorated and had attained the rank of major. On his return to Corpus Christi he joined LULAC, the League of United Latin American Citizens, and within a year became the organization's president. However, problems arose when García wanted to address the issue of Latino veterans' rights, which were being ignored by the Veterans Administration.

While LULAC had made some inroads in the education and social arenas, its policy was not to intervene in politics. That being the case, in 1948 García founded the American GI Forum (AGIF), which had as its principal goal to assist veterans in their struggles against discrimination in health, housing, education, and employment. AGIF established chapters across the state and, shortly afterwards throughout the country.

The Forum's earliest victory involved the 1949 case of Private Felix Longoria, a soldier who had been killed while on duty in the Philippines in 1945.[4] Longoria was from Three Rivers, Texas, a small town about sixty miles northwest of Corpus Christi. His body was returned to the United States, to his home-town, but the director of the local funeral home, T. W. Kennedy, denied Longoria's family access to the facilities and to burial. The local white community, he maintained, would object to having a Mexican American buried at the all-white cemetery. Kennedy also cited his personal fears that the "Latin people" would misuse the funeral home by becoming drunk and violent. The AGIF organized a protest and contacted Lyndon Baines Johnson, then a freshman senator. Johnson arranged for Private Longoria to be buried at Arlington National Cemetery in Washington, DC, with full military honors.[5]

The Forum was also active in Kingsville, which is forty miles southwest of Corpus Christi. In an incident mirroring the Longoria case, the white-run Kingsville funeral home refused to hold the service for a young Latino man from Kingsville who was killed during the Korean War.[6] AGIF members raised money to sue the funeral home.

The Garza family strongly supported causes advocated by the American GI Forum. Garza's father, Mucio, had served in the U.S. Navy during World War II, and he had experienced discrimination during the journey home. En route, he had stopped to get a meal in Alice, Texas, only to have the restaurant refuse him service. He never forgot the incident and recounted it to his children. After the creation of the American GI Forum, he became an active participant, and his wife, María, became a member of the Forum's Ladies Auxiliary.[7]

The Forum expanded its efforts in the political arena by registering voters, working to ensure voters' rights, and agitating for repeal of the poll tax.[8] One of Garza's earliest memories occurred during the AGIF's voter drives. Her parents dressed

up in their Sunday best and took the children along to witness them casting their ballots. As they drove to the polls, her parents spoke of the historic significance of what they were doing and lectured the children on the importance of voting.[9] The Forum also worked to promote political candidates who addressed the Latino community's needs, including presidential candidates. This was especially true during the 1960 presidential campaign, when "the formation of statewide Viva Kennedy clubs, the brainchild of Héctor García, did much to catapult John F. Kennedy into the presidency."[10]

The American GI Forum also worked to advance Latino education. It funded lawsuits to contest the gerrymandering practices that seemed to promote racial segregation of children, and it created college scholarships. The Kingsville Latino community supported the Forum by holding fundraising events, including "cakewalks" organized by the Ladies Auxiliary. According to Garza, "Cakewalk was a game to raise money to send Mexican Americans to the university. You paid 25 cents to stand on a number."[11] In her painting *Cakewalk* (1987, fig. 5), numbers are chalked in squares on the pavement, forming a large circle. As music plays, participants circle around, halting when the music stops. A random number is called out and the person who has landed on that number receives a cake.

Beyond supporting AGIF activities, the cakewalk also enhanced community participation and cohesion. In the painting, all members of the Forum can be identified by their blue felt hats with red and white trim—the colors of the American flag. Carmen's mother, in a pink and black dress, stands in the center of the circle with other women, while her father serves punch at the cake table. In the background, two members change the record and, to the extreme right, a couple has taken the opportunity to flirt. The one-legged owner of the local grocery store, Matilde, stands in front of her business and chats with another Forum member. It seems significant that the children, who are shown playing throughout this scene, participate in an activity that will ensure their own futures. Garza identifies herself as one of two children seated on the curb in front of Matilde's Grocery.[12] True to her future calling, she draws on the sidewalk with a twig.

Despite the Forum's best efforts toward educational reform and the community's commitment to action, long-term results

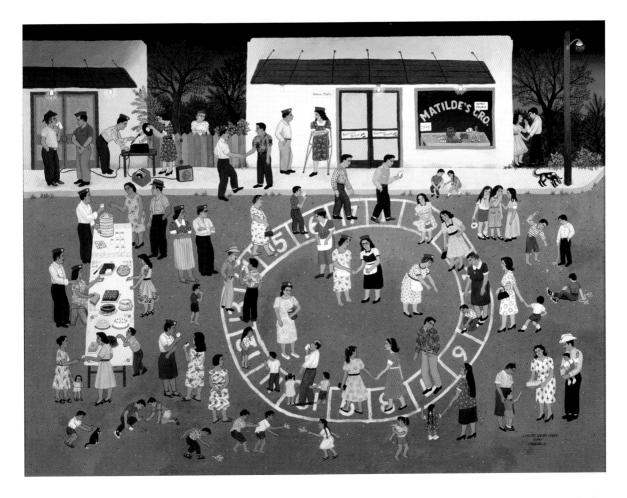

of their work took many years to become visible.[13] Garza did not attend an integrated school until junior high, and her experience there was traumatic and painful. Segregation was still very much the norm in this "integrated" school, and in this regard Garza's account of the routine division of students in her physical education class is telling:

> In gym class, all the Mexican American girls and African American girls sit on one side of the dressing room and all the white girls sit on the other side. Of course, there's more of us, so we're all crowded on one side and the white girls get the other side, and they get to go to the showers first. By the time we get in there the place is steamy and muggy and the foot powder is mud.[14]

Figure 5. Carmen Lomas Garza, *Cakewalk*, 1987. Acrylic on canvas, 36 × 48 inches. Private collection. Photograph by M. Lee Fatherree.

Here, the message to the young women of color concerned not only their societal ranking but also the nature of their bodies. The implication was that their bodies were inherently unclean and that the white girls should be protected from this. The talcum powder–filled tray through which they waded only reinforced the humiliation.

Art was not taught at this school, and moreover, the curriculum was segregated by sex: girls took courses deemed appropriate for their gender and boys did likewise. During her second year of junior high, Carmen set her sights on a biology course but instead had to enroll in a home economics class. She pleaded her case to her mother:

> Look, all they are going to do is make an apron, sew an apron, cook a cake, make some eggs, learn how to clean and stuff like that, and I already know how to do all of that. I already know how to sew, already know how to cook, at least I can help you clean and cook. So mommy, help me get the biology class.[15]

Her mother understood the absurdity of her daughter's situation and together they successfully petitioned the school for a curriculum change. Carmen enrolled in biology, where she was one of only two girls in the classroom.[16] In retrospect, she viewed the incident as her "first big protest against discrimination."[17]

Negotiating social and bureaucratic hurdles turned out to be a laborious endeavor and one that young Carmen found both strange and isolating. She spent much of her time contemplating the direction of her life. By the end of her first year of junior high, Carmen had resolved to become an artist. Because she felt the need to focus all her energies on developing her art, she also made the monumental decision not to have children. Although she was only thirteen at the time, her choice was well reasoned. Carmen had always been sure of her commitment to art, but she knew, from caring for her younger siblings, that child rearing was an enormous and labor-intensive undertaking. Having made these decisions, she was able to direct her free time toward creating art, and all of the money saved from allowances and babysitting was devoted to purchasing art supplies.

The high school Carmen attended was also officially integrated, and the curriculum offered was much broader. Even so,

patterns of segregation continued and the double standard reasserted itself, even in Spanish class. Garza recalls:

> You could take language classes. You could take French, Latin, or Spanish. But if you took Spanish class, the Mexican American kids could not practice their Spanish in the hallways. Only in the classroom. And all the other kids could practice wherever they wanted. If [Mexican American kids] spoke Spanish in junior high—in elementary school and in high school—[then they] were paddled. [We] were physically punished.[18]

Carmen began taking art classes in her junior year with Mrs. JoReene Newton, who recognized Carmen's potential and encouraged her. The teacher even helped her to get a scholarship to go to the local university. In May 1967, Carmen graduated from high school and began college that summer.

College attendance had always been a given in the Garza family.[19] Carmen's parents viewed her early enrollment at Texas A&I University (now Texas A&M University–Kingsville) as a sign of her enthusiasm and commitment. Since the School of Art did not offer a bachelor of fine arts degree, Carmen opted to work toward a degree in art education. This appealed to the young artist's pragmatic side: while she felt that she would be a success in art, she knew she could always fall back on her abilities as a teacher. Furthermore, she could enroll in studio art classes and that would allow her to expand her understanding of different media and grow as an artist.

Beyond signing up for required core courses, Carmen also enrolled in courses relevant to her major. It was at the university that she first studied art history. Although these courses were limited in scope, she remembers one class on Mexican art where she was introduced to the works of the great Mexican muralists—Rivera, Orozco, and Siqueiros.[20] While these artists were considered at the time to be outside of the canon of Western art, Dr. Ben Bailey, her professor, was dedicated to offering a class he felt relevant to his students, 50 percent of whom were of Mexican descent. Bailey, no doubt, was also swayed by the political message of the Mexican artists. He saw in their work a proven model of political engagement and a means through which his students could contend with the societal upheavals of the 1960s.

Carmen embraced the subject but she also realized that there were some omissions in the material. Bailey limited his lectures to well-known male Mexican artists. He did not include women artists such as Frida Kahlo, whose work Carmen would later discover during a trip to the library in 1970. Further, since pre-Columbian art was taught only in the context of anthropology courses, the students' understanding of *mexicanidad* and its connection to ancient civilizations was severely undermined.[21] Again, Garza relied heavily on books she obtained from the university libraries.

Her studio courses included drawing, ceramics, and printing. Of these, she immediately established a rapport with printmaking. She recognized in this medium a comfortable transition from the pen-and-ink and pencil drawings she had created during her high school years. An added advantage was that printmaking allowed her to produce multiple copies of one work. Using her by now well-developed drawing skills, she set about creating images on metal plates and stone.

These early etchings and lithographs presaged two aspects that would be developed further in her later work: subject matter centered on family, and a strong interest in delineation. Both are evident in the 1972 etching *Abuelita* (Grandma), where the matriarch of the family, Elisa Lomas, is shown seated and in profile (fig. 6). The image was taken from a life drawing that Garza had created while watching her grandmother crochet near a bedroom window.[22] Rather than developing the entire image, the artist chose to impart full three-dimensionality only to those aspects that disclosed her grandmother's personality: her smiling face and the arms with which she tended to her family's needs. Simple delineation is used to visually describe the sitter's context, her bedroom. The foot of the bed overlaps the chair on which she is seated. A small shelf supports a saint, a candle, and an image of the Virgin of San Juan de los Lagos. Above the shelf, a crucifix and a frond from Palm Sunday further demarcate the wall of the room. The proximity of the religious icons to Garza's grandmother implies an ongoing spiritual conversation, a dialogue further indicated by the rosary held in her right hand.

While she was at the university, Garza maintained her interest in science and took an introductory class in biology. This fascination dovetailed with her love of drawings, and she

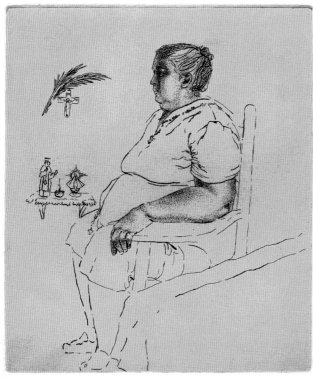

CARMEN LOMAS GARZA '72 "Abuelita" II/5

Figure 6. Carmen Lomas Garza, *Abuelita*, 1972. Intaglio print (zinc plate etching), 6⅝ × 5⅝ inches. Artist's collection.

Photograph by William Haught.

Figure 7. Carmen Lomas Garza, *Luna Nene*, 1972. Intaglio print (zinc plate etching), 5⅝ × 3⅝ inches. Artist's collection.

Photograph by William Haught.

produced a number of print images based on the human form. *Luna Nene* (fig. 7), from 1972, is an etching of a child in utero. Garza provides a moon-shaped window into the womb. The *nene*, or child, raises his hand to his mouth as though imparting a secret. The connection between parent and child is indicated through the use of stippling: the texture of the baby's pink skin is repeated in the surrounding brown surface of the mother's skin.

Beyond her academic activities, Garza immersed herself in the politics of the time. She had learned the importance of community action at a young age from her parents' involvement with the AGIF and from the early political achievements of the Viva Kennedy clubs. This lesson was reinforced in 1963, when Mexican American candidates made successful bids for

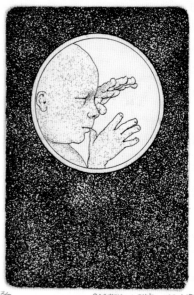

⅔ CARMEN LOMAS GARZA '72

city council and school board posts in the South Texas town of Crystal City. Their victories helped lay the basis for the nascent Chicano movement in Texas.[23]

The United Farm Workers (UFW), founded by César Chávez a few years earlier in California, played a pivotal role in Texas as well. The UFW sought to protect the rights of farm laborers, a cause that resonated in this heavily agricultural state. In 1966 the UFW supported melon workers in Starr County, Texas, who marched from the Rio Grande Valley to Austin to protest bad working conditions and low salaries. The Starr County strike marked the beginnings of *el movimiento*, the Chicano movement, in the arena of Texas agriculture. The UFW was particularly active in South Texas in 1966–67. Among other victories, the organization helped change laws in favor of limiting the jurisdiction of the Texas Rangers in labor disputes.[24] In Kingsville, Garza recalls, the United Farm Workers often came to town to organize protests in front of the courthouse.[25]

By 1964 the Chicano movement had established itself on the Texas A&I campus. By the time Garza was in college, from 1967 to 1972, she and her classmates were well aware of their roles in regional and national politics.[26] Leaders from politically active groups often came to campus to recruit, and students from the art department were asked to create posters and banners for various causes. Carmen began wondering how she could make a difference, how she could enhance the position of her community and improve its political power. After two years of listening to speakers in front of the student union building and participating in discussions, she and other students in the art program made a conscious decision to work for political change. Carmen was still living at home with her parents, and her decision was the topic of lively conversation. While her father was supportive of the movement's goals, he was also concerned about his daughter's safety. Her mother favored active engagement and recognized that the times they were living through held the potential for real change. Garza recounts that her mother argued her case before her father: "Let them do what they need to do, because you know there are still problems . . . And they're pointing it out. And now they're the new energy and the new generation that can do something about those things."[27] In the end, the women of the house won out.

Carmen and other students in the art program gathered regularly at the home of their painting and art history professor, William Renfrow. There they discussed current issues, including those important to the students' education and to Latinos throughout the state. Group members included political activist José Angel Gutiérrez, who had received his degree from Texas A&I in May 1966. Current art students included Carlos Truan, Amado Peña, José Luis Rivera, Guadalupe Silva, Billy Nakayama, and, eventually, Santa Barraza.

The students eventually joined MAYO, the Mexican American Youth Organization, a group founded in 1967 in San Antonio by José Angel Gutiérrez, Willie Velásquez, Mario Compean, Ignacio Pérez, and Juan Patlán.[28] Unlike predecessor groups also concerned with social justice issues, MAYO believed in taking direct, nonviolent political action. To this end, MAYO sponsored and organized many demonstrations on behalf of laborers and students alike. The group had a strong presence in Kingsville and organized a high school walkout there in 1969, one of at least thirty-nine student walkouts organized in the state from 1967 to 1972.[29]

In 1969 MAYO held its first national conference just south of Mission, a small town located near McAllen, Texas, and across from the Mexican border town of Reynosa. The event was slated for the end of the year, December 26–30, 1969, when the Christmas break would free students to attend. Program organizers also invited people from a broad spectrum of occupations and educational fields. While the conference drew attendance from across the United States, the majority of the participants came from Texas. According to Armando Navarro, MAYO's leadership put forward four main goals for the gathering: (1) to inform Chicano youth about MAYO's programs; (2) to select new programs; (3) to increase coordination among MAYO chapters across the state of Texas; and (4) to link up and coordinate with the growing Chicano movement.[30]

MAYO was well aware of the impact of visuals in support of any political cause. From the beginning, leaders actively recruited from Texas A&I's Art Department, asking students to create posters and banners.[31] For the Mission conference, José Angel Gutiérrez wrote to Bill Renfrow, asking for an exhibition that would feature Chicano art. Aware of Garza's level of commitment, Renfrow asked her to curate the show. For the first time,

Carmen had to determine what exactly Chicana/o art might be, and she quickly realized the difficulty of defining something so visually and materially varied. In the course of their involvement in the movement, her fellow students had produced posters and bumper stickers, but "nothing really concrete,"[32] nothing that would give the aspiring curator an idea of an overarching or governing ethos. While *la causa* had been defined, the stylistic and conceptual protocol for its art had not been. Garza realized that, in the final analysis, the most important objective was to introduce the community to work produced by Chicano students. So, despite the lack of a concrete definition, she pushed ahead.

Garza then faced a second challenge: the paucity of students left on campus during Christmas break. Despite her abbreviated timeline, she found and approached a number of students and was able to gather up about thirty artworks representing a variety of media. These included a work by the young sculptor José Luis Rivera-Barrera, who had been born and raised on the King Ranch.[33] Although now well known for his sculpture in native mesquite, at the time he was also working with rebar. He was happy to contribute a welded self-portrait, his last work in metal before his exclusive commitment to the medium of wood.[34] Carmen loaded up a trailer and hitched it to an old 1956 Chevy owned by Alberto Luera, a MAYO member. Together, the pair made the two-hour drive to Mission.

The conference was held five miles south of town at a small mission called La Lomita, or "little hill." The Oblates of Mary Immaculate had built the chapel in the mid-nineteenth century on land that had been part of a Spanish land grant dating to 1767.[35] In 1912 the oblates built a three-story brick building that was initially devoted to their novitiate program and then used to house a congregation of nuns. Decades later the oblates decided to use the property to address the needs of the Chicano movement and opened the building for migrant programs and a Head Start breakfast program. The MAYO meeting was housed in this building. The group designated the upper story as the conference space, while the lowest floor, housing the cafeteria used in the Head Start program, would serve as the site for the art exhibition.

Garza unloaded the trailer and hung the show in one afternoon. Although the MAYO conference was being held upstairs,

the participants frequently came downstairs to take their coffee breaks in the cafeteria. Garza attended some of the sessions but made sure that she was always down in the basement during break time, ready to answer questions from the participants about the art. Her presence in the room extended to the night-time hours as well. While two security guards supplied by the conference organizers stood watch at the door during the day, Garza was responsible for the safety of the works at night. She set up a makeshift bed on the concrete floor along one of the walls of the cold basement.

The exhibition included three of her own works that reflected a surprising stylistic range. In these competing art forms, a love of patterning is apparent. In her linoleum block print *Peace* (fig. 8), two figures reach out for a dove holding an olive branch in its beak. A third figure, seemingly exhausted, rises off the ground. Clouds and rolling hills provide a background for the trio. Clearly a response to domestic and international conflicts, this work celebrates the struggle and determination for peace

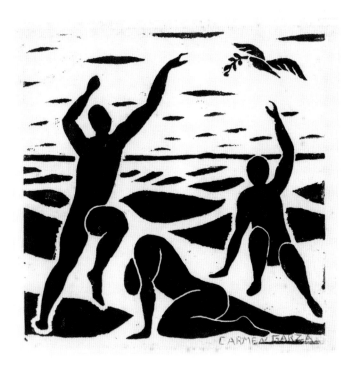

Figure 8. Carmen Lomas Garza, *Peace*, 1967. Linoleum block print, 9 × 9 inches. Artist's collection.

Photograph by William Haught.

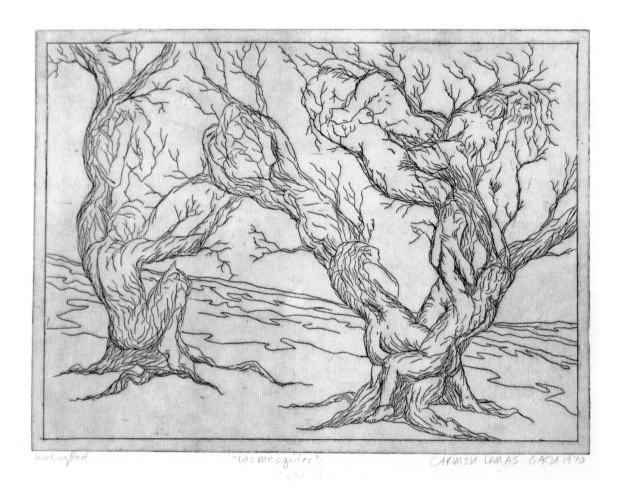

"Los Mesquites" CARMEN LOMAS GARZA 1970

Figure 9. Carmen Lomas Garza, *Los Mesquites*, 1970.
Aluminum plate etching, 8¾ × 11¾ inches. Artist's
collection.

Photograph by William Haught.

while showing the artist's interest in the formal relationship
between positive and negative ground and the decorative possi-
bilities of design.

Another work was an intaglio etching, *Los Mesquites* (fig. 9),
begun in 1969. The artist uses nature to comment on the
dynamics of human relationships. Against a barren landscape,
eleven figures have been integrated into the rough bark that
defines the trunks and branches of two mesquite trees. A range
of emotions is apparent in the body language of the males and
females. They hold each other, escape from each other's arms
into the arms of others, and even show grief after loss. With their
characteristically gnarled and tangled branches, the mesquite

trees provide an apt metaphor for the sometimes contradictory and confusing aspects of romantic love.

Finally, Garza included a remarkable lithograph, a self-portrait (fig. 10). This spontaneous three-quarter profile, created without preliminary drawings, is unusual in its starkness. The artist's disheveled black hair, contrasted against a white background, frames a face haunted by large black eyes that capture and hold those of the viewer. Three-dimensionality and texture are implied through the use of gray pigment distributed across the artist's face. This gray patterning across her skin gives the image a sense of the complexity of the times and the sitter's personality—the irregular shapes and values almost conveying syntax or, perhaps, a narrative.

Although these images seem disparate in their style and in the media employed, they share qualities that would appear later in the artist's more mature works. Arguably, they all contain an element of narrative, either stated explicitly in the actions of the subjects or suggested through the use of textured variation that takes on a life and language of its own. Texture and rhythm are also present in these works, especially in the repeating forms and lines of *Peace* and *Los Mesquites*.

One aspect not seen in these earlier works is color, which would become a hallmark of her later imagery. At this point in her artistic development, Garza was drawn to creating works in black and white for a variety of reasons. As she explains it:

> I was very interested in prints, in printmaking. . . . Because in high school I only did black-and-white artwork . . . my forte was black-and-white: pen and ink drawing, pencil drawing, charcoal drawing. So printmaking was a natural to flow into after doing so much black-and-white drawing and work, because printmaking is basically black-and-white artwork. And it served the purpose of dissemination of the image. You have multiples. You have a lot of the image. And so prints became very important for the Movement.[36]

Beyond providing her with a venue to show her work alongside that of other emerging artists, the MAYO conference represented a milestone for Garza in other ways. On a practical level, she had successfully organized her first show and, in the process, had obtained her first exposure to the different dimensions of curating. These included hanging artworks and explaining

Figure 10. Carmen Lomas Garza, *Self-Portrait*, 1969. Lithograph on Rives paper, 12 × 9½ inches. Artist's collection.

Photograph by Carmen Lomas Garza.

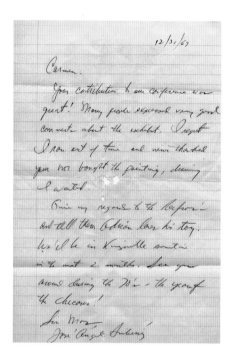

Figure 11. Letter from José Angel Gutiérrez to Carmen Lomas Garza, December 31, 1969.

Photograph by Carmen Lomas Garza.

the context of the show to viewers, in this case the conference attendees. On a more personal note, the appreciation voiced by visitors to her gallery and by the MAYO staff reinforced her sense of satisfaction in a job well done. Shortly after the conference, José Angel Gutiérrez wrote her a brief note expressing his gratitude for her hard work, noting that "many people expressed very good comments about the exhibit" (fig. 11).[37] Additional acknowledgments of Garza's contribution would continue long after the event, and indeed many of the high school and college students who attended the MAYO conference have recontacted her in recent years. Like Garza, most have become successful in their life work. She notes, "These are my peers, now, who are attorneys, people in positions now that remember me from that show, so I made an impression."[38]

Perhaps most important, for the first time Garza found it possible to combine her love for art with her commitment to social justice. By placing herself and the artwork in the context of a political conference, she was able to connect events in her life and her family's struggle to a broader state and national community and its history. She began to understand how her art could be an important vehicle through which she could give voice to aspects of the Latino experience.

The MAYO conference led to a number of opportunities for Garza to continue combining activism with art. During the meeting, the group, along with the Oblates, decided that the breakfast program for children at La Lomita would continue. They invited Garza to supervise the children in painting murals for the monastery, and the artist took a one-semester leave from the university in order to undertake the task. Unfortunately, because of lack of funding, the mural never materialized.

Garza had a bit more success with the short-lived Colegio Jacinto Treviño, a MAYO-based institution named after an early twentieth-century Mexican American who had killed a Texas Ranger for unjustly beating his brother.[39] Initially the school was to be located at the site of La Lomita's residence hall. However, shortly after MAYO's plans became public, local controversy forced a change in location and the college was moved to Mercedes, Texas.[40] Working with the help of Antioch College, in Yellow Springs, Ohio, the MAYOs set up an undergraduate training program for teachers. Volunteer faculty from other universities also helped. After obtaining public and private

funding, the college was established in Mercedes with the aim of creating a bilingual and bicultural program for teachers who primarily taught Latino children. While Carmen never managed to teach at the Colegio during the main semester, she maintained connections with those directly involved and was able to rent a house in Mercedes. At the Colegio, she set up a silk-screening studio and taught a printing class during the summer. In the meantime she continued producing art, using the print shop of an instructor at the Pan-American University in Edinburg, Texas, whom she had befriended.

During this time she also formed a close relationship with Xavier Gorena and Enrique Flores, partners in a frame shop and gallery in Mission (fig. 12). They became her mentors and, during this and many subsequent summers, helped Garza learn about the business of art. Both she and Xavier started working with *papel picado* at the same time, and she began exploring the potential of incorporating paper cutouts in her work. While Carmen stayed within more traditional boundaries, Xavier's work was geometric and stylized in its patterning, and he would sometimes even spray-paint his cutouts.[41] Xavier and Enrique believed in Carmen's work and gave her a first solo show in October 1972. Held at their Estudios Rio Gallery, the show was called *Lotería y Otros Monitos*.

The exhibition included one of Garza's earliest suites of prints. In one of these, *Lotería—Primera Tabla* (1972, fig. 13), she draws on her community experiences to create her own series of lotería tablas.[42] The game card consists of twenty-five different figures compartmentalized within a block of five rows and columns. Two-dimensional line drawings, the *monitos*—little figures—float on varied fields of color. Within the figures, stippling has been used to indicate texture. Under each drawing, the name of the object or a descriptive term for it is written in double-lined letters. The artist used monitos that are part of South Texas traditions and were copied from old monitos given to her mother.[43] Both the pre-Columbian and colonial worlds are referenced here. For instance, a "speech scroll" comes out of a man's mouth to indicate someone who is long-winded or talks too much (*pico largo*). This is the same type of speech scroll found in indigenous precontact and colonial painting. An orb bearing a cross, often held by Christ in colonial representations to signal his dominion, indicates *el mundo*, the world.

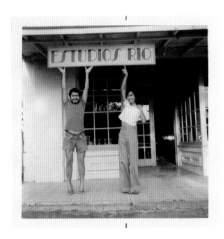

Figure 12. Carmen Lomas Garza and Xavier Gorena in front of Estudios Rio Gallery, Mission, Texas, circa 1972.

Photograph courtesy of Carmen Lomas Garza.

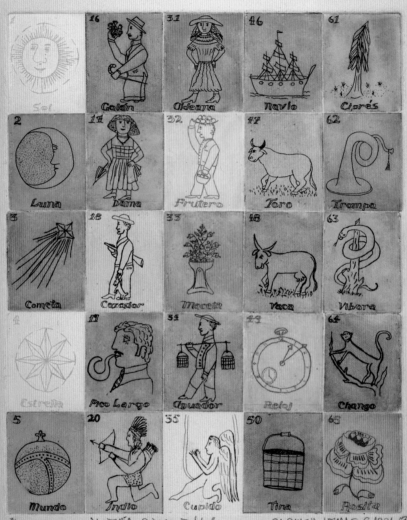

1 Sol	16 Galan	31 Aldeana	46 Navío	61 Cíprés
2 Luna	17 Dama	32 Frutero	47 Toro	62 Trompa
3 Cometa	18 Cazador	33 Maceta	48 Vaca	63 Víbora
4 Estrella	19 Pico Largo	34 Aguador	49 Reloj	64 Chango
5 Mundo	20 Indio	35 Cupido	50 Tina	65 Rosita

3/8 "LOTERÍA - Primera Tabla" CARMEN LOMAS GARZA '72

The close friendship that developed between Carmen and the two men over the years was very dear to her. Even after she moved to California, she continued visiting Enrique and Xavier during the summers. After both men succumbed to AIDS, in 1990 and 1991 respectively, Carmen would think of them frequently, and she eventually devoted part of an installation to the memory of her early teachers.

By fall 1970, Carmen had returned to her studies. She moved to Austin for a semester at the University of Texas, then traveled back to Kingsville to complete her degree in art education at Texas A&I. As part of her degree plan, she was required to fulfill a semester practicum that involved student teaching. As it turned out, this was less than the positive experience that she had hoped for. She was assigned to a class at Robstown High School, twenty-three miles north of Kingsville, where roughly 80 percent of the students were Mexican American.[44] As was typical for the times, the Mexican American teachers posted to the campus were few: Garza, an assistant coach, and another student teacher were the only Latinos on staff. Administrators assigned the morning art classes to Garza and instructed her not to speak Spanish to students. She quickly found that this was impossible, as many of the students had only recently arrived from Mexico and spoke no English. Realizing that without proper instruction these students would not be able to pass the class, she opted for compromise: she gave the initial instructions for projects in English, and then, as she went around the room, translated one-on-one for the Spanish-speaking students.

Yet another problem arose when Garza tried to play some of the music that the students brought from home.[45] At that time, the only background music allowed in school was country and western, which was piped in from the adjoining auto shop class. Many of the students expressed a desire to listen to other types of music, so Garza again sought a compromise: they would listen during the first half hour of class to country and western, and during the second half hour to whatever the students brought in. She borrowed a portable record player from the school library. On the third day, after she put on a Carlos Santana album, one white student, a relative of the principal, became agitated and complained to the principal. The principal sanctioned Garza's supervising teacher, who in turn strongly cautioned Carmen. After that, her supervisor and the principal kept a close eye on

Figure 13. Carmen Lomas Garza, *Lotería—Primera Tabla*, 1972. Color etching, 12 × 10 inches. Nettie Lee Benson Latin American Collection, University of Texas, Austin.

Photograph courtesy of Nettie Lee Benson Latin American Collection, University of Texas, Austin.

her. Although she stopped playing the music, the principal's
young relative then lodged a complaint about Garza speaking
Spanish to some of the students. She was put on notice, with the
warning that if she made another mistake she would be unwel-
come as an instructor in the Robstown school district.

Events came to a head when MAYO-affiliated students led a
walkout on campus.[46] MAYO was particularly concerned with
educational reform, and their agenda included promotion of
bilingual education, advocacy of a historical pedagogy that was
more inclusive, and greater inclusion of minorities in teacher
recruitment and hiring. It was clear to the Robstown MAYO group
that their high school was deficient in all three. Many of Garza's
students left the room. When some of the students asked her
whether they should go or stay, she replied in English, "Whatever
you feel you have to do, do. I cannot physically stop you."[47]

Since the start of her student-teaching assignment at
Robstown High School, Garza had eaten her lunch at a picnic
table located across the street in a little park. That day she
took her sack lunch and walked to the park, only to find that
the MAYO students had chosen that same place to congregate.
While she ate her lunch, she asked them if they knew what they
were doing. As she was speaking to the students, the superinten-
dent of schools drove by slowly.

The fallout the next day was devastating. In the morning, as
she carpooled to school with another Mexican American student
teacher, she was chastised by her companion for talking to the
students. As she walked into the school, she was met by her
university supervisor, who informed her that the superintendent
did not want her teaching at Robstown High School anymore.
Garza insisted on meeting personally with the superintendent.
She went to his office, where she was told that he did not want to
speak to her, and that if she persisted or even stepped on school
property again, he would sack all of the Mexican American
student teachers. Carmen went home angry and in tears.

The backlash continued. To enable her to graduate, her
Texas A&I professor eventually had her reassigned as a student
teacher in Falfurrias, about thirty miles from Kingsville. This
time new restrictions were placed on her teaching from the
beginning. She was not allowed to have her own class and thus
she functioned more as a teacher's aide than as the teacher of
record. But that was not the end of the repercussions from the

Robstown walkout. To her horror, Garza later found out that all the boys who had been active in the walkout had been drafted as soon as they turned eighteen, then sent to boot camp and on to the Vietnam War. After hearing this, Carmen understood the cost of direct action for equality and decided to devote her energies to creating a bridge of understanding through her art. More than any other event in her life, the Robstown incident had a powerful impact on her. It was at this point that she decided that she wanted to be a full-time *Chicana* artist.

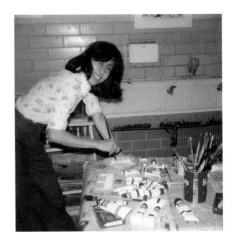

After earning her degree in 1972, Garza moved to Austin to teach and to continue her education. Earlier, in 1971, Leonard Maestas and André Guerrero, whom she had met at the Colegio Jacinto Treviño, had broken off from the Colegio and moved to Austin.[48] By 1972 they had established the Juárez-Lincoln Center, then housed at St. Edward's University, a private institution in Austin.[49] They asked Garza to design the books that the Center was publishing with their research on migrant education.[50] While she was there, she obtained a master's in education from the Juárez-Lincoln Center, accredited by the Antioch Graduate School of Education.

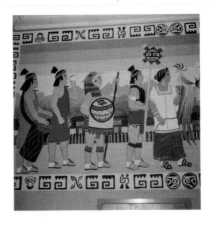

In September 1974, Carmen began teaching at Allan Junior High School in Austin as an art instructor (fig. 14). During her one year at the school, she organized a class mural project for the cafeteria.[51] Since the principal would not allow paint on the wall, the students painted their images onto two large sheets of paper using acrylic paints. Many of the Latino and black students had requested a theme pertinent to their own histories and the coming together of Old and New World cultures, so it was decided that the mural would address the topic of the Conquest of Mexico. Each of the sections featured a group of figures in profile, with the two groups facing each other (figs. 15, 16). One showed Hernán Cortés and his soldiers, some of whom were black, making their way to the center of Mexico. The other part of the mural featured Motecuhzoma and the Aztecs. Work on the painting began in March 1975. Every afternoon, the students met with their teacher; together they rolled out their nine-foot-long section of paper and painted until it was time to go home. Garza recalls that the students were very committed to the project and, as the deadline approached, they began working on weekends as well. The mural was hung in the cafeteria on Cinco de Mayo.

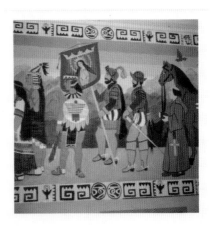

Although the children were inspiring, Garza realized that she could never be as committed a teacher as she was a professional artist. Two years before, she had reconnected with César Martínez, a graduate of Texas A&I who was by then living in San Antonio and was an active member of the art group Con Safo.[52] The group included artist Melesio Casas, who wrote many of the position papers, and art historian Jacinto Quirarte. Con Safo, which came together around 1972, had as one of its goals to create exhibition opportunities for its members. By the time Carmen appeared in Austin, Martínez and several others had become dissatisfied with what they perceived to be the creative limitations and general mainstreaming of the group.[53] Hoping to more tangibly bridge the arts with activism, they formed a new group, Los Quemados, consisting primarily of Martínez, Amado Peña, and Garza.[54] Together they hoped to challenge the hegemonic practices of galleries and museums in San Antonio and the region by exhibiting "in gymnasiums, store-fronts, or whatever spaces were offered."[55] Garza regularly drove to San Antonio to converse informally with other members of Los Quemados and attend the group's monthly meetings. During this time, she created artworks that invoked her childhood experiences. These were exhibited alongside works by other Quemados artists and at a solo exhibition at San Antonio's Trinity University in 1975.

An image from this period is the etching *Curandera* (1974, fig. 17).[56] While exemplifying a continued interest in detail and texture, it also represents the direction in which the artist would take her work: a celebration of childhood spaces. The etching foregrounds an important aspect of border spirituality known as *curanderismo*, or folk healing.[57] Garza depicts a cleansing ceremony taking place in a Kingsville bedroom. Here, a *curandera*, or healer, cleanses a woman by sweeping over her reclined body with a broom. The woman is being rid of *susto*, a type of fright that results in a loss of spirit and can cause weakness and anxiety.[58] In this case, the woman's susto came from the shock suffered when her husband lost his arm at work. Even though the patient is covered during the cleansing ritual, the artist allows us an X-ray peek under the blanket. Two kneeling women pray, rosaries in hand, while a one-armed man, the ailing woman's husband, watches respectfully. A boy, too young to understand the ritual, has been banished to a small porch on the other

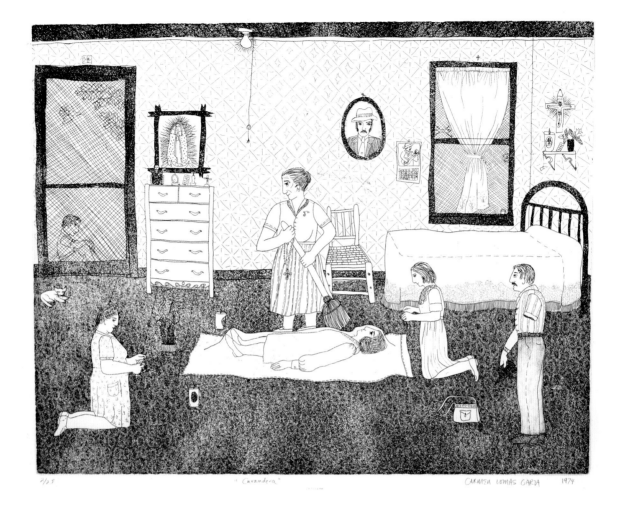

Figure 17. Carmen Lomas Garza, *Curandera*, 1974. Etching, 48¼ × 56½ inches. Artist's collection. Photograph by Wolfgang Dietze.

side of a screen door. At the patient's feet are two candles and a burning censer from which copal smoke emanates.[59]

The era in which Garza grew to adulthood was one of far-reaching social change in Texas. Latinos in Kingsville worked for economic and political parity through the American GI Forum and the United Farm Workers, but this commitment sometimes came at great personal cost. Garza herself experienced discriminatory practices in education, but these were tempered by her closeness to her family and community, who provided support and direction. As she developed into a young artist, her innate

tenacity and her sense of social justice drove her to make an early commitment to her art.

Her experiences at Texas A&I, which prepared her academically for her career, also helped guide her toward political activism. At the home of her instructor, William Renfrow, she and other students discussed issues at the core of the nascent Chicano movement. Many of the students joined MAYO and had their artwork displayed at the first MAYO conference in Mission, Texas. Garza's organization of the MAYO exhibition drew her further into activism and afforded her the opportunity to exhibit her work to a larger audience. She realized that mastery of lithography and etching made it possible to bring her message to a broader community. Her participation in the conference increased her confidence and furthered her resolve to make a difference through her art. It also brought her into contact with like-minded individuals who would open new doors of opportunity.

Certainty about her direction would sustain her through the Robstown High School walkout and the move to Austin, where she undertook her first year of teaching. During this time she reassessed her commitment to art and made the decision to devote herself to a type of artistic production that would be valued not only for its inherent expressive value but also as a narrative of the often-ignored history of Tejanos after World War II. By 1975 she was ready to take her message to a larger forum. She would test herself in a new arena, the West Coast.

A TEJANA ON THE WEST COAST

Education was the impetus for the move west.[1] Garza had received a master's in education while in Texas, but she wanted to focus on the development of her art in an academic environment. Pedro Rodriguez, who had been the first Chicano art instructor at Texas A&I, had taken a position at Washington State University, located in Pullman. He recruited Garza into a master of fine arts program there in 1975 and arranged for her to receive a teaching assistantship. While she enjoyed her classes, she missed her family and the Tejano community back home. Furthermore, she found the environment to be less than hospitable. The cold weather and the unfamiliar snow were matched by the frosty reactions of the white students, many of whom apparently believed that the Chicano students had been admitted because of their color rather than on the merits of their artwork.

Although her stay in Pullman lasted only a year, Garza was able to take painting classes and directed her energies to the study of color.[2] She was initially confused by the numbers of colors and then overwhelmed by the color possibilities. She feared making mistakes and wasting costly paint. She also wondered if the colors she combined would match the colors in her memory. To overcome her fear, she set about doing endless color scales, carefully noting nuances of hue and value.

With two semesters under her belt, Garza enrolled in and completed a summer session. During the week of July 4, 1976, her sister Mary Jane flew in from Texas to visit her.[3] Together they drove to San Francisco to spend time with a high school friend, Michael Vera, who had moved to the city. At Vera's suggestion, Carmen visited the Galería de la Raza, an arts center that she had first read about in the publication *Quinto Sol* while still a student at Texas A&I.[4] She was excited by the prospect of an arts environment devoted exclusively to Latino arts and community. After visiting with the codirectors, Ralph Maradiaga and René Yáñez, Garza realized that she would have a place there if she wanted it. She traveled back to Pullman, finished the summer session, and moved to San Francisco in August 1976.

Located in San Francisco's Mission District, the Galería de la Raza had been founded in 1970 by Chicano artist-activists, including Maradiaga, who became one of its first administrative directors.[5] It was a nonprofit organization devoted to exhibiting Latina/o art. By the time Garza arrived, the arts center had moved to its permanent space at the corner of 24th and Bryant streets.

For the first few months, Garza did volunteer work at the Galería. But seeing her industrious nature, Maradiaga and Yáñez quickly realized her value as a worker and put her on part-time salary. She became the assistant to Maradiaga. Although the times were lean, she was happy to be working with a group of like-minded people. She moved in with Yáñez but the relationship lasted only two years. She also enrolled in San Francisco State University in August 1978, earning a master's in art in 1981. She continued at the Galería until that year.

To Garza, her professional life began when she moved to San Francisco. Working at the Galería de la Raza expanded her knowledge of the art world and taught her about every aspect of running a nonprofit organization. Like others at the Galería, she did everything from organizing and mounting exhibitions to scrubbing toilets. She recruited board members, reviewed grant proposals, and coordinated volunteers. She also met many artists and learned from them how to present herself professionally. She carefully observed the many artists who came through the door: some of them made mistakes and others were quite successful in marketing their work. She made mental lists of their more effective qualities and approaches and integrated them into her own practices. She learned how to create a professional statement and résumé and how to photo-document her work to its best advantage. She resolved that if asked for materials and slides, she would be ready.

One of Garza's greatest contributions to the Galería was the exhibition *Homenaje a Frida Kahlo: Día de los Muertos* (1978), which she curated (fig. 18). She first conceived of the show during the gallery's 1976 exhibition celebrating Día de los Muertos, or the Day of the Dead.[6] Although she had seen book illustrations of Kahlo's work in 1970 while a student in Texas, she had never seen her image incorporated into contemporary work until the Galería's Day of the Dead altar show in 1976. One of the participants in that show, Amalia Mesa-Bains, had created an altar dedicated to five women, one of whom was Frida Kahlo.[7]

Figure 18. Posters for *Homenaje a Frida Kahlo: Día de los Muertos*, 1978. The poster was created by Rupert García.

Photograph by Ralph Maradiaga; courtesy of Rena Bransten Gallery.

Carmen noticed that the installation attracted strong community interest. She realized that the life and work of Kahlo, who was quickly becoming an icon, merited and could easily sustain a show of artistic tributes to her.

Garza's 1978 exhibition would be one of the most ambitious ever undertaken by the gallery. It included the single and combined efforts of some fifty artists.[8] Her extensive research on the project was aided by art historian Hayden Herrera's traveling exhibition of Frida Kahlo's work that opened in January 1978 at the Museum of Contemporary Art in Chicago.[9] Garza made a point to see it at the Denver, Colorado, venue. Back in San Francisco, she, Mesa-Bains, and María Pinedo interviewed people who had actually known Kahlo; they then worked together to create an informational booklet on the artist (fig. 19). While discussing the show with potential artists, Garza realized that many of them did not know about Frida. She formed a committee to discuss education and organized workshops for the participants in which they learned about Kahlo's life and work.[10] The exhibit opened in November 1978 to positive reviews.[11]

Garza created two works for the show. The first of these introduced the space to passersby via a cutout image that filled the width of the Galería's front window (fig. 20). In the center, a hand supports a banderole with the title of the show, *Homenaje a Frida Kahlo*. This format was chosen as a tribute to Kahlo, who employs scripted banderoles throughout her work.[12] Garza's second contribution was a *nicho*, a small box containing art, which

Figure 19. Exhibition booklet for *Homenaje a Frida Kahlo: Día de los Muertos*, 1978.

Photograph by Carmen Lomas Garza.

HOMENAJE A

FRIDA KAHLO

HOMAGE TO FRIDA KAHLO

NOVEMBER 2 - DECEMBER 17, 1978

GALERIA DE LA RAZA / STUDIO 24

Figure 20. Carmen Lomas Garza, window display created for the exhibition *Homenaje a Frida Kahlo: Día de los Muertos* at the Galería de la Raza, 1978.

Photograph by Carmen Lomas Garza.

features a sacred heart and, above it, Frida's well-known eyebrows, forming the wings of a bird (fig. 21). A child emerges from a painted flower on the floor of the box (fig. 22). This is clearly a reference to Frida's miscarriage during her stay in Detroit.

During the time that Garza worked at the Galería, she made progress in promoting her own work to outside agencies. Her success with the Kahlo exhibition made her competitive for grants and other monies, which in turn allowed her more time to devote to art production.[13] In addition to showing her work at the Galería, Garza found success at other local venues such as San Francisco's Mexican Museum. In 1977 the museum's director and curator, Peter Rodríguez, paired her work with that of a Mexican painter, Ester Gonzalez, but gave Garza her own room. Since it was primarily a print show, she was able to exhibit many of the works that she had produced earlier in Texas. For Garza, seeing the space filled with her images validated her hard work and her abilities as an artist.

Her work as a printmaker also led to a two-woman show with Oakland artist Margo Humphrey in 1980 at San Francisco's Museum of Modern Art.[14] At this venue, Garza displayed not only her aptitude for etching but also her talent as an emerging painter. Tomás Ybarra-Frausto, an admirer of her work, wrote an essay for the catalog, noting the uniqueness of her style and subject matter:

Although there is a naïve earnestness and folkloric-like element in the art of Carmen Lomas Garza, her expression is neither instinctive nor primitive. The artist is technically adept and academically trained. She has deliberately chosen to stand outside and remain independent from dominant artistic trends seeking to evolve private aesthetic responses to her social concerns. Although her work does not posit an overt political statement, it originates from a conscious desire to respond to the contemporary situation of the Chicano by projecting positive images derived from its culture.[15]

Figure 21. Carmen Lomas Garza, *Vida y Muerte/Homage to Frida Kahlo*, 1978. Oil on wood, 19½ × 12⅛ × 3⅝ inches. Artist's collection.
Photograph by M. Lee Fatherree.

Figure 22. Carmen Lomas Garza, *Vida y Muerte/Homage to Frida Kahlo* (detail).
Photograph by Carmen Lomas Garza.

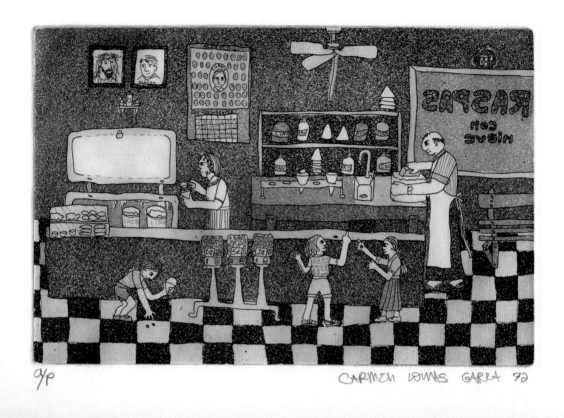

Figure 23. Carmen Lomas Garza, *Raspas con Nieve*,
1972. Intaglio print, 5¾ × 9 inches. Artist's collection.
Photograph by William Haught.

The "folkloric-like element" to which Ybarra-Frausto refers is
the characteristic flatness and linear quality found in these early
images. As he noted later, this aspect of Garza's work owes much
to the *retablo* and *ex voto* traditions of the Southwest.[16] Retablos
are small images of saints painted on metal or wood; in New
Mexico, they are outlined and flat in their coloration. These
images were meant for devotional spaces in churches and for
private home altars. New Mexican ex votos are small paintings
on tin that are left at shrines to offer public thanks to specific
holy figures. These works depict historic people usually involved
in an event that required sacred intervention.

Despite these referents, Garza's work is firmly situated in
modernity, and as Ybarra-Frausto notes, "her expression is

Figure 24. Carmen Lomas Garza, *Raspas con Nieve*, undated. Intaglio print and watercolor, 5¾ × 9 inches. Artist's collection.

Photograph by Carmen Lomas Garza.

neither instinctive nor primitive." While the visual devices in the creation of these meticulously planned images do invoke traditional genres, the motivation for their use sets them apart from the earlier retablo tradition. In the modern works, Garza self-consciously chooses to employ these techniques in an indexical way: that is, they are used as signs that point to something else, something larger and beyond their own materiality and the immediacy of the contained narrative. These lines and areas of flat color invoke time—eras past—as well as an ongoing dialogue with Garza's culture and its history.

Ybarra-Frausto was particularly intrigued by Garza's hand-painted etchings. Garza had reworked images such as *Raspas con Nieve* by adding bright colors (figs. 23, 24). The image is a visual recollection of a visit to an ice cream and snow cone shop located on the corner of Santa Gertrudis and 9th streets in Kingsville. From the walls, the faces of Jesus, John F. Kennedy,

and Benito Juárez peer down at the children who wait for their treats as the shopkeepers scoop ice cream and shave a block of ice. Whereas in the earlier version, lines provided variation in texture and modeling, lines are minimized in the later version and differing hues now carry much of the formal and expressive information. The artist's choice to limit the colors to a primary palette enhances the notion of childhood, while the judicious placement of these colors successfully guides the viewer's eye across the surface.

While formal similarities between retablos and ex votos and Garza's work are readily apparent, her images can also be linked to the traditions on another level. There is a quiet air about her work, a solemnity that underlines the sacred nature of memory and of community and family life. Like ex votos, her images depict real people involved in daily, even mundane, activities. Like a retablo, they establish a one-to-one dialogue between image and viewer that resonates on the personal level of recognition.[17]

Ybarra-Frausto understood the colored etchings included in the San Francisco Museum of Modern Art show as an "intermediate phase" directed toward the development of paintings in the artist's oeuvre.[18] However, the works should also be considered as autonomous explorations of the parameters of each medium. The choice of print or painting is often determined by Garza's intent regarding the foci of the works and her desire to establish a dialogue between primary and secondary subject matter. For instance, when two works from the exhibit, the etching *Curandera II* (1979, fig. 25) and the gouache painting *Curandera* (1977, fig. 26), are considered together, it is clear that the shared subject is border spirituality and healing. However, the medium and the use of color determine both viewer understanding and response.

In *Curandera II*, immediate attention falls on the healer. She brushes her patient with branches from the *ruda* plant, which is believed to repel evil influence that may be directed against unsuspecting victims. A tilted, almost "bird's-eye" view, inspired by ex voto painting, is used to fully communicate the event. Aspects of the room, given in exquisitely lined detail, are downplayed by the addition of color. This maintains a focus on the unspoken dialogue between patient and curandera. Intimacy is further enhanced by the red brocaded blanket forming a cocoon around the young woman.

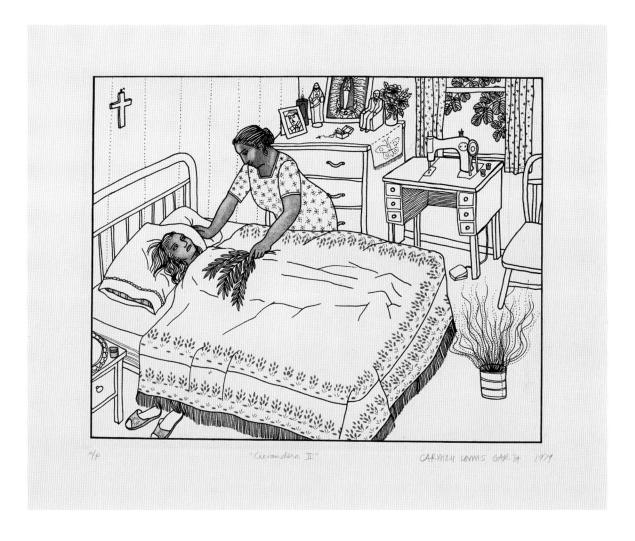

"Curandera I" CARMEN LOMAS GARZA 1979

Figure 25. Carmen Lomas Garza, *Curandera II*, 1979. Etching, 11 × 13½ inches. Color etching, 10½ × 13⅜ inches (image). Artist's collection.

©1979 Carmen Lomas Garza. Photograph by Wolfgang Dietze.

In the gouache painting *Curandera*, on the other hand, the uniform use of pigment directs the viewer's attention to different areas of the composition, thereby expanding the narrative between the actors and their environment. The theatricality of the action and the centrally placed group command our attention.[19] Here, Carmen's mother has called in a well-known curandera named Doña María to "cleanse" her daughter Mary Jane, who is experiencing a difficult adolescence.[20] In the center of the room, the curandera brushes Mary Jane with a ruda plant while copal incense smoke rises from the coffee can situated between them. Carmen and her mother, seated in chairs, watch

Figure 26. Carmen Lomas Garza, *Curandera*, 1977. Gouache on cotton paper, 11 × 14 inches. Artist's collection.

Photograph by Blair Paltridge.

over the proceedings while her little brother fidgets on a bed. The details of the surroundings are treated with equal interest. The walls of the room are decorated with a photograph and an image of the Virgin of San Juan de los Lagos. Beneath her, a shelf supports a framed passage from the Bible, a lit candle, and a small plaster sculpture of Don Pedrito, a famed local curandero.[21] The presence of Catholic icons in conjunction with curanderismo is not incidental, nor is it a contradiction, for it was common for healers to invoke the aid of saints and of the Virgin to effect their cures. From the scene, viewers understand that cures were approached in a holistic manner, one that relied on the presence of family and familiar settings and on different

types of spirituality.[22] The expanded narrative in Garza's work thereby hints at the broader culture context in which the ritual is enacted.

Beyond her duties at the Galería and her artistic production, Garza also tried to expand her understanding of the artistic community of which she was quickly becoming part. Her work at the gallery brought her into constant contact with artists, many of whom became her friends. They included Rupert García as well as Ester Hernandez, Patricia Rodriguez, and Irene Pérez, all members of the art group known as Las Mujeres Muralistas.[23] But primary among her newfound friends was artist and culture critic Amalia Mesa-Bains, in whom Garza found a kindred spirit. Garza also took several trips to Sacramento to meet with members of the art group called Royal Chicano Air Force (RCAF), who were networking with artists across the state.[24]

As part of her activism, Garza interceded with museums and art funding agencies on behalf of the Latino art community. She strongly believed that publicly funded agencies and art venues had a responsibility to the communities they served and that minorities should be represented on decision-making committees. She had the opportunity to act on these beliefs when she was placed on a panel for the California Arts Council as a reviewer of proposals for institutional grants.[25] Despite opposition from the organization's upper echelons, in meetings she consistently reminded others of the importance of addressing minority interests. She understood the significance of minority presence on granting boards and in curatorial positions and knew that she herself had benefited greatly by the presence of Latinos in these positions.

Shortly after leaving the Galería de la Raza in 1981, Garza received her first large public art commission from the San Francisco Water Department.[26] The paintings would relate to the history of water and would eventually be displayed in the department's Millbrae facility. The large undertaking occupied her from 1982 to 1984. During the initial planning stages, Garza researched the topic, narrowing the subject to the uses of water in Northern California with a special focus on the Bay Area. The result was a suite of eight acrylic paintings called History of California Water: The Everyday Use of Water. With the exception of the larger final painting, a map of the water route, each measures 36 x 48 inches and is narrative in form.

These paintings represent a conceptual departure from her previous work. They are primarily historical—to be read sequentially and chronologically—and by necessity forgo the intimacy of her earlier paintings in order to foreground factual depictions of the past. Taken together, the panels illustrate the many uses of water and the impact of population growth and urbanization on this precious resource.

The first pair of paintings, chronologically situated in the eighteenth century, dramatically contrast the different uses of water by Native Americans and Europeans. In *Native Americans* (fig. 27), Miwok Indians, who lived in the area that is now Yosemite Valley, use water for fishing and other daily activities. The painting emphasizes the almost seamless integration of nature with indigenous life through the incorporation of baskets used for bathing children and cooking acorn mush. In the second painting, *The Missionaries* (fig. 28), water is harnessed and removed from its natural context by the Franciscans, followers of Fray Junípero Serra, the founder of Mission Dolores (Mission San Francisco de Asís).[27] Two small vignettes, inset in arched frames echoing the church door, illustrate the primary uses for water. On the left, two Native Americans work fields watered by irrigation ditches. On the right, a priest supervises workers as they mix the elements of adobe—water, earth, and straw—in a large vat and fashion bricks on the ground before them. In both vignettes, the Native Americans, like the water, have been removed from their indigenous context through the intervention of Europeans.

Following imagery referencing the nineteenth century, Garza also included two panels that testify to the state's growing population and anxieties over water in the twentieth century. These paintings focus on public solutions to water scarcity in Northern California. In *Man Made Pond* (fig. 29), she illustrates how rain is captured to provide water for livestock consumption and to irrigate agricultural fields. *Hetch Hetchy Dam* (fig. 30) shows a dam constructed in 1923 in Yosemite Park to provide water and hydroelectricity to San Francisco and its environs, which receive water via an aqueduct. In the painting, a man located in the lower right-hand corner opens the floodgates, allowing water to escape.

From the four examples described here, it can be understood that the artist has deliberately forgone the autonomy associated

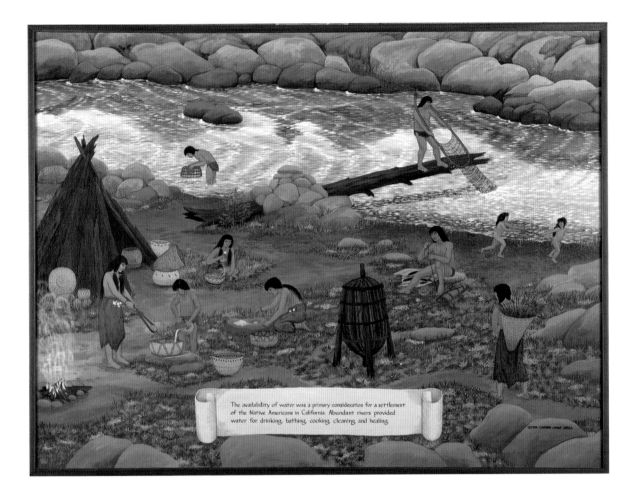

The availability of water was a primary consideration for a settlement of the Native Americans in California. Abundant rivers provided water for drinking, bathing, cooking, cleaning, and healing.

with earlier canvases: the series must be understood as a group. The suite is held together by the narrative banderoles introducing each painting and a strong emphasis on a central element in each—river, church, water pond, dam. However, while an overall centralized format has not been totally abandoned, objects are no longer contained by the parameters of the canvas. Characters and natural elements continue beyond our view and seemingly move toward the next panel in the series, and toward the future.

The History of California Water series firmly established Garza's reputation in the region. By October 1985, she had acquired a studio in Hunters Point Naval Shipyard, located in the southeastern part of the city.[28] Having found a space, she

Figure 27. Carmen Lomas Garza, *Native Americans*, 1984. From the History of California Water: The Everyday Use of Water series. Acrylic on Masonite, 36 × 48 inches. Collection of the San Francisco Water Department, City and County of San Francisco. Photograph by Wolfgang Dietze.

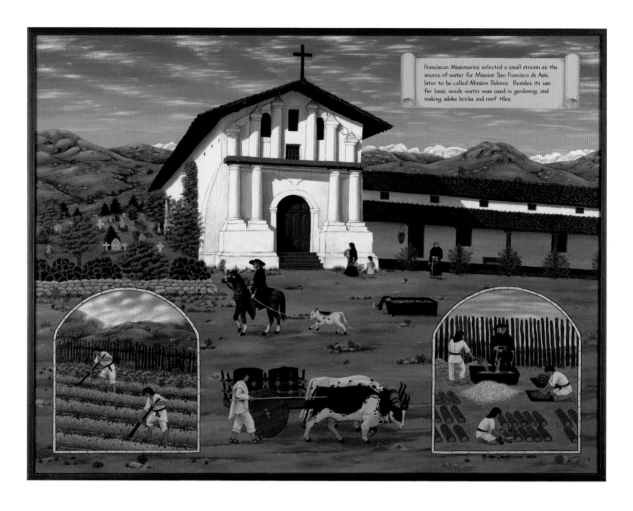

In the upper right, on a scroll within the image:

Franciscan Missionaries selected a small stream as the source of water for Mission San Francisco de Asis, later to be called Mission Dolores. Besides its use for basic needs water was used in gardening, and making adobe bricks and roof tiles.

Figure 28. Carmen Lomas Garza, *The Missionaries*, 1984. From the History of California Water: The Everyday Use of Water series. Acrylic on Masonite, 36 × 48 inches. Collection of the San Francisco Water Department, City and County of San Francisco. Photograph by Wolfgang Dietze.

now concentrated on generating a body of work far from the city's noisy center. Her timing was fortuitous, as by 1987 Garza was involved in two major shows.

Hispanic Art in the United States was the first major traveling Latino exhibition in the United States. Cosponsored by the Corcoran Gallery (Washington, DC) and the Museum of Fine Arts, Houston, the show focused on artists from multiple Latino groups within the United States who, despite various sites of origin, shared a language and a spiritual tradition.[29] For Garza, the exhibition turned out to be an education in introducing a national audience to Latino art: she learned about viewer and organizational reception of Latino works and about the institutional dynamics of participating in a major traveling exhibition.

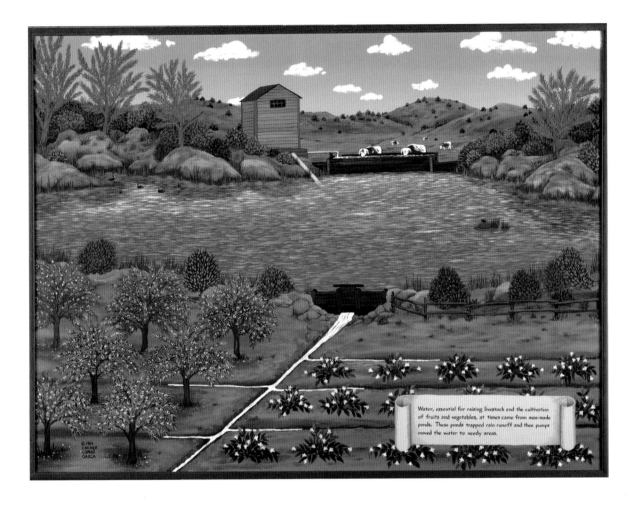

Figure 29. Carmen Lomas Garza, *Man Made Pond*, 1984. From the History of California Water: The Everyday Use of Water series. Acrylic on Masonite, 36 × 48 inches. Collection of the San Francisco Water Department, City and County of San Francisco. Photograph by Wolfgang Dietze.

She was able to show *Day of the Dead/Offering to Frida Kahlo*, an artwork inspired by the Day of the Dead altar that was produced collectively for the 1978 Frida Kahlo show (fig. 31). The piece took the form of a two-tiered stepped platform framed by papel picado at the top and, at the bottom, by marigolds and a papier-mâché figure of San Sebastiana, the skeletal saint who accompanies the dead into the hereafter. The altar's main tier was divided into two regions associated with Frida's life as an artist and her family ties (fig. 32).

For Garza, the circumstances of the 1987 *Hispanic Art* exhibition undermined the intended meaning of this work. This was in part because of Western European art traditions that favor the primacy of the single artist and in part because of the

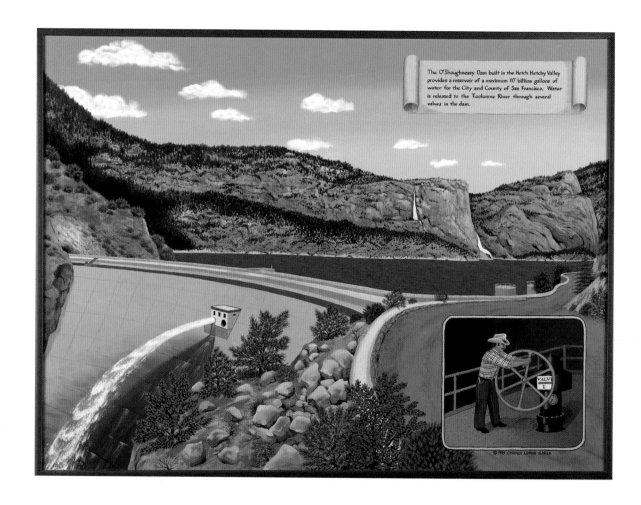

The O'Shaughnessy Dam built in the Hetch Hetchy Valley provides a reservoir of a maximum 117 billion gallons of water for the City and County of San Francisco. Water is released to the Tuolumne River through several valves in the dam.

Figure 30. Carmen Lomas Garza, *Hetch Hetchy Dam*, 1984. From the History of California Water: The Everyday Use of Water series. Acrylic on Masonite, 36 × 48 inches. Collection of the San Francisco Water Department, City and County of San Francisco.
Photograph by Wolfgang Dietze.

Figure 31. Carmen Lomas Garza, *Day of the Dead/ Offering to Frida Kahlo*, 1987. Mixed media, 8 × 8 × 4 feet. Artist's collection.
Photograph by Wolfgang Dietze.

itinerant nature of the *Hispanic Art* exhibition. Like many *altares*, the original work produced in 1978 had been a collaborative effort—a kind of community offering, with Garza orchestrating the process. Since the *Hispanic Art* exhibition organizers recognized only single artists, the 1987 piece was attributed solely to Garza, with no mention of group participation and solidarity. Furthermore, since the show was traveling, the work would be set up at various times during the year and not necessarily in the appropriate period of late October through early November. This weakened the altar's connection with the traditional celebration of Día de los Muertos. For the artist, these decontextualizations of the work were early warning signs of a degree of cultural insensitivity.

Figure 32. Carmen Lomas Garza, *Day of the Dead/Offering to Frida Kahlo*, 1987 (detail). Mixed media, 8 × 8 × 4 feet. Artist's collection.

Photograph by Wolfgang Dietze.

Because assembly of the altar required the artist's presence at each of the venues, Garza was able to remedy other missteps early on. One of the greatest gaffes was that the curators had not planned to clearly identify the artists in the exhibition or to introduce them at the openings. The organizers obviously did not know their audience. As Garza later noted with respect to the opening in Houston, "for a lot of the Mexican American community that was coming to the museum to see this exhibition, [lack of formal introductions was] a big no-no because, you know, we're used to being introduced. If you're invited to somebody's home, there's introductions all the way around. Children, adults, everybody."[30] It was fortunate that one of Garza's pieces was a self-portrait; visitors were able to identify her, the only Chicana in the show, and to ask her to introduce them to the rest of the Latino artists.

As the exhibition was being set up at the Corcoran Gallery in Washington, DC, one of the curators and writers of the exhibition catalog, Jane Livingston, came by with a representative of the Rockefeller Foundation, which had underwritten the show. Carmen detailed the content and meaning of her work to the visitors. She then suggested identification badges for the exhibition artists and a receiving line so that they could greet the public at the opening. The Rockefeller representative thought this an excellent idea and name tags were quickly generated. At all the other venues—Miami, New Mexico, Los Angeles, and Brooklyn—the artists were similarly made known to the exhibition viewers.[31]

Based on her experience with the *Hispanic Art* show, Garza developed personal guidelines for her participation in future exhibitions. First, museums would have to meet her halfway with respect to her requirements for the presentation of works. Second, they should consider with cultural sensitivity the Latino audience coming to see the show. And, finally, the institutions should schedule openings on Sundays, when working people would be free to attend. Carmen realized that this would enhance community participation, as most Latino families dress up for church and are therefore more likely to attend a show afterward. This would also provide an opportunity for children—future museum patrons—to meet the artists and have a memorable visit.

In November 1987, *Carmen Lomas Garza: Lo Real Maravilloso: The Marvelous/The Real* opened at the Mexican Museum in San

Francisco. This was Garza's first major solo exhibition. Although she had participated earlier in a two-person show at the museum, this time the attendance and recognition were much greater. No doubt this was due both to her work, which was gathering a following, and to the institution's new Fort Mason location. While a few prints were included in the show, Garza now had a forum to showcase her spectacularly detailed large paintings. A full-color exhibition catalog included an introduction by Terezita Romo and an insightful essay by scholar Tomás Ybarra-Frausto.

The vibrant images reflected the full development of Garza's use of oils and her mastery of gouache, a water-based pigment that has an opaque quality, unlike standard watercolor, which can be translucent. Technically, gouache is one of the most complex painting pigments to master. The medium is totally unforgiving and designs must be established before the application of color, as, unlike in oil or acrylic, mistakes cannot be corrected. Also, because of the large size of the suspended color particles, if the pigment is applied too thickly or overpainting is attempted, the paint begins to flake off. Adding to the complexity of the process, the wet color is not the same as the dry color. Dark pigments tend to dry lighter, and light pigments tend to dry darker. As she works, the artist must see beyond the present color; in her mind's eye, she must look at the work and imagine what it will be. For these reasons, Garza took extraordinary caution with her gouache paintings. Because of their large size and her attention to detail, each work required three to nine months to complete.

The exhibition also underscored Garza's versatility in terms of subject matter. The History of California Water series was displayed alongside canvases rooted in childhood memories, notably an earlier version of the now-famous *Tamalada* (1988, fig. 33). In this work, the artist captures the labor-intensive process of creating tamales in the kitchen of her childhood home. All of her extended family participates and tasks have been delegated.[32] Her mother, standing behind a white and blue mixing bowl, spreads masa (cornmeal dough) across the length of an *hoja*, a cornhusk. Her uncle and aunt, seated across from each other, lay down a line of *carne* (meat) along the length of masa. The filled hojas are folded up and given to Carmen's grandmother, who places them carefully in a pan for steaming. To the side of the table, a group of three, including Carmen's grandfather, is

Figure 33. Carmen Lomas Garza, *Tamalada*, 1988.
Oil on linen mounted on wood, 24 × 32 inches.
Private collection.

Photograph by M. Lee Fatherree.

involved with the earlier preparatory process. Dried hojas must
be separated and the corn silk, often left in the husk, must be
extracted. The hojas are soaked until pliable in a sink or, as is
the case here, in a large tub. Carmen's grandfather, wearing his
characteristic blue overalls, pulls the hojas from the water while
Carmen and her sister Margie help. At the doorway, observing
all, a little girl stands on her father's feet in a timeless gesture of
intimacy. For Garza, the position references the manner in which
her father taught all the children how to dance.

Lo Real Maravilloso: The Marvelous/The Real also included an
innovative development in Garza's works: "zoom-ins." These
paintings are focused examinations of particular details found
in earlier paintings. An example of this transition from general

to particular can be found in a consideration of two works from 1986: *Sandía/Watermelon* (fig. 34) and *Sandía*, the latter from her Pedacito de Mi Corazón (Piece of My Heart) series (fig. 35). In *Sandía/Watermelon*, Garza's family enjoys cold watermelon on their front porch on a summer evening. The porch, with its decorative wrought-iron pillars, is an isolated stage illuminated only by electrical lighting.[33] The group is spread out across our field of vision and is framed by Garza's grandmother, seated on a porch swing, and her grandfather, who concentrates on his melon. Children are painted throughout, but it is to their father that we are drawn. He stands before a table cutting the melon into quartered slices.

The focus of the zoom-in, *Sandía*, is the watermelon itself. We see the hands and forearms of Carmen's father as he slices into the fruit held captive by a shallow enameled white and blue pan. Unlike the larger painting, in which horizontality is emphasized, *Sandía*'s composition is diagonal, thus drawing attention to the actual act and direction of slicing. With its emphasis on motion, the work can be understood as a gerund rather than a noun. That is, the focus here is on the action rather than on a simple reiteration of subject. Further, the abstracted yellow background of the zoom-in has the effect of flattening the image to a point where arms, melon, and table begin to meld with each other. This spatial ambiguity borders on *passage*, a technique developed by Paul Cézanne and later employed in analytical cubism to explore the internal logic of a painting beyond the stated subject matter.

Nevertheless, the theme of familial unity and affection, conspicuous in *Sandía/Watermelon*, is never lost to formal considerations in the zoom-in. *Sandía* is from the Pedacito de Mi Corazón series, and as such, it carries the same semantic load. In this context, the image clearly refers to the sweetest part of the watermelon, its core or "heart." Additionally, when a parent says to a child "eras un pedacito de mi corazón" (you are a piece of my heart), great affection is implied. Thus, Garza takes on a symbolic parental role, and the entire Pedacito de Mi Corazón series reflects all the love in her heart for her family and its history and culture.

During the time that she was displaying her two-dimensional work, Garza continued working in three dimensions but on a much larger scale. Earlier, for the Mexican Museum show, she had fashioned a miniature *ofrenda* dedicated to her grandfather.

Figure 34. Carmen Lomas Garza, *Sandía/Watermelon*, 1986. Gouache on cotton paper, 20 × 28 inches. Private collection.

Photograph by Wolfgang Dietze.

She now chose to expand on her previous ideas and fabricated *Día de los Muertos/Ofrenda para Antonio Lomas* (1988–90). Measuring about 10 x 12 x 10 feet, this installation was created for a Day of the Dead exhibition at the Mexican Fine Arts Center Museum in Chicago (now the National Museum of Mexican Art). Although the work is mixed media, the primary vehicle for the work is papel picado. Here, a domestic interior references the outside world by means of a black-framed "window" suspended 30 inches from a painted yellow field. The viewer gazes out into Antonio Lomas's garden and watches him watering his yard. Lomas is surrounded by plants evoking the South Texas locale: maize, nopales, and behind a fence, a mesquite tree (fig. 36).

The "interior," framed on either side by papel picado curtains, centers on a kitchen table turned altar, situated before the

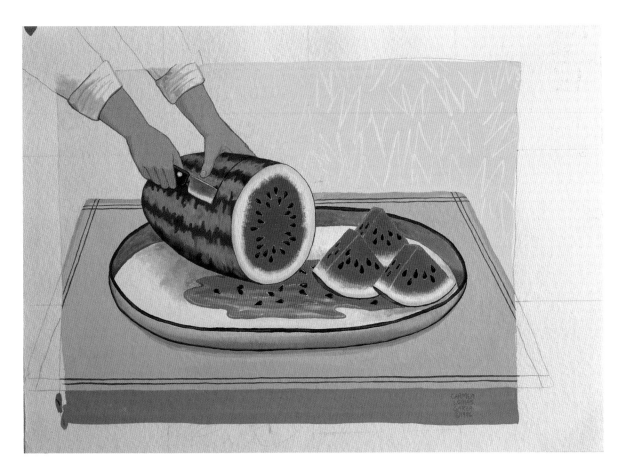

Figure 35. Carmen Lomas Garza, *Sandía*, 1986. From the Pedacito de Mi Corazón series. Gouache on Arches paper, 11½ × 15 inches. Artist's collection. Photograph by Wolfgang Dietze.

window. Papel picado table runners hang from the top of the altar and papier-mâché skulls flank a 1950s radio. Traditional Day of the Dead food offerings—oranges, sugar skulls, and *pan de muerto*, as well as a coffee cup—beckon her grandfather to interrupt his work and come in for a break. The turquoise chair has been pulled out, its paper doily reminiscent of the needlework and embroidery lovingly created by her grandmother Elisa Lomas.[34]

Antonio Lomas's pathway into the realm of the living has been marked with paper *cempoalxochitl*, marigolds that are the traditional flowers of the Day of the Dead.[35] This is in keeping with traditional representations of Day of the Dead altars, where carpets of the strong-smelling flowers are used to lure the dead back to the realm of the living for a brief visit. Once there, the spirits acknowledge the homage paid them by their descendants.

Figure 36. Carmen Lomas Garza, *Día de los Muertos/
Ofrenda para Antonio Lomas*, 1988–90. Black paper
cutout and mixed media, 10 × 12 × 10 feet. Artist's
collection.

Photograph by Steve Nelson.

In Garza's work, that the enticement has worked is indicated by the breeze-blown movement of the left curtain and by the presence of the hat, handkerchief, rake, and hoe—implements of her grandfather's labor—that have found a resting place on the papel picado–covered podium. Antonio Lomas has come in from the South Texas heat and is taking his midafternoon break at the kitchen table.

It is in this work that Garza has most fully engaged *domesticana Chicana*, the feminine variant of *rasquachismo*.[36] In a seminal article on domesticana, Amalia Mesa-Bains states that this aesthetic relies heavily on "bric-a-brac, memorabilia" and "decorative elements [that] are created by women." She notes that altars produced by Chicanas are natural vehicles for domesticana because they "allow a commingling of history, faith, and the personal."[37] Day of the Dead altars, such as the one fashioned by Garza, are by definition related to personal histories as well as to faith, and the grandfather's belongings located on the table/altar do much to personalize this sacred space. At

the same time, this installation is more than just a celebration of the domestic. As Mesa-Bains notes, domesticana challenges "the subjugation of women in the domestic sphere" by creating a "mimetic world view that retells the feminine past from a new position."[38] In the case of Garza's altar, it celebrates a space and a person that had much to do with her empowerment as a child.

Ofrenda para Antonio Lomas was seen again in 1991 in *Carmen Lomas Garza: Pedacito de Mi Corazón*, an exhibition at Austin's Laguna Gloria Art Museum (now the Austin Museum of Art–Laguna Gloria). The show marked the artist's first major traveling one-person show and her triumphal return to Texas. It included forty-eight two- and three-dimensional works of art, many of which appeared in an illustrated catalog. A catalog essay written by Amalia Mesa-Bains enhanced Garza's visual messages. It was clear that, beyond their beautiful imagery, the artworks appealed to the public because of their ability to inform viewers about Latino culture. In her comments on the *Ofrenda*, Mesa-Bains noted Garza's position as an interpreter and emissary of that message:

> Carmen Lomas Garza has been a historic conduit in the spread of Chicano *muertitos* art through her knowledge of tradition and *artesanías* (crafts). She occupies a unique role among artists in her contribution to the Chicano celebration of the Day of the Dead. Her transmission of Texas regional artistry to San Francisco's Bay Area has been a major development in the Chicano national celebration of *Día de los Muertos*.[39]

The show's two-dimensional work included a new canvas, *Earache Treatment* (fig. 37), which documents the use of a home remedy. The setting is evening on the porch in front of Garza's childhood home. As her mother prepares the remedy, the pair is illuminated by two lightbulbs. Her father, seated on a blue stool, directs his gaze downward as her mother carefully administers the treatment. According to Garza, this image was based on a childhood memory:

> I remember watching my mother and father go out to the front porch with a bucket of water. My mother took a sheet of newspaper, rolled it up into a cone shape, and placed it on my father's ear. She kept telling us to stay back. She

very briefly ignited the paper, then threw it into the water to extinguish it. I was amazed.

You see, my father would sometimes get water trapped in his outer ear when he went swimming, because of an injury when he was in the Navy during World War II. This treatment, called *ventosa*, would create a vacuum and evaporate the water.[40]

This painting would be the basis for a later composition titled *Earache Treatment Close-up*, created in 2001 (fig. 38). As in other zoom-ins, the shift in focus enables Garza to more fully explore the subject matter, in this case the remedy and its recipient. The change in meaning is remarkable. The painting becomes a portrait, and its sitter, cradled by nature, the recipient of knowledge born of cultural practice. The Spanish-language newspaper now seems a conduit through which voiced communication is

Figure 38. Carmen Lomas Garza, *Earache Treatment Close-up*, 2001. Oil and alkyd on canvas, 18 × 14 inches. Artist's collection.

Photograph by M. Lee Fatherree.

heard. The handlike flames stretching toward smoke now take on an almost spiritual quality. Garza's father becomes the beneficiary of this power that is funneled through the news of the day.

Three paintings representing innovations in the artist's oeuvre also appeared in the Laguna Gloria show. The first of these, *Breakdancers, San Francisco* (fig. 39), represents the first time that Garza integrated the contemporary urban environment of San Francisco into her work. In an interview, she explained the inspiration for the painting:

> We were driving on 24th Street in the Mission District, and it was already in the evening, and there was a traffic jam ahead of us. So I told Jerry [Jerry Avila Carpenter, Garza's husband],

Figure 39. Carmen Lomas Garza, *Breakdancers, San Francisco,* 1988. Gouache on cotton paper, 20 × 25 inches. Collection of The Oakland Museum of California.
Photograph by Wolfgang Dietze.

Figure 40. Carmen Lomas Garza, *Heaven and Hell,* 1989. Gouache on cotton paper, 28 × 20 inches. Private collection.
Photograph by Wolfgang Dietze.

Figure 41. Carmen Lomas Garza, *Heaven and Hell II,* 1991. Alkyd and oil on canvas, 36 × 48 inches. Artist's collection.
Photograph by M. Lee Fatherree.

let me go see what it is, because I saw a bunch of people in front of the store. So I got off to see real quickly, and what it was, was all these *cholos,* these kids dancing in front of the store. This was in the early '80s, and they were . . . doing breakdancing in front of the store. And they had taped a big sheet of corrugated cardboard on the sidewalk and they had their boom box in front of the store. And they were dancing to the music, they were doing breakdancing. And I just, I was mesmerized, because each kid had his own style of dancing.[41]

In *Breakdancers, San Francisco,* Garza lends the same attention to detail manifested in her earlier Tejano pieces. The tile

work characteristic of shops along this busy street is present, as is the decorative wrought-iron grating of the homes located on either side of the store. People of different ages gather to watch the twirling and gyrating youth. Even in the store windows, mannequins seem to be stunned by the spontaneous eruption of dancing.

The second and third works representing a different artistic development for Garza are *Heaven and Hell* (fig. 40) and *Heaven and Hell II* (fig. 41). These works fall into a category that the artist has labeled "*fantasías.*" They are renditions that allow Garza to explore her imagination and use allegory to investigate "imagined worlds."[42] In the earlier work, *Heaven and Hell* (1989), the artist presents parallel worlds. Above, winged figures dance to music provided by a four-piece band. In the hell below, chained figures have been consigned to pick up stones for eternity, surrounded by flames. A single window allows them a view of a world that they will never be able to enter. In *Heaven and Hell II*, completed two years later, Garza develops the theme. She maintains the format

but has increased the number of dancers, musicians, and inhabitants in hell. The transition between the two domains is much more subtle as the artist has traded the scalloped divider seen in the earlier work for an undulating line. It is as though the floor of heaven has become the ceiling of hell, and the indefinable aspect that separates the two realms is much more tenuous.

Carmen Lomas Garza's first fifteen years on the West Coast correspond with her emergence as a professional artist of national standing. Her time spent working at San Francisco's Galería de la Raza enabled her to extend her knowledge of the art business and opened doors to friendships and artistic collaborations. Once established at the Galería, she successfully competed for grants and sat on local art funding boards in order to work for parity on behalf of the Latino art community.

In 1987, her involvement in two major shows, the traveling *Hispanic Art in the United States* and *Lo Real Maravilloso: The Marvelous/The Real* at San Francisco's Mexican Museum, firmly established her reputation. Beyond introducing a much larger public to Latino art, these exhibitions also provided further opportunities to engage in a more immediate and practical type of activism. She contended with the decontextualization of her work and the schism between the Latino community and art institutions by developing a set of personal guidelines that would shape her future interactions with museums and galleries.

Throughout these years, Garza's work underwent dramatic changes in terms of media and presentation. Her fully developed monito style invoked the recognizable Southwestern retablo tradition, but it offered a contemporary dialogue with the past as well as a reaffirmation of cultural continuity. She expanded her palette and reconsidered earlier monotone prints in terms of color; through the use of pigment, she was able to advance the narrative between the actors and their environment. Likewise, the zoom-ins enabled her to closely examine the possibilities of meaning found in detailed renderings of sections from earlier works. Through fantasías she explored the inner workings, desires, and basic beliefs of her own mind.

Garza's format and subject matter also underwent change. While her work retained its traditional references, small three-dimensional altars gave way to far more ambitious installations. Likewise, her first large public commission, on water use in

California, reflected a new confidence in handling a large, time-consuming project that was not based on Tejano subject matter.

Her accomplishments during this fifteen-year span culminated in 1991 with her exhibition at the Laguna Gloria Art Museum, a show that represented a triumphal return home to Texas. But this time, she displayed her work on her own terms. She brought with her an understanding of the workings of the larger art world and a body of work that reflected her newfound sensibilities as an established professional. All of this would serve her well in the year that followed, when she would engage the international phenomenon known as the Quincentenary.

A CHICANA RECONQUISTA
THE QUINCENTENARY

> In fourteen hundred ninety-two
> Columbus sailed the ocean blue . . .
> —Columbus Day song

In 1992 Europe and the Americas celebrated the Quincentenary, the 500-year anniversary of the European encounter with the Americas. In Europe, the occasion was marked by increased trade negotiations with Latin America and by cultural events and scholarly endeavors. The Archivo General de Indias in Seville, Spain, instigated a massive project, digitizing some 45 million documents related to the Spanish presence in the Americas. The city of Seville meanwhile constructed the pavilions for Expo '92, the world's fair that would mark the Quincentenary event.[1] Elsewhere in Spain, Madrid was designated the "European Capital of Culture" and Barcelona hosted the Summer Olympics.[2] While showcasing Spain's history, the Quincentenary also advanced the country's identity as a thriving and modern member of the European Union—a profile much desired after the dark, repressive years of Francisco Franco.[3]

In the Americas, the Quincentenary was more controversial. Governmental agencies in Canada, the United States, and Latin America reacted favorably to European suggestions of heightened trade and even sponsored joint and independent cultural celebrations. But within indigenous and Chicano communities, the response was much more circumspect. Mexican anthropologist Héctor Díaz-Polanco expressed the concerns of many when he critiqued the frenzied excitement shown by governmental institutions.

A festive commemoration of these events would be the equivalent of celebrating the domination by force of the weak by the powerful (colonialism, imperialism), extolling genocide, ethnocide, and unlimited exploitation, and exalting intolerance of ethnic and sociocultural diversity. All these issues of freedom, pluralism, equality, and so on, that emerge as a result of colonial conditions are as urgent today as they were five centuries ago.

In this sense, I can see nothing worth celebrating. Instead, the quincentenary of the European invasion of these lands is an opportunity to reflect on democracy, colonialism, neocolonialism, and, especially, the internal colonialism that millions of indigenous peoples and black communities still suffer today. As far as ethnic oppression is concerned, we must judge not only the three centuries of colonial rule but also the almost two centuries of independence. Fundamentally, we must call attention to the condition of [the] indigenous population today and the prospect of ameliorating that condition.[4]

Díaz-Polanco's response to the celebrations aptly mirrors sentiments expressed by many in the arts. Numerous Native American and Chicana/o exhibitions reflected this alternative perspective on the "Conquest." Artists coming from groups heretofore marginalized viewed the Quincentenary as an opportunity to address historical omissions and to reinsert themselves and the groups they represented into the timeline of the hemisphere. This reassessment and reclamation of history can be understood as a *reconquista*, a reconquest, by artists and indigenous peoples.[5]

Carmen Lomas Garza's visual response to the Quincentenary was to create two works that challenge our reading of history while reminding us of the contributions of Native and Chicano peoples: *Codex Lomas Garza: Pedacito de Mi Corazón* and *Homenaje a Tenochtitlán: An Installation for the Day of the Dead*. The first of these, *Codex Lomas Garza*, was part of one of the more successful traveling exhibitions produced during 1992: *The Chicano Codices: Encountering Art of the Americas*. The show, organized and curated by Marcos Sánchez-Tranquilino, opened at San Francisco's Mexican Museum and ran from September 23 through November 29. It featured the work of twenty-six Chicana/o artists. Sánchez-Tranquilino viewed the exhibition as a contemporary visual response to the destruction of indigenous codices at the hands of mendicant friars during the Conquest period and "the dispersion of the surviving codices . . . to libraries and art collections throughout the continent of Europe."[6] He hoped the show would function as a forum in which to problematize the Quincentenary in light of the Chicano community.

Codex Lomas Garza: Pedacito de Mi Corazón (fig. 42) measures 15½ x 75 x 10 inches and is a single-sided work. Like many

Figure 42. Carmen Lomas Garza, *Codex Lomas Garza: Pedacito de Mi Corazón*, 1992. Gouache and watercolor on paper, 15½ × 75 × 10 inches. Artist's collection. Photograph by M. Lee Fatherree.

of the participating artists, Garza took as her template the pre-Columbian screen-fold format. This accordion-folded configuration lends itself to narrative and also invokes the precontact world of the Amerindian scribe, thereby effectively inserting the artist into a revered lineage. The expanded format also allowed Garza room to demonstrate her talent for mixed media. Here, her favorite media of papel picado and gouache are combined with the written word.

Both Sánchez-Tranquilino and art historian Ann Marie Leimer have noted that the overarching theme of *Codex Lomas Garza* is one of physical healing.[7] Plants and animals depicted throughout the pages are well known for their medicinal qualities. However, as in all her works, Garza's imagery also confers a kind of spiritual and informational healing of both the individual and his/her larger history. Painted figures, in everyday dress, engage in activities that reaffirm knowledge of healing that has been passed down from earlier generations. The broader historical context and continuity are indicated by the presence of red and black ties located on the front and back covers of the volume (fig. 43). The colored ribbons appropriately reference "those who carried with them the black and red ink."[8] These were Aztec wise men whose duty it was to record genealogies, histories, accounts, religious ceremonies, and scientific discoveries. Using red and black painted lines, these scribes divided the individual pages into rows or columns, thereby ordering their history and indicating the sequence in which events were to be read.

On Garza's front cover, lines of red and black ribbon surround a painting of a green anole, or Mexican chameleon.

Figure 43. Carmen Lomas Garza, *Codex Lomas Garza: Pedacito de Mi Corazón* (cover), 1992. Gouache and watercolor on paper, 15½ × 75 × 10 inches. Artist's collection.

Photograph by Hanson Digital.

While in her earlier works lizards are incidental to the main subject—usually peeking out from under leaves or bushes—her foregrounding of the creature here demands an alternative reading. Given the overall theme of the work, the animal's curative properties, which in the Americas range from easing sore eyes to curing hernias, are of great significance.[9] Of additional importance, perhaps, is the Mexican chameleon's uncanny ability to change colors and avoid detection by seemingly vanishing into any setting. Thus, despite their fragility and size, the creatures survive. The importance of this mechanism for self-preservation is not lost on Garza.

Figures 44, 45. Carmen Lomas Garza, *Codex Lomas Garza: Pedacito de Mi Corazón* (first through fourth panels), 1992. Gouache and watercolor on paper, 15½ × 75 × 10 inches. Artist's collection.

Photographs by Hanson Digital.

The interior of the codex consists of four paired pages read from left to right. The cutout panels on the left introduce and inform their facing pages. In the first panel (fig. 44), a lizard rests on a bauhinia branch and faces a page of writing. The text on the following page is introduced by intertwining yellow and black elements composing the symbol *ollin*. This Aztec symbol indicates "change" or "movement" and references the day name on which the current era, Nahui Ollin (4 Movement), began.[10] The passage, written by the artist, touches upon history, culture, and the implications of the past on the present. It also outlines

the very purpose of Garza's *Codex* and the means through which past knowledge might be "REKINDLED."

The second set of images begins with a cutout of a hummingbird darting in and out of nopal cactus flowers (fig. 45). The hummingbird, a Mesoamerican symbol of death and rebirth, is also associated with warriors because of the rapidity with which it "attacks" flowers with its long beak and the fierceness with which it defends its territory. Amid the hazardous cactus spines and barbed wire of Garza's representation, the beautiful hummingbird is well equipped to move in close and retrieve the life-sustaining nectar. On the adjoining page, a pair of hands, armed with a long knife and fork, carefully harvests the tender pads. The zoom-in reminds us of earlier representations of Garza's grandfather, who wields similar implements and dons long sleeves to protect his arms.[11] The caution required to harvest the plant's pads is well worth the trouble, as nopal is both tasty and nutritious.[12] Below the scene, a row of scarlet *tunas*, sweet cactus fruit, creates a groundline for the page.

A horned toad situated at the base of two aloe vera plants initiates the third set of pages (fig. 46). Protected by its tough, spiny skin, the horned toad (actually a short-horned lizard) repels predators by squirting stinky and foul-tasting blood from the corners of its eyes. Among Southwestern indigenous people, horned toads are also admired for their strength, which can be spiritually invoked.[13] On the adjacent page, Garza's mother stands near the kitchen table treating her brother Arturo with the gel of an aloe vera plant. The juice is used to soothe scrapes, sunburns, and insect bites and to aid a variety of digestive problems. Above the scene, Garza has painted an aloe vera leaf before and after it has been partially stripped of its outer skin. This is in keeping with the belief that the best part of the plant is to be found in the area of the leaf that is closest to the heart of the plant.

The final pages offer dahlias, papel picado banners, and *calaveras*, or skulls (fig. 47). Taken together, these elements reference Día de los Muertos (November 1–2) as well as the Aztec past. Europeans caught their first glimpse of dahlias in Motecuhzoma's palace gardens. In Garza's *Codex*, the flowers pay tribute to the Aztecs and to the ancestors who came from them, here referenced on the next page in the form of papel picado calaveras. Dividing the rows of calaveras, festive banners

Figures 46, 47. Carmen Lomas Garza, *Codex Lomas Garza: Pedacito de Mi Corazón* (fifth through eighth panels), 1992. Gouache and watercolor on paper, 15½ × 75 × 10 inches. Artist's collection.

Photographs by Hanson Digital.

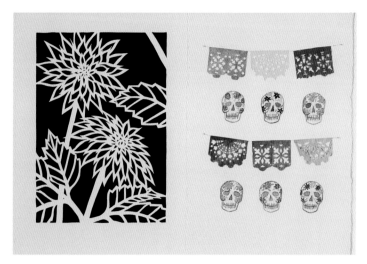

remind the viewer that lives are to be celebrated, not just remembered. The last page of the codex, then, can be read as a two-dimensional altar honoring past generations from whom the knowledge of medicinal healing through plants is acquired. Through her acknowledgment and reverence of the past, the artist salves the wound caused by the destruction that was part of the sixteenth-century encounter and the subsequent attempted erasure of history.

The mixture of spiritual and practical healing found in *Codex Lomas Garza* is not surprising, nor is the idea of sharing

this knowledge with the public. After all, during her childhood Garza witnessed the healing powers of curanderas and heard stories of the great healer Don Pedrito Jaramillo. Her volume celebrates the existence of indigenous flora and fauna and recognizes their continued use. The juxtaposition of plants and animals with modern figures and the presence of an ofrenda on the final page bespeak the successful conveyance of information from one generation to the next.

Garza's second major work during the fall of 1992 was far larger: *Homenaje a Tenochtitlán: An Installation for the Day of the Dead (Homage to Ancient Mexico City and Doña Marina, "La Malinche")*. This three-part, multigallery installation was created for Smith College Museum of Art in Northampton, Massachusetts.[14] As in her *Codex*, the artist merges past with present, but here she does so in a much more explicit way. She visually retells the story of the Conquest, referencing historic events and people and emphasizing the far-reaching consequences of their actions. Access to the installation was, appropriately, through an entrance where marigolds outline the form of the Aztec symbol of change and movement. Here the hieroglyph also functions as a kind of modern benediction. According to Amalia Mesa-Bains, "This image and its flowery form are taken from Nahuatl writings and the contemporary *Día de los Muertos* blessing traditions of Mexican Concheros religious dancers."[15] In the main room of the installation, an altar pays homage to Tenochtitlán, the ancient island capital of the Aztecs. In this honored space, surrounded by images of the flora and fauna of Mexico, both conquerors and indigenous rulers are acknowledged. A smaller room recognizes La Malinche, indigenous translator and consort to Hernán Cortés. Here, the altar's pivotal figure heralds the coming of *mestizaje*, the merging of two cultural traditions. It introduces us to three modern figures close to the artist who translated culture through their artistic practices: Elisa Lomas, Garza's grandmother, and Xavier Gorena and Enrique Flores, her early mentors in Mission, Texas.

Prior to European contact, Tenochtitlán was connected to the shores of Lake Texcoco by floating movable causeways (fig. 48). These led to the heart of the metropolis, the walled Sacred Precinct. This square enclosure housed the most important *teocallis*, temples before which the Aztecs held their monthly rituals. According to their foundation mythology, the

Figure 48. Luis Covarrubias, *Tenochtitlán*, 1963. Mural showing the city of Tenochtitlán, looking east from the shore of Lake Texcoco. Museo Nacional de Antropología, Mexico City.

Photograph copyright Michel Zabé; courtesy of Museo Nacional de Antropología.

Aztecs constructed the largest of these teocallis, the Templo Mayor, on the site where an eagle with a serpent perched on a nopal cactus.

Garza's *Homenaje a Tenochtitlán* takes the form of a schema of the city and its surrounding area. The viewer is meant to experience some of the same splendor that the Spaniards did as they came over the mountain pass. In her abbreviated version, a seven-foot multitiered red pyramid references the island's sacred architecture and also functions as a Day of the Dead altar. This sacred space is accessed through an elevated black causeway, flanked by small red altars and marigolds (fig. 49). As viewers walk the path (and the history), they scuff the black paper. Leaving this remnant of their own journey into the "city," they become indirectly implicated in the Conquest. On either side, swirling blue designs stenciled onto darker blue paper represent the waters of the great lake.[16] The walls have been painted a golden yellow, creating the perception that the environment is bathed in light from late in the day. Suspended from the ceiling and lining the causeway, large black paper cutouts invoke the plants and animals once found in the lowlands and highlands of Mexico.

Objects placed on the pyramid's risers and treads reference pre-Columbian spirituality, culture, and politics at the time of the European encounter. Attached to the top riser, a gold-leafed copper disc, embossed to resemble the Aztec sun symbol, receives offerings of red and gold maize. Tear-shaped golden elements represent the sweat of the sun and line the riser's edge while leading down to the second level.[17] Against the second riser, a colored detail of the Aztec Calendar Stone's central cartouche reveals the face and claws of Yohualtonatiuh,

Figure 49. Carmen Lomas Garza, *Homenaje a Tenochtitlán: An Installation for the Day of the Dead (Homage to Ancient Mexico City and Doña Marina, "La Malinche")* (causeway), 1992. Paper cutouts, acrylic on paper and cloth, copper, gold leaf, wood, feathers, vegetables, flowers, and water, 14 × 20 × 20 feet. Installed at Smith College Museum of Art, Northampton, Massachusetts. Artist's collection. Photograph by Carmen Lomas Garza.

the Night Sun in the Underworld, who must fight for his life each night to be born again in the morning. He is flanked by profiled images of two other warriors: Motecuhzoma (on the left) and his nephew Cuauhtémoc (figs. 50, 51). These were the last Aztec kings and the rulers who witnessed the Conquest. To differentiate between the two, Garza has flanked them with their alter egos—gesso skulls with nopales growing out of their heads. Whereas the plant associated with Motecuhzoma has nopal flowers in full bloom and references birth, the one next to the younger ruler shows the nopales with ripe tunas, ready to pluck and consume, and is clearly associated with death. This combined imagery is an apt metaphor for the flowering of the empire and its eventual consumption by the Europeans during Cuauhtémoc's final days of rule. Offerings placed on the tread before each ruler relate to his specific role in history. The feathered headdress, feather fan, and golden pectoral are attributes of Motecuhzoma's rulership. The feathered shield and golden wrist guard—implements of war—allude to Cuauhtémoc's conflict with the Spaniards. A *molcajete*, a mortar used for grinding herbs and chilies, is aligned before the god.

On the third riser, golden sweat introduces a row of *calaveras máscaras*, paper skeletal masks decorated with cutout

Figures 50, 51. Carmen Lomas Garza, *Homenaje a Tenochtitlán: An Installation for the Day of the Dead (Homage to Ancient Mexico City and Doña Marina, "La Malinche")* (altar and detail of altar), 1992. Paper cutouts, acrylic on paper and cloth, copper, gold leaf, wood, feathers, vegetables, flowers, and water, 14 × 20 × 20 feet. Installed at Smith College Museum of Art, Northampton, Massachusetts. Artist's collection.

Photographs by Carmen Lomas Garza.

flowers that have been collaged on their surfaces. These represent the unnamed deceased inhabitants of the city and, as they are meant to be donned by the living, refer to the cycle of life. Before them, the shell-shaped symbol of the god of knowledge, Quetzalcoatl, has been embroidered onto a piece of cloth. On

either side, the artist has placed offerings of *amate*, a multi-functional paper on which Aztec scribes wrote their illustrated histories. Sheets from the plant were also fashioned into priestly garb for special religious rituals. The rubber balls both reference the youthful Cuauhtémoc and remind the viewer that the American resin was painted on amate paper and burned as offerings. Interspersed amid all of this are beans, squash, and maize—*las tres hermanas*, or three sisters, the food staples of Mesoamerica and the Southwest.[18] Additionally, cacao in the form of beans has been placed on top of the amate paper. Cacao was offered to the gods by the Aztecs and was reserved for consumption by the ruling elite.

The small temple-shaped altars lining the causeway are also imbued with a historic specificity grounded in literary and archaeological sources. Each of these represents a city through which Cortés traveled on his trek from the Gulf Coast to the Aztec capital. Formally, the altars resemble the shrines found lining the Street of the Dead at Teotihuacán, a site of Aztec pilgrimage and, according to the Aztecs, the location of the beginning of our era.[19] Garza has updated the temples by placing offerings of water, tortillas, chocolate, and maize atop each of the temple platforms. Before the centrally placed tortilla, the artist has written the name of a city on amate paper. All have been placed before a double-layered paper mask that takes the form of a skull covered with a layer of intricately cut green paper foliage. On each mask, a lizard crawls amid the leaves. Each skull represents the collective presence of the town's community and the ancestors of many of Mexico's contemporary populations.

The papel picado wall hangings give the installation a geographic context and pay tribute to the flora and fauna of Mexico. They offer a sampling of what the Spaniards saw when they first entered Mexico from the Gulf Coast region of Veracruz. The first work, located to the right, is a diptych of a quetzal and a jaguar, two inhabitants of the lowland jungles of Veracruz (fig. 52). Well known for its nocturnal hunting habits and love of swimming, the jaguar is the largest land mammal in Mesoamerica. As such, it was the only predator feared by human hunters. The shy quetzal, celebrated for its iridescent green plumage, supplied feathers for Aztec warrior shields and for the kingly backracks and headdresses of the Aztecs and Maya.[20] In

Figure 52. Carmen Lomas Garza, *Flora and Fauna of Mexico: Quetzal with Jaguar*, 1992. Black paper cutout, 44 × 58 inches. Detail of *Homenaje a Tenochtitlán: An Installation for the Day of the Dead (Homage to Ancient Mexico City and Doña Marina, "La Malinche")*. Installed at Smith College Museum of Art, Northampton, Massachusetts. Artist's collection.

Photograph by Bob Hsiang.

this diptych, Garza presents us with a peaceable kingdom. Both creatures cohabit spaces side by side as they calmly gaze out at the viewer from the lush foliage. A hummingbird buzzes the pair from the upper left-hand corner.

The next pair of panels feature two animals that hold places of honor in the Aztecs' diet and in their mythohistory: the deer and the *guajalote*, or turkey.[21] In the first of these works, a deer peeks out from behind maize plants. This animal was hunted for food and was symbolically equated with sacrificial victims. Here, the creature stands behind the most important plant of the new world, maize.[22] Along with beans and squash, maize provided the basis of the Aztec diet. In the second cutout, the turkey stands in front of a maguey and a jalapeño pepper plant. The

bird was one of the first animals in the Americas to be domesticated. Beyond their use as a food source, turkeys were raised for their plumage, used in much-treasured Aztec feather work, and were associated with the Aztec creator god Tezcatlipoca in one of his manifestations.[23]

Flanking Garza's red pyramidal altar are two panels that relate directly to the flora and fauna of Lake Texcoco itself. *Rabbit with Dahlias* foregrounds activity occurring on the shore (fig. 53), while *Fish and Turtle* refers to the aquatic aspects of the lake (fig. 54). In the first of these, a rabbit peeks out from

Figure 53. Carmen Lomas Garza, *Flora and Fauna of Mexico: Rabbit with Dahlias*, 1992. Black paper cutout, 44 × 30 inches. Detail of *Homenaje a Tenochtitlán: An Installation for the Day of the Dead (Homage to Ancient Mexico City and Doña Marina, "La Malinche")*. Installed at Smith College Museum of Art, Northampton, Massachusetts. Artist's collection.

Photograph by Bob Hsiang.

behind a flowering dahlia, a plant admired for its brilliant color. Additionally, the tree variant called *acocotli* (water cane) had hollow stems used for carrying water.[24] In the second panel, fish swim amid the reeds in the lake's clear waters while a turtle crawls up the embankment. Both of these works remind the viewer of the lake's abundance before it was drained by the colonial European government.

The next cutout, an extraordinary triptych, features an eagle holding a writhing rattlesnake (fig. 55). The eagle's wings spread out against the background hills that surround Lake

Figure 54. Carmen Lomas Garza, *Flora and Fauna of Mexico: Fish and Turtle*, 1992. Black paper cutout, 44 × 30 inches. Detail of *Homenaje a Tenochtitlán: An Installation for the Day of the Dead (Homage to Ancient Mexico City and Doña Marina, "La Malinche")*. Installed at Smith College Museum of Art, Northampton, Massachusetts. Artist's collection.

Photograph by Bob Hsiang.

Figure 55. Carmen Lomas Garza, *Flora and Fauna of Mexico: Eagle with Rattlesnake*, 1992. Black paper cutout, 44 × 86 inches. Detail of *Homenaje a Tenochtitlán: An Installation for the Day of the Dead (Homage to Ancient Mexico City and Doña Marina, "La Malinche")*. Installed at Smith College Museum of Art, Northampton, Massachusetts. Artist's collection.

Photograph by Bob Hsiang.

Figure 56. Replica of the front cover of the Codex Mendoza, depicting the founding of Tenochtitlán. Color lithograph. Museo Nacional de Antropología, Mexico City.

Photograph by Ian Mursell; courtesy Mexicolore/The Bridgeman Art Library.

Texcoco. The artist is clearly referencing the ancient origin myth of the great city. As the story goes, during a battle with forces from the city of Malinalco, Huitzilopochtli, the god and leader of the Aztecs, tore out the heart of Copíl, king of Malinalco.[25] Summoning his attendant, the god directed him to throw the heart into the middle of the lake. After the battle was over, Huitzilopochtli told his people to search for a place where an eagle was sitting on a cactus. This marked the place that Copíl's heart had landed and the place where the Aztecs would establish their capital. The site would be known as "the place of the fruit of the cactus," or, in Nahuatl, Tenochtitlán. The emblem of the eagle on the cactus became synonymous with the ancient capital and appeared in codices throughout the colonial period (fig. 56).

The final cutout panel focuses attention on the plants and animals of the arid northern desert. The maguey plants featured are well known for their ability to grow in the harshest of climates. These plants were grown for fiber used in clothing and for their sap, which was the basis of a mildly alcoholic but highly nutritious fermented drink, *pulque.* In the panel's upper right-hand corner, the artist placed a dandelion plant, also known

Figure 57. *Homenaje a Tenochtitlán: An Installation for the Day of the Dead (Homage to Ancient Mexico City and Doña Marina, "La Malinche")* (altar to Malinche), 1992. Paper cutouts, acrylic on paper and cloth, copper, gold leaf, wood, feathers, vegetables, flowers, and water, 14 × 20 × 20 feet. Installed at Smith College Museum of Art, Northampton, Massachusetts. Artist's collection.

Photograph by Carmen Lomas Garza.

for its medicinal properties.[26] Animals represented include a horned toad and an *itzcuintli*, or indigenous dog.

The final room of the installation is dedicated to Malinche as well as to Garza's grandmother, Elisa Lomas, and to her two friends Xavier Gorena and Enrique Flores (fig. 57). Malinche, one of the most enigmatic characters of the Conquest, had fascinated the artist for many years. Malinche's role as a mediator especially resonated with Garza, and she commented on the relationship between this translator and contemporary individuals:

I as a Chicana—and a lot of Chicanas—see ourselves in certain ways as Malinches, in that we are the liaisons between two groups of people. On the downside is that we're seen as traitors because that's how La Malinche was seen. She was a traitor. She was a scapegoat that became the traitor . . . so if a Mexicano calls you a *Malinchista*, it's a cuss word. It's like you're being called a traitor.[27]

The positive and negative extremes in the interpretations of Malinche may largely be attributed to the paucity of eyewitness accounts. What we do know about her was that the Gulf Coast Maya of Potonchan gave her to Cortés as a slave shortly after his arrival. Because she was multilingual, she proved an invaluable asset to the Spaniard, who spoke neither the local Mayan dialect nor the Nahuatl of the Aztecs. Learning Spanish, Malinche became Cortés's principal translator, even mediating conversations between the conquistador and Motecuhzoma, the Aztec king.[28] After the fall of Tenochtitlán, she became Cortés's mistress and had a son by him; during an expedition to Honduras, she was summarily married off by the conquistador to one of his subordinates.

Because so little is known of her, she has become a blank slate on which writers and artists inscribe their desires and preoccupations. As such, she has been characterized as traitor, whore, victim, heroine, and survivor.[29] It comes as no surprise, then, that even her very name lacks stability when writers and artists invoke it. While "Malinche" sometimes carries a pejorative connotation, to those who admire her she is "Malintzin," with its honorific Nahuatl suffix; to those who view the Conquest through a Spanish lens, she is "Doña Marina," the Christian name given to her at her baptism. And finally, she is often referred to as "Malinalli," the etymological source of her name, which means "grass" and privileges her indigeneity.

Garza's perspective on Malinche is a sympathetic one, full of reverence and understanding. Her double-tiered pink altar with its bright white papel picado cutouts invokes the idea of doilies found in a home interior—clearly an invocation of Mesa-Bains's concept of domesticana Chicana. The function of the work as a domestic shrine is also referenced by the four chairs, seemingly awaiting ghostly guests, and by the sea of golden papel picado marigolds. Nonetheless, we are reminded of the architectonic nature of the altar by the sky blue field behind it. Here, papel picado clouds rain streams of pale blue ribbons.

Because Malinche was a mediator, it seems appropriate that this altar and its contents go beyond ancient and contact-period referents. In contrast to the unframed paintings of Motecuhzoma and Cuauhtémoc, a gilded copper frame of the type reserved for retablos of the late colonial period surrounds Malinche's image. The figure stands at the apex of the altar,

dressed in a *huipil*, a pre-Columbian dresslike garment made of a single piece of woven fabric. Her hands are raised in a gesture associated with speaking. Symbols, seemingly of the newly introduced Christian religion, surround her, but their meaning is as polysemous as the figure herself. For instance, the four large gilded hearts hovering above her reference the four souls honored by the altar. But they can also allude to the sacred heart of Christ, or to the pre-Columbian practice of heart excision; they may even function as *milagros*, tin images often offered at a saint's shrine in the hope of beneficence. To the left, a cross. But, again, is it Christ who is referred to here or a much more primal indigenous world tree? To the right of Malinche is an image of the Virgin of Guadalupe, a true mestiza who is simultaneously the mother of Christ as well as an Aztec earth deity.[30]

Before the image of Malinche, the artist has placed references to women's work. A modern huipil speaks to the continuity of the ancient craft of weaving, as do two belts on either side of it. A small weaving, still on its warp end rod, is a more direct reference to process. Interspersed among these are sugar skulls and glasses of water.

The tier below the group features products of women's works and framed black-and-white images of Garza's grandmother Elisa Lomas and of Gorena and Flores (fig. 58). In placing these individuals together, the artist honors three role models who taught her the importance of caring for family and loved ones and for the community. Candles bring light to their faces and

Figure 58. *Homenaje a Tenochtitlán: An Installation for the Day of the Dead (Homage to Ancient Mexico City and Doña Marina, "La Malinche")* (detail of altar to Malinche), 1992. Paper cutouts, acrylic on paper and cloth, copper, gold leaf, wood, feathers, vegetables, flowers, and water, 14 × 20 × 20 feet. Installed at Smith College Museum of Art, Northampton, Massachusetts. Artist's collection.

Photograph by Carmen Lomas Garza.

illuminate gesso skulls bearing the names of the esteemed dead. The offerings spread out before them reference the artistry of each: an embroidery hoop and thread for her grandmother, a paper cutout done by Xavier before his image, and two pieces of metal jewelry crafted by Enrique.

The reconquista and reinscription of the past that are present in Carmen Lomas Garza's works for the Quincentenary can be understood as an extension of her earlier pieces. There are, however, some marked differences. Although Garza had referenced indigeneity in her earlier works, these new works from 1992 more specifically cite Mesoamerican practices, as is appropriate to the Quincentenary. Rather than depending on personal lived experiences, she manipulates historic sources, privileging the actors who had dynamic roles in the Conquest.

These two works also mark a departure in her understanding of the range of viewer participation. Because of our intrinsic response to books, *Codex Lomas Garza* lends itself to a more intimate, one-to-one reading of her message. *Homenaje a Tenochtitlán*, on the other hand, compels the viewer to physically and psychologically journey to Tenochtitlán and consider the implications of the Conquest.

Finally, Garza's critique of historical exclusion is much more pointed here than in previous works. While the art produced in 1992 references the encounter between the Americas and Europe, the artist undermines the novelty experienced by Europeans and the subsequent "othering" of the indigenous inhabitants by connecting her family and friends to precontact practices. They become participants in a long line of cultural mediators. The line between pre-Columbian peoples and Chicanos is thereby reinscribed, and the gaps in our collective memory are filled.

CARMEN VERSUS THE FUTURE

> The creation of the work is your private joy.
> But the most precious reward is seeing how your
> dream brightens another human being, even if it is
> just for the few seconds it takes to see a painting.
>
> —Carmen Lomas Garza

The 1990s, which saw Garza so active around the Quincentenary, was also the decade in which her work gained greater visibility through exhibitions and a groundbreaking series of children's books. While the level of her art production remained consistent, her work was increasingly seen in venues far beyond California. Following her successes at the Mexican Museum (1987 and 1992), the Laguna Gloria (1991), and the Smith College Museum of Art (1992), individual exhibitions opened at the Academy of Art in Honolulu (1994) and at the Smithsonian Institution's Hirshhorn Museum and Sculpture Garden in Washington, DC. (1995).[1] These were followed, in 2001, by a retrospective exhibition that traveled for two years throughout the Southwest and then on to Florida.[2] This show included more than thirty paintings, twelve cutouts, and an altar installation, works that spanned the preceding three decades. Garza was quickly becoming one of the most successful and well-known Chicana artists working in the United States.

Garza continued working on themes that reflected her South Texas childhood, such as *Barbacoa para Cumpleaños* (1993, fig. 59). She recognized that imagery in this vein operated on multiple levels and fulfilled a variety of needs. On numerous occasions, Latinos viewing her painted images and papel picado creations had commented on the socially cohesive possibilities of traditions depicted in the works. For the artist and her patrons, the images embraced the possibility of sustaining these cultural practices and introducing them to younger generations. Garza realized that her work could serve as a catalyst for the childhood memories of others.[3]

Barbacoa para Cumpleaños (Birthday Barbeque) celebrates such community connections through memory. Here, people

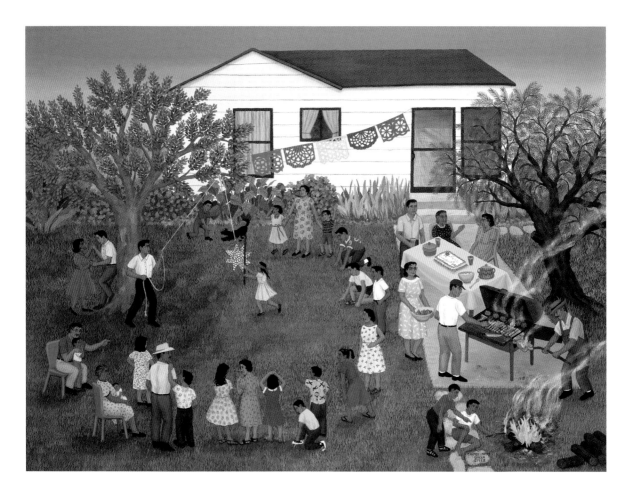

Figure 59. Carmen Lomas Garza, *Barbacoa para Cumpleaños*, 1993. Alkyd on canvas, 36 × 48 inches. Collection of the Federal Reserve Bank of Dallas. Photograph by M. Lee Fatherree.

gather for her sister Mary Jane's birthday party. Markers of cultural identity include the suspended piñata and the papel picado banners spanning the distance from house to tree. Garza's interest in detail and variation and her keen awareness of human nature are conveyed in the individuals who encircle her sister. Mary Jane lurches forward as she tries to strike the piñata with a stick. Outside the circle, on the left, an amorous pair are caught up in each other, and on the right, two boys play with the fire that has been set up to produce coals for the barbecue.[4]

At the same time, Garza also worked to expand her geographic references by including activities from Northern California. In the 2001 work *Quinceañera*, people gather outside a San Francisco church in anticipation of a young woman's fifteenth birthday

Figure 60. Carmen Lomas Garza, *Quinceañera*, 2001.
Oil and alkyd on linen on wood, 36 × 48 inches.
Collection of National Museum of Mexican Art,
Chicago.

Photograph by M. Lee Fatherree.

celebration (fig. 60). She sits, waiting with her father, in the back-seat of a blue lowrider driven by a young man. Common in Latino communities throughout the United States, this coming-of-age celebration combines a party and a religious ceremony.[5] Garza's subject matter and choice of locale compel viewers to stop and ponder the individual lives of the celebrants and perhaps take stock of their own pasts and the universality of this celebration. The artist hopes that viewers of her work will come to realize that even in busy city environments, beauty is to be found in the memories of people and events embedded in their own daily lives.

Garza was pleased by the public and critical acclaim for her exhibited works, but she also felt the need to connect with a younger audience. Working with museums only enhanced this

desire: "You know, I cannot escape being a teacher when I'm doing my exhibitions. Because once you're a teacher, you're always a teacher, and a lot of the times museums are trying to expand their audience, which is one of the reasons they ask me to exhibit in their galleries."[6]

But for Garza, teaching the importance of art and cultural practice via gallery walls was not enough. From interactions with museum visitors, she knew the power of imagery as a catalyst for memories of childhood activities; in some instances, such memories had prompted viewers to reintroduce these cultural practices into their own households.[7] Nonetheless, museum visits by adults and children constituted only brief interludes in their lives. Garza sought a vehicle through which children, in particular, could explore her detailed imagery at their leisure.

With this in mind, she set about creating a series of children's books that would introduce Mexican American culture to young readers. Her first volume, *Family Pictures/Cuadros de familia*, came out in 1990, followed in 1996 by *In My Family/En mi familia* (figs. 61, 62). Both were published by Children's Book Press of San Francisco. In these two award-winning bilingual volumes, Garza couples reproductions of her paintings with easily understood text that historicizes the imagery within the context of the artist's personal experience.[8] In doing so, she provides an essential link to a past that has never been documented in canonical history books.

The visual beauty of Garza's volumes and their appeal across cultural lines made them enormously popular. In 2005 the Iowa Stories 2000 Foundation, sponsored by the first lady of Iowa, Christie Vilsack, adopted *Family Pictures* as its book of the year. As part of the program, the foundation and state education agencies distributed 45,000 copies of the book to the state's kindergarten children. This was done to recognize the state's changing demographic makeup and, it was hoped, encourage children to broaden their language skills. Vilsack predicted the potentially transformative nature of the work:

> This bilingual book gives every family a chance to talk about their special family and cultural traditions. . . . Like German, Scandinavian, Dutch, Italian, Irish, and Southeast Asian immigrants, who joined the Native Americans here in Iowa, Latino families are blending into communities across our state and contributing to a growing and changing Iowa. This

Figure 61. Cover of *Family Pictures/Cuadros de familia*, a children's book of paintings and stories by Carmen Lomas Garza (San Francisco: Children's Book Press, 1990).

Photograph courtesy of Children's Book Press.

Figure 62. Cover of *In My Family/En mi familia*, a children's book of paintings and stories by Carmen Lomas Garza (San Francisco: Children's Book Press, 1996).

Photograph courtesy of Children's Book Press.

Figure 63. Carmen Lomas Garza, *Haciendo Papel Picado/Making Paper Cutouts*, 1999. Black paper cutout, 22 × 30 inches. Artist's collection.

Photograph by Northern Lights.

book helps us celebrate our rich immigrant heritage and helps our children understand the importance of speaking and reading more than one language.[9]

Eventually, many other school districts throughout the United States adopted Garza's books, including the Los Angeles Unified School District and various school districts in Silicon Valley.[10]

In addition to her picture books, Garza wrote and illustrated books about papel picado. These drew on her experience working in the medium and on the numerous papel picado workshops that she had organized and conducted over the years. In these workshops she instructed participants on the traditional folded tissue-paper cutouts of her youth, as well as on the more complex craft-knife cutouts (fig. 63). The latter,

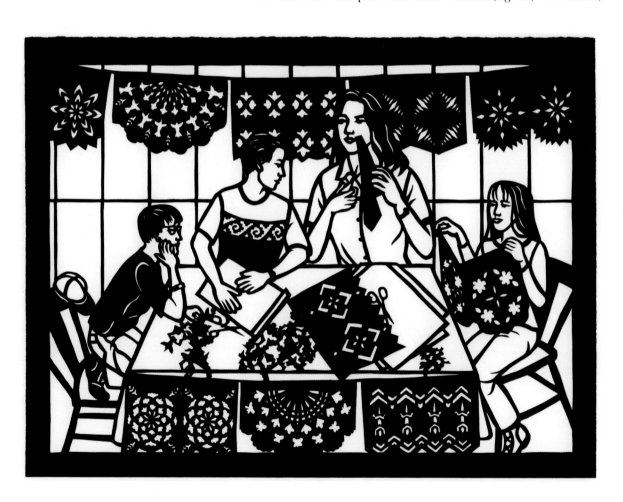

created using thicker paper cut on a flat surface, requires drawing skills and an understanding of positive and negative design areas. Garza realized that written instruction would greatly facilitate the lessons, so she wrote a small black-and-white booklet called *Papel picado/Paper Cutout Techniques*, published by Xicanindio Arts Coalition in Arizona in 1984. Eventually the volume evolved into two books, *Making Magic Windows: Creating Papel Picado/Cut-Paper Art with Carmen Lomas Garza* and *Magic Windows/Ventanas mágicas*, both published in 1999 by Children's Book Press (figs. 64, 65). In these, Garza showcases the creative possibilities of papel picado and gives practical instructions to youngsters and their parents.

Each of the 1999 volumes takes a different approach to the art. In *Making Magic Windows*, Garza offers children and their parents an instruction manual on how to create three types of cutouts: folded cutouts, craft-knife cutouts, and multiple cutouts. As in all artistic endeavors, preparation is half the work, and she instructs readers on how to prepare the space for papel picado, listing materials and tools. Step-by-step illustrations of how to produce different patterns are followed by instructions on how to hang the banners on a string.

Magic Windows/Ventanas mágicas offers a variety of Garza's works that illustrate the craft-knife technique. The images are large and, as in her children's picture books, are accompanied by bilingual text explaining each one in terms of its historical significance or the artist's own past. While some of the cutouts were produced earlier as part of the Tenochtitlán installation at Smith College, others, such as *Baile y Pintura* (Dance and Painting, 1993), were produced as autonomous works of art. In this cutout, the artist incorporates her hands into the image as she seemingly paints the flowing skirt of a *jarabe tapatío* dancer (fig. 66).

Although the book projects were time-consuming, the satisfaction for Garza has gone beyond book sales and publication awards. After two years of research and discussion, in 2007 the Los Angeles Unified School District Board approved the community's nomination of Garza's name for a new primary school in East Los Angeles. Teachers and parents who had read her books to children wanted to acknowledge her impact by placing the artist's name on a building dedicated to child development. At a community ceremony on June 12, 2008, with Garza's family

Figure 64. Cover of *Making Magic Windows: Creating Papel Picado/Cut-Paper Art with Carmen Lomas Garza* (San Francisco: Children's Book Press, 1999). Photograph courtesy of Children's Book Press.

Figure 65. Cover of *Magic Windows/Ventanas mágicas* (San Francisco: Children's Book Press, 1999). Photograph courtesy of Children's Book Press.

Figure 66. Carmen Lomas Garza, *Baile y Pintura*, 1993. White paper cutout, 36 × 28 inches. Artist's collection.

Photograph by Rudy Gomez Photo Arts.

Figure 67. The Carmen Lomas Garza Primary Center at 2750 E. Hostetter Street in Los Angeles.

Photograph by Carmela Lafarga.

and friends present, the Carmen Lomas Garza Primary Center was formally named (fig. 67).[11] By Los Angeles mega-school standards, the ten-room center is intimate, welcoming some 200 students from prekindergarten to second grade. Most of the students come from the neighborhood's first-, second-, and third-generation Mexican American households.[12]

This honor delighted and overwhelmed Garza:

Over the years, teachers, parents and children have expressed their delight in seeing my artwork and reading my books. Many times, teachers expressed their appreciation of the availability of the books for their curriculum development, and the inclusion of my artwork in textbooks. I did not

imagine that the appreciation would some day result in my name on a school.

This school naming is a tremendous honor that surpasses any recognition I have received in my career as an artist. It gives me great joy to know that my artwork and bilingual stories inspire children to read more, to talk and write about their own lives, and to create their own artwork.[13]

Garza's imagery surrounds the students as they go through their school day. The artist gave the school five fine art prints, including *Cumpleaños de Lala y Tudi* (2003) and *Cakewalk* (2003), which adorn the walls of the main office and the library. With respect to cultural affirmation, it seems likely that these students' early school experiences will be very different from Garza's.

The artist's work on books coincided with her deeper exploration of the medium of papel picado. Although she respected the traditional techniques associated with the art form, the fragility of paper had always been problematic, and she searched for ways to create her works in more durable materials. She found her answer in the laser-cutting technology widely employed in industry. In this technique, images are scanned into a computer using a special program that directs the laser. The laser melts or vaporizes the negative areas and gives the work a finished edge. Unlike paper cutouts, artworks created from painted steel can be installed without fear of tearing.

At first, the artist began her investigations of the technique by reworking some of her earlier cutouts. In 1995, for example, she recut the window for her 1989–90 *Ofrenda para Antonio Lomas* in steel, painting it with a black powder-based pigment. Newer paintings, such as *Hormigas* (1995, fig. 68), were used as conceptual springboards for her laser-cut *Horned Toads and Hummingbirds at the Border* (1998, fig. 69). In the latter work, as in *Hormigas,* the emphasis is on nature, but *Horned Toads* takes on a decidedly more political edge. Here, the only allusion to humanity is the presence of barbed wire. Though the barrier is meant to deter passage from either side of the border, it is no match for the horned toads and hummingbirds, indigenous inhabitants of the borderlands. An allusion is clearly being made here to migrants from Mexico.

In 1999 Garza had the opportunity to create a much larger metal cutout when she accepted a public art commission for the

San Francisco International Airport. The artwork would be part of San Francisco's Public Art Program and would be located in the international terminal at gate G93. Before beginning her work, she examined the art already in place and decided to do something totally different. Other artists had created painted murals and mosaics of tile and ceramic work, but no one had done anything in metal. To create something unique for the space, Garza opted to combine the cutout technique of papel picado with the focus on detail that characterized her zoom-ins, and to render the final work in metal. The work, *Baile* (Dance), is a cutout of two jarabe tapatío dancers shown from the waist down.

For Garza, *Baile* stands as one of the more ambitious projects of her career. Measuring about sixteen by twenty-four feet, the work was larger than any two-dimensional piece she had undertaken. She began by creating a small cutout. She then divided it into smaller sections and, working with a fabricator, scanned photographs of the work into a computer program. The digitized pattern was cut on twelve metal sheets of sixteen-gauge copper, each measuring eight by four feet. For this piece, she chose to work in copper rather than steel, a decision that made standard laser-cutting problematic. Copper conducts heat better than most materials; because of this, the high temperatures generated by a laser had the potential to warp and discolor the metal.[14] Instead, she made cuts using a high-pressure stream of water. The finished work was then coated with varnish so that it would not oxidize. In distinction to her earlier metal works, a field of painted blue steel backed the cutout and provided a striking contrast to the copper imagery (fig. 70).

Baile's subject matter had been partially explored in 1993 in *Baile y Pintura*. However, in the airport work, Garza reenvisioned and expanded the image to include both partners. The jarabe tapatío, also known as the Mexican hat dance, was created in the eighteenth century and expresses courtship between a woman and a man.[15] The dance came to be associated with the Mexican Revolution and with Mexican culture in general. In her work, Garza focuses on the dancing legs of a man and a woman. The couple moves against a backdrop of tiles, the bottom part of the woman's striped skirt swirling around her as her partner stamps to the rhythm of the music. The buttons adorning the outer seam of his pants mark him as a *charro*, an equestrian from the state of Jalisco. He dances with his hands clasped behind his

Figure 68. Carmen Lomas Garza, *Hormigas*, 1995. Gouache on cotton paper, 13¾ × 18½ inches. Private collection.
Photograph by Bob Hsiang.

Figure 69. Carmen Lomas Garza, *Horned Toads and Hummingbirds at the Border*, 1998. Laser-cut 20-gauge, powder-coated steel, 32 × 24½ inches. Artist's collection.
Photograph by Judy Reed.

Figure 70. Carmen Lomas Garza, *Baile,* 1999. Clear-coated copper cutout on powder-coated steel, 16 feet × 24 feet × 5 inches. Photograph taken during the installation at San Francisco International Airport, gate G93. Collection of San Francisco International Airport, City and County of San Francisco.

Photograph by Carmen Lomas Garza.

back: as is typical in this dance, it is the movement of the charro's legs and his proximity to his partner that convey his amorous intent. The ruffled hem of another dancer's skirt is visible at the upper left, implying a fiesta context. As in *Baile y Pintura,* Garza incorporates herself into the imagery through the presence of her hands: one hand holds a pigment-filled jar while the other hand paints details onto the dancing woman's garment. A grid is superimposed on the entire composition, suggesting that the viewer is outside looking in through the window of an artist's studio.[16] Thus the subject touches not only on Mexico's national dance but also on the act of creativity itself.

Work on *Baile* lasted over a year, and it was unveiled to the public in September 2000 along with works by sixteen other artists for the international terminal. Although Garza's contribution was on a grand scale, its proportions perfectly suited the vast space. Workmen had suspended the metal cutout far above the heads of visitors on the second- and third-level walls of a three-story-high gate room, so that the whole of the composition might be taken in from a single vantage point. Prior to the opening, the *San Francisco Chronicle*'s well-known art critic, Kenneth Baker, reviewed the terminal works. He praised Garza's work in particular for its balance of representation and abstraction, stating that it achieved "an almost Matissean grandeur" in its scope.[17]

While *Baile*'s public location ensured a wide audience for Garza's work, by the 1990s the Internet offered an additional means of vastly extending her reach. Living and working just north of Silicon Valley, Garza quickly recognized the potential for connecting online with a geographically diverse population. With the help of a website designer, Rebeka Rodriguez, and Garza's husband, computer engineer Jerry Avila Carpenter, the artist created what would become a frequently visited website.[18] In a 1997 interview, she reflected on the implications for reception of her artwork:

> What's also really interesting—talking about timing—is what is happening with modern electronics, with computerization and the global shrinking that's happening as a result of that. And [what that process], coupled with everything else that's happening to modern life, is doing to culture not only in the Southwest but in Mexico. And so you will see urban Mexicans be very much like urban Mexican Americans in San Antonio. And both seeing my artwork from the same position or a very similar position, in that some of those [cultural practices] in my artwork no longer are done by [people who] are very urban and very modern. And then you see those from Oaxaca, who are Zapotec Indian, seeing my artwork and still living that experience and directly relating to it, [as well as] somebody from the Caribbean, from Puerto Rico. . . . My work was being shown in New York to a group of kids from the Caribbean, and [they related] to some of the paintings, saying, "We did that, exactly that, in my family. We do that in my family."[19]

The website offered benefits beyond making her work accessible to the outside world. It allowed her to answer questions about her art and provided research links useful to scholars. She was also now able to market her work to the public in a variety of media, including print forms such as color lithographs, linoleum prints, and a new medium, high-quality computer digitized images.

Although she had continued to produce prints during the 1980s, several factors caused her to renew her attention to the medium in the 1990s. First, Garza's success during the last three decades of the century had expanded the market for her art, and because each of her paintings took many months to

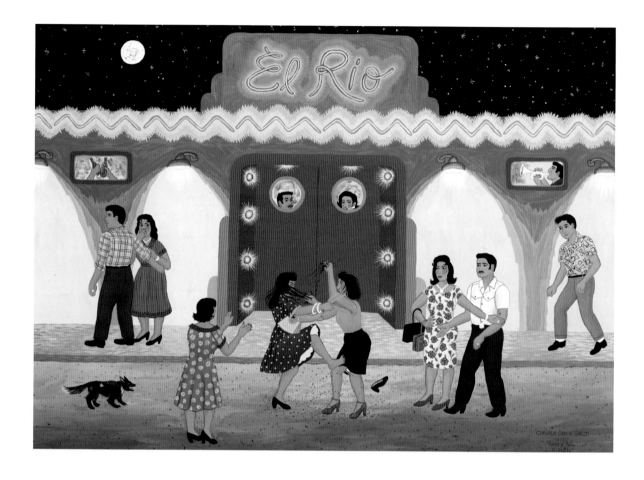

Figure 71. Carmen Lomas Garza, *Polvo y Pelo, el Pleito*, 1987. Gouache on Arches paper, 20 × 28 inches. Private collection.

Photograph by Wolfgang Dietze.

complete, she found herself unable to keep up with demand. The second reason was that, over time, prices for her paintings had necessarily risen.[20] Garza realized that her paintings were out of reach for the middle-class clientele with whom she had established a long-standing relationship. Prints, however, were another matter: they could be made affordable to most of the art-loving public. Finally, she welcomed the opportunity to showcase her diversity as an artist and to remind the public that she was a printmaker as well as a painter.

Garza had already resumed working with printmaking in the mid-1980s. She found that the focus on prints enabled her to rework earlier images that had been especially popular, such as *Sandía*, in a medium that allowed for replication in limited editions. She returned to lithography, appreciating its painterly

Figure 72. Carmen Lomas Garza, *Las Peleoneras*, 1988.
Color lithograph (edition of 100), 22 × 30 inches.
Artist's collection.

Photograph by Wolfgang Dietze.

process and the possibility of working with layers of ink. Because of the distinct qualities of this medium, differences in color intensity and contrast were sometimes dramatic. This is evident in a comparison between a 1987 gouache painting, *Polvo y Pelo, el Pleito* (Dust and Hair, the Fight), and a 1988 color lithograph, *Las Peleoneras* (The Fighting Girls) (figs. 71, 72). In each, Garza maintains the overall format and subject matter: two women are arguing over a man and have taken the fight outside. Onlookers outside and inside the El Rio bar watch the brawl, with varied responses. As is typical for gouache painting, the surface of *Polvo y Pelo* is activated by muted and subtle variations of hue. The viewer is allowed to examine the humorous ruckus from the emotional distance provided by flat areas of color. In the later lithograph, the colors have become highly saturated, and

the artist resurrects and expands upon her earlier interest in the potential of line. By drawing on the stone, Garza gives a three-dimensionality to the figures while animating the background wall, the sidewalk, and, most especially, the dirt road and agitated dog. The result is that the mayhem generated by the two squabbling women has invaded the surrounding environment, its inhabitants, and the viewer's imagination.

Garza also revisited the production of monochromatic prints using linocut. This technique is similar to woodcut in that negative areas are carved out of the surface of the linoleum block. What remains of the raised surface is then inked and the image is transferred to paper by means of a printing press. Like metal plate etching, the technique offers the advantage of potentially reworking the block, its subsequent generations of modified images being referred to as "states." In the 1992 state 2 linoleum block print called *Nopalitos* (fig. 73), Garza reexamines the theme of her grandfather engaged in picking nopals. The absence of color is hardly noticeable because, as in Garza's earliest prints, line carries much of the semantic load. The work becomes as much about variation in texture as it is about the actions of Antonio Lomas.

In 2000 Garza embraced the innovative process of digital printing. In this technique, an artwork is digitally photographed and uploaded into a computer program. These images are taken at an extremely high resolution, so they use tremendous amounts of memory. During the printing process, called giclée, the printer transfers the image by means of colored ink sprayed onto a surface. Like traditional prints, digital prints are created in limited editions, and like paintings, many of them are offered on both archival paper and canvas. Because of improvements in technology, the process yields highly accurate results, and it is sometimes difficult to tell the print from the original. This medium represents a solution to the rising costs of Garza's paintings as digital images are much more affordable, usually priced at less than $1,000.

An example of this approach is *Tito's Gig on the Moon* (fig. 74), a 2002 fantasía digital print created after a larger, similarly titled painting. Garza's inspiration for the work came from an obituary of the New York Latin jazz master Tito Puente, who died in 2000. According to the newspaper account, Puente, who "remained optimistic and focused on performance," had stated

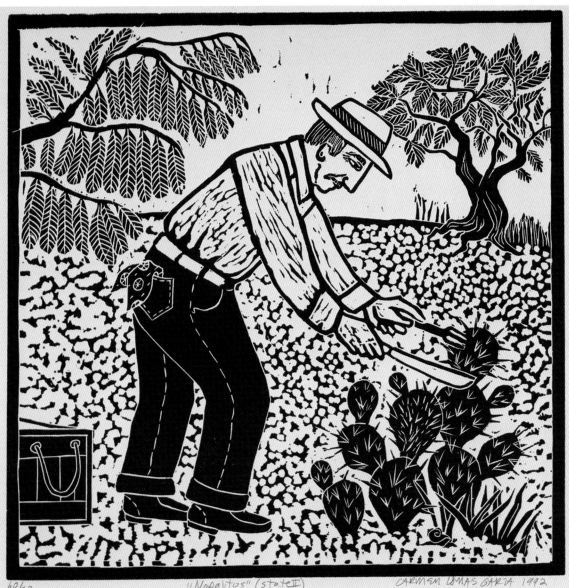

60/90 "Nopalitos" (state II) CARMEN LOMAS GARZA 1992

Figure 74. *Tito's Gig on the Moon*, 2002. Digital print on paper (edition of 180), 35 × 44½ inches. Private collection.

Photograph by M. Lee Fatherree.

that one of his goals was to "stay alive in the year 2000 and have the first Latin orchestra to play on the moon."[21] Because he was unable to attain this goal in his life, Garza wanted to fulfill his wish posthumously through her imagery while paying tribute to the great man. She visually relocated Puente and Birdland, a club where the musician played frequently, to the lunar surface. Puente and his band appear in heavenly white garments. As the band plays, paired dancers swirl across the dance floor. Recurring colorful symbols emanate from the various instruments and indicate musical cadence. As they fly through the air they are transformed, becoming the colors and patterns on the dancers' clothing. They remind viewers of the joy that Puente's music brought to many lives.

In 1969 Garza asked herself: "What exactly is Chicana/o art?" She has since come to realize that this question is one that each artist must answer visually for himself or herself. And while the source of the response varies from artist to artist, she has based her own reply on personal experience and her reaction to that experience. Her art finds its strength in her South Texas childhood and her unique comprehension of social, political, and family interactions in that setting.

At the same time, Garza's identity, like all identity, is fluid and temporally polyvalent. Although she acknowledges the importance of the past, she simultaneously recognizes the present and the world around her. Her roots are in South Texas, but she lives and works in San Francisco, a place that she has come to love and that she and her husband have made their home. It is not surprising that the same celebratory air of intimacy and understanding conveyed in her mesquite-filled images of Texas should find its way into works reflecting the urban environment of California.

Garza's growth as an artist is closely aligned with her ability to expand her definition of what an artist does and to embrace multiple technologies that lie outside the traditional realms of artistic practice. This has allowed her to merge past and present identities with the future. Her children's books, widely used in schools, have influenced and will continue to influence new generations. Her use of laser technology, computer digital imaging, and the Internet has led to a different handling of imagery and a new potentiality realized in the medium of print.

Regardless of the medium and the subject matter, Garza remains keenly aware that her art is a dialogue. Like all dialogues, it is a two-way process. Through her art she conveys to the viewer a message about the past and the present, and the viewer responds by relating that imagery to his or her own experience. As characters and situations reveal themselves, the art gives voice to that part of the human condition that requires reaffirmation and that is fortified by shared memories of private joy. Through recognition comes a quiet resolve. The viewer, like Garza, is freed to dream dreams and make plans for the future.

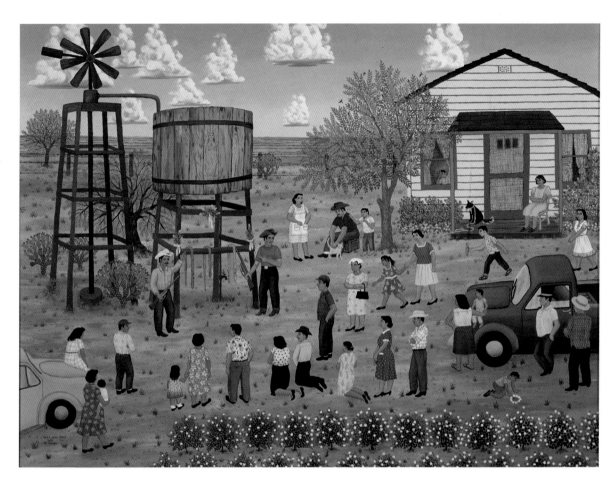

Carmen Lomas Garza, *El Milagro/The Miracle,* 1987. Oil on canvas,
36 × 48 inches. Private collection.

Photograph by M. Lee Fatherree.

NOTES

A BED FOR DREAMS

1. Today Kingsville is home to about 25,000 people, but at the time of Garza's birth its population was much smaller.

2. The King Ranch was established in 1853, shortly after the signing of the Treaty of Guadalupe Hidalgo, when Richard King, along with business acquaintance Gideon Lewis, acquired the Rincon de Santa Gertrudis Spanish Land Grant. This 15,500-acre purchase formed the core of a cattle empire that would eventually cover an area larger than the state of Rhode Island. The ranch became a major economic and political force in Texas; see the two-volume history by Tom Lea, *The King Ranch* (Boston: Little, Brown, 1957). The story of the King family and their struggles also became the stuff of myth and literature, romanticized in Edna Ferber's Pulitzer Prize–winning novel *Giant* (Garden City, NY: Doubleday, 1952).

3. The Garza children were Mucio Jr., Carmen, Arturo, Margarita, and the youngest, Mary Jane.

4. Carmen Lomas Garza, oral history interview by Paul J. Karlstrom, San Francisco, April 10–May 27, 1997, transcript, Smithsonian Archives of American Art, Washington, DC, http://www.aaa.si.edu/collections/oralhistories/transcripts/Garza97.htm.

5. For the artist's description of this work, see Carmen Lomas Garza, *Family Pictures/Cuadros de familia* (San Francisco: Children's Book Press, 1990), 4.

6. See, for instance, Paul Richard, "Tejana Nostalgia: Lomas Garza's Colorful, Festive Barrio Lacks Bitter Realities," *Washington Post*, December 3, 1995, G5.

7. Garza, *Family Pictures*, 16.

8. Children's book writer Maurice Sendak is known for *Where the Wild Things Are* (1988), a volume said to have both delighted and terrorized its readers. Beatrix Potter's sweetly tempered works, such as *The Tale of Peter Rabbit* (1902), represent a more established and sedate form of children's literature.

POLITICS AND LIFE IN TEJAS

1. Henrietta King, Richard King's widow, and Robert J. Kleberg, her son-in-law, played a major role in bringing the railroad to Kingsville. Its arrival in 1904, while economically beneficial to the area, pitted the white population against Mexican Americans who competed for the same jobs. Lea, *The King Ranch*, 539–59.

2. The relationship between the Latino community and the ranch had always been an ambivalent one. Historically, the ranch's expansionist practices led to land grabs and created tensions between the King family and the Mexican American owners of the *ranchitos* (small ranches) surrounding it. At the same time, the ranch provided employment for *vaqueros* and other Mexican American service workers, albeit for very low wages. See Joe S. Graham, *El Rancho in South Texas: Continuity and Change from 1750*, catalog of an exhibition at the John E. Connor Museum, Texas A&M University–Kingsville (Denton: University of North Texas Press, 1994), 37–38.

3. For a recent examination of García and the rise of the American GI Forum, see Michelle Hall Kells, *Héctor P. García: Everyday Rhetoric and Mexican American Civil Rights* (Carbondale: Southern Illinois University Press, 2006).

4. See George Norris Green, "The Felix Longoria Affair," *Journal of Ethnic Studies* 19, no. 3 (1991): 23–34. A short summary of the incident is "Felix Longoria Affair," *Handbook of Texas Online*, http://www.tshaonline.org/handbook/online/articles/FF/vef1.html. For a more exhaustive treatment, see Patrick Carroll, *Felix Longoria's Wake: Bereavement, Racism, and the Rise of Mexican American Activism* (Austin: University of Texas Press, 2003).

5. Héctor García relates a conversation with Kennedy in which the funeral director told him, "You know how the Latin people get drunk and lay around all the time. The last time the Latin Americans used the home, they had fights and got drunk. I—we have not let them use it and I don't intend to start now." Cited in Julie Leininger Pycior, *LBJ & Mexican Americans: The Paradox of Power* (Austin: University of Texas Press, 1997), 68.

Pycior's work provides background on the long-standing relationship between Mexican Americans and Lyndon Baines Johnson.

6. Carmen Lomas Garza, telephone conversation with author, February 12, 2008.

7. According to Garza, in the oral history interview by Karlstrom: "When I was growing up in Kingsville, going to the elementary school, I was very much affected by the kinds of stories and happenings and activities that were going on around me, not only in school but in my community, with discrimination and racism. Because my parents were very much involved with the American GI Forum, which is a World War II veterans' organization set up to fight for the civil rights of World War II veterans— Mexican American veterans that were coming back from the war and still finding discrimination and racism after having served in the war. So I was very much starting to become aware of the fact that things were not correct and they had to be corrected by civil rights action. And my parents were involved in that."

8. "In 1949 and 1950, [the AGIF] began local 'pay your poll tax' drives to register Tejano voters. Although they failed in repeated efforts to repeal the tax, a 1955–56 drive in the Rio Grande Valley resulted in the first majority Mexican American electorate in the area. . . . Ratification of the 24th Amendment finally abolished the poll tax requirement for Federal elections in 1964. In 1966, the tax was eliminated in all state and local elections by a Supreme Court ruling." George Mason University, "'Our First Poll Tax Drive': The American G. I. Forum Fights Disenfranchisement of Mexican Americans in Texas," History Matters: The U.S. Survey Course on the Web, http://historymatters.gmu .edu/d/6582/.

9. Garza, interview by author, San Francisco, August 4–5, 2004.

10. Constance Cortez, "Texas," in *Latino America: A State-by-State Encyclopedia*, ed. Mark Overmyer-Velázquez (Westport, CT: Greenwood Press, 2008), 781. Cortez goes on to explain, "Kennedy had been active in World War II and became an AGIF member in 1960. Many members of both AGIF and LULAC were involved in the clubs and actively recruited people to get out and vote. Kennedy won the election with 91 percent of Latino votes from Texas. In 1964, many of the same people formed Viva Johnson groups in support of LBJ, who

had been Kennedy's vice president and who had always been sympathetic towards the state's Mexican-American populace." For more on the Viva Kennedy clubs, see Ignacio García, *Viva Kennedy: Mexican Americans in Search of Camelot* (College Station: Texas A&M University Press, 2000).

11. Garza, *Family Pictures*, 24.

12. Ibid.

13. Although the desegregation of Texas schools began in the 1950s, the process continued well into the 1970s. "The American GI Forum of Texas also fought and won cases related to the segregation of Mexican Children into 'Mexican Schools.' In 1957, a federal court ruled that segregation of Mexican-American children in Texas public schools was unjustifiable. In 1973, Governor Dolph Briscoe signed the Texas Bilingual Education Act into law. This legislation required that, in grade groups consisting of 20 or more non-English-speaking children, those children be taught in their native language. In 1974, bilingual education was assured in a case successfully argued before the U.S. Circuit Court of Appeals, by the director of the Mexican American Legal Defense and Educational Fund (MALDEF), Vilma Martínez. This effectively ended the 1905 prohibition against speaking Spanish in schools." Cortez, "Texas," 781.

14. Garza, interview by Karlstrom.

15. Ibid.

16. Garza, interview by author.

17. Garza, interview by Karlstrom.

18. Ibid.

19. Carmen's parents had serious expectations that all of their children would attend university; indeed, the point was nonnegotiable. When Mary Jane, Carmen's younger sister, left college, her mother started working as a florist so that Mary Jane could go back and finish. Garza, telephone conversation with author.

20. Garza, interview by Karlstrom.

21. Garza prefers the term *pre-Cuauhtémoc* rather than *pre-Columbian*. She considers this a modern attitude of resistance, given that Cuauhtémoc was the last of the Aztec rulers to resist Spanish domination. Garza, interview by Karlstrom.

22. Garza, telephone conversation with author.

23. José Angel Gutiérrez, e-mail to author, June 18, 2008. For more on the Crystal City elections and their aftermath, see John S. Shockley, *Chicano Revolt in a Texas*

Town (Notre Dame, IN: University of Notre Dame Press, 1974), and Armando Navarro, *The Cristal Experiment: A Chicano Struggle for Community Control* (Madison: University of Wisconsin Press, 1998).

24. In the 1974 Supreme Court case *Allee v. Medrano*, the powers of the Rangers to break up strikes were severely curtailed. This case stemmed from an incident in 1967 when Rangers beat two UFW workers. On the Texas Rangers during the twentieth century, see Robert M. Utley, *Lone Star Lawmen: The Second Century of the Texas Rangers* (New York: Oxford University Press, 2007).

25. Garza, interview by Karlstrom.

26. José Angel Gutiérrez, personal communication, June 18, 2008. For a description of the political events at Texas A&I University during this time, see Cecilia Aros Hunter and Leslie Gene Hunter, "Time of Turmoil: Texas A&I University, 1968–1977," chap. 6 in *Texas A&M University Kingsville* (Chicago: Arcadia, 2000).

27. Garza, interview by Karlstrom.

28. The group lasted until 1972. For a summary, see "Mexican American Youth Organization," *Handbook of Texas Online*, http://www.tshaonline.org/handbook/online/articles/MM/wem1.html. For a more detailed account of MAYO's political activities, see Armando Navarro, *Mexican American Youth Organization: Avant-Garde of the Chicano Movement in Texas* (Austin: University of Texas Press, 1995).

29. Armando Navarro, *Mexicano Political Experience in Occupied Aztlán: Struggles and Change* (Walnut Creek, CA: AltaMira Press, 2005), 368–69. José Angel Gutiérrez estimates the number of walkouts in Texas during this period as closer to fifty (personal communication, June 18, 2008).

30. Armando Navarro, *Mexican American Youth Organization*, 177.

31. Garza, interview by author.

32. Garza, interview by Karlstrom.

33. Ibid.

34. José Luis Rivera-Barrera, telephone interview by author, July 13, 2007.

35. "La Lomita Mission," *Handbook of Texas Online*, http://www.tshaonline.org/handbook/online/articles/LL/uql7.html.

36. Garza, interview by Karlstrom.

37. José Angel Gutiérrez, letter to Carmen Lomas Garza, December 31, 1969, Carmen Lomas Garza

Archives, Nettie Lee Benson Latin American Collection, University of Texas, Austin.

38. Garza, interview by author.

39. Daniel García Ordaz, "Once Upon a Chicano College: Hispanics United to Create the First School of Its Kind in the U.S.," *Valley Morning Star* (Harlingen, TX), October 4, 2005.

40. "La Lomita Mission," *Handbook of Texas Online*.

41. Garza, telephone conversation with author.

42. Lotería in New Spain dates to the eighteenth century, although it appears to have originated in Italy some three centuries earlier. The game was created to raise funds for a variety of causes, especially those involving the indigent. It is likely that even before Mexico's independence, lotería was an established tradition in what would become Texas and New Mexico. See *El arte de la suerte/The Art of Luck* (Mexico City: Artes de México, 1997).

43. The term *monitos* can be translated as "little figures" (like those found in comic books) or "little dolls." As noted by Ilan Stavans, monitos vary according to tradition and region. Some may be related to political positions or represent heroes (both indigenous and mestizo), while others celebrate the church. For instance, "there is an ecclesiastical Lotería set with depictions of priests, biblical scenes, and the seven deadly sins." Teresa Villegas and Ilan Stavans, *Lotería!* (Tucson: University of Arizona Press, 2004), xvii.

44. Garza, interview by Karlstrom.

45. Ibid.

46. The Robstown walkout was one of many similar political actions initiated by MAYO between 1966 and 1969 to protest educational inequities and discrimination. According to Armando Navarro, the walkouts at Edcouch-Elsa (1968), Kingsville (1969), and Crystal City (1969–70) received the most media attention (*Mexicano Political Experience in Occupied Aztlán*, 368). For a discussion of the events at Robstown High School, see chapter 5 of Ignacio M. García, *Chicanismo: The Forging of a Militant Ethos among Mexican Americans* (Tucson: University of Arizona Press, 1997).

47. Garza, interview by Karlstrom.

48. By 1971 tensions within the Colegio's board were so severe that the group splintered. The Colegio closed its doors in the mid-1970s because of external protests. "Colegio Jacinto Treviño," *Handbook of Texas Online*,

http://www.tshaonline.org/handbook/online/articles/
CC/kbc51.html.

49. In 1975, after the Center had grown to 200 students, it moved to a building on First Street and changed its name to Juárez-Lincoln University. It closed in 1979 because of financial and administrative problems. "Juárez-Lincoln University," *Handbook of Texas Online*, http://www.tshaonline.org/handbook/online/articles/JJ/kcj3.html.

50. Garza, interview by author, August 4–5, 2004.

51. Ibid.

52. For a recent reexamination of the history of Con Safo, see Ruben C. Cordova, *Con Safo: The Chicano Art Group and the Politics of South Texas* (Los Angeles: UCLA Chicano Studies Research Center Press, 2009).

53. Tomás Ybarra-Frausto, "Santa Barraza: A Borderlands Chronicle," in *Santa Barraza: Artist of the Borderlands*, ed. María Herrera-Sobek (College Station: Texas A&M University Press, 2001), 70. See also the oral history interview with César Martínez by Jacinto Quirarte, August 21–28, 1997, transcript, Smithsonian Archives of American Art, http://www.aaa.si.edu/collections/oralhistories/transcripts/martin97.htm.

54. Other group members included Luis Guerra, Jesse Treviño, Santa Barraza, Vicente Rodriguez, and Carolina Flores. Ybarra-Frausto, "Santa Barraza," 70.

55. Ibid.

56. This image would later be developed into a full-scale painting, *Barriendo de Susto* (1986).

57. Curanderismo is common in Mexican American communities of the rural Southwest. It blends elements of Catholicism and indigenous belief systems and may include such practices as prayer, herbal medicine, and healing rituals.

58. According to Eliseo Torres, "Sometimes *susto* is translated as loss of spirit or even loss of soul. Occasionally, it is translated as shock, though it shouldn't be confused with the life-threatening medical condition known as shock. A common definition is fright. . . . Receiving bad news can cause *susto*, as can any bad scare. It is thought that such a scare can temporarily drive the person's spirit or soul from the body. Susto has to be treated immediately or it will lead to a much more serious version, called *susto pasado* or, in Mexico, *susto meco*—an old *susto* which is much more difficult to treat and which can lead to death." Torres, *The Folk Healer: The Mexican-American Tradition of Curanderismo* (Kingsville, TX: Nieves Press, 1983), 14.

59. For a detailed account of modern cleansing (*barrida*), see Deedy Esther Ramos, "A Mexican-American Folk Healer in Kingsville, Texas," master's thesis, Texas A&I University, Kingsville, 1993.

A TEJANA ON THE WEST COAST

1. Garza, interview by Karlstrom.

2. Garza, interview by author, August 4–5, 2004.

3. Garza, telephone conversation with author.

4. Ibid.

5. The Galería opened its doors in 1970 on the corner of 14th Street and Valencia. It was established by Chicano artists and community activists who included Rupert García, Peter Rodríguez, Francisco X. Camplis, Gustavo Ramos Rivera, Carlos Loarca, Manuel Villamor, Robert González, Luis Cervantes, Chuy Campusano, Rolando Castellón, Ralph Maradiaga, and René Yáñez. Garza, e-mail to author, August 22, 2008. For more information see the organization's website at http://www.galeriadelaraza.org/index.html.

6. Garza, interview by author.

7. According to Amalia Mesa-Bains, "The work was dedicated to my grandmothers Mariana Escobedo Mesa, Amalia Gonzales and to my tia Angelina Anaya and to my school friend Susan Jessup and of course to Frida Kahlo. . . . It was also an important Day of the Dead exhibition because I exhibited alongside my mentor, Yolanda Garfias-Woo, who was a major influence on all of us in the Bay Area in regard to the Day of the Dead. She was a dear friend to Ralph Maradiaga who also ran the Galería de la Raza." Mesa-Bains, e-mail to author, June 30, 2008.

8. Alfredo Arreguin, Amalia Mesa-Bains, Miranda Bergman, Manuel Alvarez Bravo, José Antonio Burciaga, Michael G. Burns, Ignacio Canales, Graciela Carrillo, Yreina Cervantez, Kate Connell, Teresa de la Riva, Daniel de los Reyes, Daniel del Solar, Lucienne Block Dimitroff, Pele deLappe, Rudy Fernández, Ellen Felcher, Enrique Flores, Juan Fuentes, Mia Galaviz, Rupert García, Salvador Garcia, Carmen Lomas Garza, Rafael Jesús González, Xavier Gorena, Blanca Gutiérrez, Ester

Hernandez, Nancy Hom, Lisa Kokin, Consuelo Kurz, Louis LeRoy, Ralph Maradiaga, Raúl Martínez, Sue Martínez, Gloria Maya, Hugo Mercado, Emmanuel Montoya, Jane Norling, María Pinedo, Xesus Guerrero Rea, Mike Rios, Jose Romero, Patricia Rodriguez, Esteban Chavez Sanchez, Joseph M. Sanchez, Herbert Siguenza, Beryl Landau/Nina Serrano, Teddy (ASCO), Calvin Barajas Tondre, Manuel Villamor, and René Yáñez (http://www.galeriadelaraza.org/eng/exhibits/time-line.html).

9. See *Frida Kahlo*, exhibition catalog, essay by Hayden Herrera (Chicago: Museum of Contemporary Art, 1978).

10. The committee was composed of Carmen Lomas Garza, Amalia Mesa-Bains, Rupert García, María Pinedo, Kate Connell, and Galería codirectors Ralph Maradiaga and René Yáñez. Garza, interview by author.

11. According to the Galería, the show ran for over two months, from November 2, 1978, through January 12, 1979. Rupert García's exhibition poster has it ending on November 17, 1978.

12. Kahlo took her inspiration from colonial Mexican art, where scripted banderoles can be found in both sacred and secular painting.

13. One of the more prestigious grants came from the California Arts Council in 1979; she combined it with a residency at the Galería.

14. *Carmen Lomas Garza/Prints and Gouaches, Margo Humphrey/Monotypes*, April 11–May 25, 1980.

15. Tomás Ybarra-Frausto, *Carmen Lomas Garza/Prints and Gouaches, Margo Humphrey/Monotypes*, exhibition catalog (San Francisco: San Francisco Museum of Modern Art, 1980), 3.

16. Tomás Ybarra-Frausto, "Lo real maravilloso: The Marvelous/The Real," in *Carmen Lomas Garza: Lo Real Maravilloso: The Marvelous/The Real*, exhibition catalog (San Francisco: Mexican Museum, 1987), 9. For a discussion of the distinction between retablo and ex voto paintings, see Jorge Durand and Douglas S. Massey, *Miracles on the Border: Retablos of Mexican Migrants to the United States* (Tucson: University of Arizona Press, 1995).

17. Amalia Mesa-Bains notes that the artist's lotería-related works marked "the beginning of the long process of charting the Chicano cultural cosmos." She points to Garza's practice of simultaneously invoking the everyday and the celestial. "Chicano Chronicle and Cosmology:

The Works of Carmen Lomas Garza," in *Pedacito de Mi Corazón*, exhibition catalog (Austin: Laguna Gloria Art Museum, 1991), 20.

18. Ybarra-Frausto, *Carmen Lomas Garza/Prints and Gouaches, Margo Humphrey/Monotypes*, 3.

19. The inspiration for the visual handling of characters in the painting can be found in Garza's past. While still a child, she went to the opera in San Antonio to see *Madame Butterfly* and was captivated by the pageantry and costumes. "It was fantastic. . . . It was wonderful, it was magical to see that in San Antonio. One of my mother's cousins, a great uncle for us kids, was very much into opera; he was a bachelor and . . . was the one to encourage us to go see the opera. So, the whole family went with him to go see *Madame Butterfly*." Garza, interview by author.

20. Garza, *In My Family/En mi familia* (San Francisco: Children's Book Press, 1996), 16.

21. Don Pedrito Jaramillo was the most famous curandero in South Texas. Born in Guadalajara, Jalisco, Mexico, in the nineteenth century, he was the child of Tarascan parents. Eventually he settled on Los Olmos Ranch near Falfurrias, Texas. He was renowned for his ability to successfully treat even the toughest afflictions by means of his "water cures." Although his status, even during his life, was legendary, he never accepted money for his work. After his death in 1908, his grave became a shrine. Today the site, which has become a historic monument, is visited daily, candles are lit, and, it is said, miracles continue to happen. The most extensive work on Don Pedrito is Ruth Dodson's 1934 treatise, *Don Pedrito Jaramillo "Curandero"* (repr., Corpus Christi, TX: Henrietta Newbury, 1994). For use of the shrine today, see Mary Lee Grant, "Don Pedrito Still Attracting Visitors after Almost 90 Years," *Corpus Christi Caller-Times*, December 22, 1997.

22. This multifaceted approach was in keeping with the role of the curandera herself. Garza notes, "Besides being a healer, the *curandera* was also a counselor. She helped my mother and my sister communicate. I think that's why my sister got better." Garza, *In My Family*, 16.

23. For information on the Mujeres Muralistas, see Terezita Romo, "A Collective History: Las Mujeres Muralistas," in *Art/Women/California, 1950–2000*, ed. Diana Burgess Fuller and Daniela Salvioni (Berkeley: University of California Press, 2002), 177–86.

24. For more on the RCAF, see José Montoya, "The Anatomy of an RCAF Poster/Anatomía de un cartel de la RCAF," in *Just Another Poster: Chicano Graphic Arts in California/Sólo un cartel más? Artes gráficas Chicanas en California*, ed. Chon Noriega (Santa Barbara: University Art Museum, University of California), 25–38. See also the RCAF website at http://www.chilipie.com/rcaf/.

25. Garza, interview by Karlstrom.

26. Garza, interview by author. Garza was able to take on the commission because she had saved enough money during her five years at the Galería to support herself for a year. Her funds were supplemented by grants from the National Endowment for the Arts (1981) and the California Arts Council (1982, 1984).

27. Mission San Francisco de Asís (Mission Dolores) is the church around which the city of San Francisco developed. It gave its name to the Mission District, now a primarily Latino quarter of the city.

28. Artists had occupied work spaces at the ship-yard since the early 1980s. Garza heard about it through Ralph Maradiaga and Patricia Rodriguez, who already had studios there, and both encouraged her to follow through on Maradiaga's advice to move her production space out of her home. The studio offered a well-venti-lated environment for Garza's "dirty" work, aspects of art production involving the use of toxic chemicals. Garza, telephone conversation with author.

29. For more on the linkages between the groups, see Octavio Paz, "Art and Identity: Hispanics in the United States," in *Hispanic Art in the United States: Thirty Contemporary Painters & Sculptors* (Houston: Museum of Fine Arts; New York: Abbeville Press, 1987), 13–37.

30. Garza goes on to state that, beyond being just plain bad manners, the museum's unintentional slight negated the association between the artists and their work, an association that was important to the Mexican American viewers attending the show. Garza, interview by Karlstrom.

31. Ibid.

32. While *tamaladas* are traditionally associated with women, Garza notes that in her family everyone partici-pated. Garza, *Family Pictures*, 16.

33. According to Carmen, this furthered the cohe-sion, as "the light was so bright on the porch that you couldn't see beyond the edge of the lit area. It was like being in our own little world." Garza, *Family Pictures*, 24.

34. Garza, interview by author.

35. *Cempoalxochitl* is a compound noun derived from the Nahuatl term *cempoalli*, meaning "twenty," and *xochitl*, "flower." The "twenty" here is a reference to the flower's numerous petals. Just we might say "dozens" in English, in the pre-Columbian vigesimal system, *cempoalli* (read: "twenties") was used to mean a great many objects.

36. For a discussion of domesticana Chicana, see Amalia Mesa-Bains, "Domesticana: The Sensibility of Chicana Rasquache," in *Distant Relations: A Dialogue among Chicano, Irish, and Mexican Artists*, ed. Trisha Ziff (New York: Smart Art Press, 1996), 156–63. Rasquachismo, according to Tomás Ybarra-Frausto, is a conceptually vague aesthetic appearing in Chicano art that can be defined in a myriad of ways. Rasquachismo is the "good taste of bad taste," an aesthetic that is vernac-ular, visceral, and a celebration and reflection of Chicano worldview. It can be witty and playful, on the one hand, while bitingly political and serious on the other. In the end, it is also an aesthetic of cultural survival. Tomás Ybarra-Frausto, "Rasquachismo: A Chicano Sensibility," in *Chicano Art: Resistance and Affirmation, 1965–1985*, ed. Richard Griswold del Castillo, Teresa McKenna, and Yvonne Yarbro-Bejarano (Los Angeles: Wight Art Gallery, University of California, 1991), 155–62. For a compara-tive analysis of rasquachismo and domesticana and the importance of both in the comprehension of Chicana/o art, see Holly Barnet-Sánchez, "Tomás Ybarra-Frausto and Amalia Mesa-Bains: A Critical Discourse from Within," *Art Journal* 64, no. 4 (Winter 2005): 91–93.

37. Mesa-Bains, "Domesticana," 159.

38. Ibid.

39. Mesa-Bains, "Chicano Chronicle and Cos-mology," 31.

40. Garza, *In My Family*, 14.

41. Garza, interview by author.

42. Mesa-Bains, "Chicano Chronicle and Cos-mology," 35–37.

A CHICANA RECONQUISTA

1. An accompanying exhibition was held simul-taneously in Genoa, Italy, the home of Christopher Columbus.

2. Each year the European Union designates a different city as the European Capital of Culture. During the year it is honored, the chosen city displays its cultural achievements, enhancing its international reputation.

3. Stephen J. Summerhill and John Alexander Williams, *Sinking Columbus: Contested History, Cultural Politics, and Mythmaking during the Quincentenary* (Gainesville: University Press of Florida, 1992), 130.

4. Héctor Díaz-Polanco, "Indian Communities and the Quincentenary," trans. John F. Uggen, *Latin American Perspectives* 19, no. 3 (Summer 1992): 7.

5. The term *reconquista* has been used to describe a variety of political and military efforts to reclaim territory. These include the political movement in Mexico to recover the nation's territory after the signing of the Treaty of Guadalupe Hidalgo in 1848, as well as Spain's attempt to bring the Americas back into the fold in the early nineteenth century. However, the term is most frequently associated with the 750-year period during which Spanish and Portuguese Christians attempted to reclaim the Iberian Peninsula from the Moors. That period ended in 1492 with the conquest of Granada and the formal expulsion of Muslims and Jews from Spain. Here, however, I use the term to reference a historical and cultural reclamation rather than a territorial one.

6. Marcos Sánchez-Tranquilino, foreword to *The Chicano Codices: Encountering Art of the Americas* (San Francisco: Mexican Museum, 1992), 3.

7. Marcos Sánchez-Tranquilino, "The Chicano Codices: Feathered Reflections on an Aztlanic Archaeology," in *The Chicano Codices*, 5. Ann Marie Leimer, "Performing the Sacred: The Concept of Journey in *Codex Delilah*" (PhD diss., University of Texas, Austin, 2005), 84.

8. *Códice Matritense de la Real Academia de la Historia* (Nahuatl texts of the Indian informants of Sahagún), facsimile ed. of vol. 8 by Francisco del Paso y Troncoso (Madrid: Hauser y Menet, 1907), fol. 192, r. Cited in Miguel León-Portilla, *Aztec Thought and Culture: A Study of the Ancient Nahuatl Mind*, trans. Jack Emory Davis (Norman: University of Oklahoma Press, 1978), 23.

9. George M. Foster, "The Relationship between Spanish and Spanish American Folk Medicine," *Journal of American Folklore* 66, no. 261 (July–September 1953): 212.

10. According to the Aztec "Leyenda de los Soles" (Legend of the Suns), there were four other creations before Nahui Ollin (4 Movement), the era in which the Aztecs lived and which extends to the present. Each of the previous ages ended in a different type of cataclysm. A transcription of the earliest version of the legend, from 1558, can be found in Francisco del Paso y Troncoso, *Leyenda de los Soles* (Florence: Tipografía de Salvador Landi, 1903).

11. See Garza's 1980 gouache painting *Abuelitos Piscando Nopalitos* (Grandparents Harvesting Cactus), in Garza, *Family Pictures*, 15.

12. The plants are known to normalize blood sugar and are therefore useful in the treatment of diabetes. They are also used to treat stomach upset and diarrhea.

13. Wade C. Sherbrooke, *Introduction to Horned Lizards of North America* (Berkeley: University of California Press, 2003), 148–55.

14. A 24-minute documentary by Liz Sher and Carmen Lomas Garza, *Homenaje a Tenochtitlán: An Installation for the Day of the Dead*, examines the construction of this work (http://www.ivstudios.com/Web_02/index.html).

15. Amalia Mesa-Bains, *Homenaje a Tenochtitlán: An Installation for the Day of the Dead, by Carmen Lomas Garza*, exhibition catalog (Northampton, MA: Smith College Museum of Art, 1992), 5. Originally Chichimec dancers, the Concheros came into being after the Conquest of Mexico. See Marti Stone, *At the Sign of Midnight: The Concheros Dance Cult of Mexico* (Tucson: University of Arizona Press, 1975).

16. The glyphic designs indicating the swirling waters of Lake Texcoco are based on designs found in indigenously produced sixteenth-century manuscripts from Mexico. A similar indigenous colonial representation of water is the "Battle of the Tolteca Causeway" from the Lienzo de Tlaxcala. See Diego Muñoz Camargo, *Historia de Tlaxcala: Crónica del siglo XVI*, annotated by Alfredo Chavero (Mexico City: Editorial Innovación, 1979).

17. Carmen Lomas Garza, interviewed in the documentary video *Homenaje a Tenochtitlán: An Installation for the Day of the Dead*.

18. Throughout Native America, maize, beans, and squash are known as the "three sisters" and are part of an ancient companion planting system. According to Jack Weatherford: "The broad leaves of the hardy corn plant shade the delicate bean plants from the harsh

sun, and the strong corn stalk provides a living stake on which the bean and squash vines grow. The squash vines meander across the ground between the corn and bean plants, providing cover for the earth and thereby ensuring maximum capture of rain and minimal erosion of the land from wind or water. At the same time, the broad leaves and long vines of the squash plant so effectively cover the ground that they prevent unwanted plants from growing. This reduces the need for weeding while ensuring a better harvest. In turn, the beans fix nitrogen in the soil to help the corn and squash grow." Weatherford, *Indian Givers: How the Indians of the Americas Transformed the World* (New York: Crown, 1988), 83.

19. Predating the Aztecs, the civilization at Teotihuacán reached its zenith between AD 300 and 900. After their arrival in the region, the Aztecs named the ruins Teotihuacán (the place of the gods), believing that it was the primordial location where the gods sacrificed themselves in order to give birth to the sun and moon. The event started time, and the Aztecs would periodically visit the site and leave offerings to the gods. Fray Bernardino de Sahagún, *Florentine Codex: General History of the Things of New Spain, Book 3—The Origin of the Gods*, trans. Arthur J. O. Anderson and Charles E. Dibble (Salt Lake City: University of Utah; Santa Fe: School of American Research, 1952), 1.

20. The most famous example of the use of quetzal feathers is Moctezuma's headdress, now located at the Museum of Ethnology in Vienna.

21. The Spanish term *guajalote* is derived from the Aztec *huexolotl*.

22. So important was maize to the Aztecs that it was equated metaphorically to human developmental stages. Constance Cortez, "Aztec Images of Woman: The Myth and Ritual of Pregnancy," unpublished paper.

23. As Chalchiuhtotolin, Tezcatlipoca was associated with the cleansing of pestilence. See Fray Diego Durán, *The History of the Indies of New Spain*, trans. Doris Heyden (Norman: University of Oklahoma Press, 1994), 387 n.

24. The acocotli, or dahlia, is first mentioned in the sixteenth century by Sahagún. See Fray Bernardino de Sahagún, *Florentine Codex: General History of the Things of New Spain, Book 11—Earthly Things*, trans. Arthur J. O. Anderson and Charles E. Dibble (Salt Lake City: University of Utah; Santa Fe: School of American Research, 1963), 133.

25. Fernando Alvarado Tezozomoc first recorded the foundation myth in 1609 as part of his *Crónica mexicana*. For an English translation of the myth, see Thelma D. Sullivan, "The Finding and Founding of Tenochtitlán," *Tlalocan* 6, no. 4 (1971): 312–36.

26. Dandelion is a diuretic and has been used to treat maladies of the stomach, skin, and kidneys.

27. Garza, interview by Karlstrom.

28. Before mastering Spanish, Malinche was involved in a three-way translation involving Cortés and Jerónimo de Aguilar, a shipwrecked Spanish sailor who had been living among the Maya for eight years. Once inland and among Nahuatl-speaking people, Malinche would translate from Nahuatl to Maya for Aguilar, and Aguilar in turn would translate from Maya to Spanish for Cortés.

29. See Constance Cortez, "Now You See Her, Now You Don't: Memory and the Politics of Identity Construction in Representations of Malinche," in *Invasion and Transformation: Interdisciplinary Perspectives on Images of the Conquest of Mexico*, ed. Margaret Jackson Ferrer and Rebecca Brienen (Denver: University Press of Colorado, 2007), 75–89.

30. There are numerous volumes devoted to the connection of the Virgin of Guadalupe to the Aztec earth deity, Tonantzin ("Our Grandmother"). Two volumes that deal with her polysemous meanings include the classic by Jacques Lafaye, *Quetzalcoatl and Guadalupe: The Formation of Mexican National Consciousness 1531–1813* (Chicago: University of Chicago Press, 1976) and D. A. Brading's *Mexican Phoenix: Our Lady of Guadalupe: Image and Tradition across Five Centuries* (New York: Cambridge University Press, 2001).

CARMEN VERSUS THE FUTURE

Epigraph. Statement by Garza in a telephone conversation with the author, September 15, 2008. See also "East Los Angeles Primary School to Be Named after Artist, Author and A&M–Kingsville Alumna Carmen Lomas Garza" (Texas A&M University–Kingsville press release, June 9, 2008), http://www.tamuk.edu/news/2008/june/lomas_garza.

1. The 1994 exhibition at the Honolulu Academy of Art was *Día de los Muertos/Ofrenda para Antonio Lomas,*

and the 1995 show at the Hirshhorn was *Directions: Carmen Lomas Garza.*

2. *Carmen Lomas Garza: A Retrospective* was curated by Patricia Hickson and opened on January 21, 2001, at the San Jose Museum of Art. Subsequent venues included the San Antonio Museum of Art; the South Texas Institute for the Arts in Corpus Christi; the Ellen Noël Art Museum in Odessa, Texas; the National Hispanic Cultural Center of New Mexico in Albuquerque; and the Polk Museum of Art in Lakeland, Florida.

3. Garza, interview by Karlstrom.

4. Garza, *In My Family/En mi familia*, 10.

5. Until recently, the religious aspect of the quinceañera was informal, but in 2007 the Vatican formalized and approved the ritual for the liturgy. See United States Conference of Catholic Bishops, *Order for the Blessing on the Fifteenth Birthday* (http://www.usccb.org/liturgy/Quinceanera.pdf).

6. Garza, interview by author.

7. Garza, interview by Karlstrom.

8. The numerous awards for these books included the Américas Honor Award for Children's and Young Adult Literature, which Garza received in 1997 from the Consortium of Latin American Studies Programs (CLASP).

9. Vilsack Foundation, "Governor, First Lady Launch Kindergarten Book Tour at Des Moines Art Center," http://www.christievilsack.org/Mrs_Vilsack/iowa_stories/verizon_literacy/books_kindergartners05.html.

10. The Silicon Valley school districts put in a huge order for 50,000 volumes, with funding from First 5 Santa Clara County and the Community Foundation Silicon Valley. Janet del Mundo, sales and marketing manager at Children's Book Press, telephone conversation with author, July 9, 2008. See also Texas A&M University–Kingsville, "East Los Angeles Primary School to Be Named After Artist."

11. Carmen Lomas Garza, e-mail to author, May 8, 2008.

12. Texas A&M University–Kingsville, "East Los Angeles Primary School to Be Named After Artist."

13. Ibid.

14. Furthermore, copper's high reflectivity causes it to bounce light back in unexpected directions, making it a hazard to use the laser. Will Cannings, telephone conversation with author, June 15, 2008.

15. For the historic development of the dance and its meaning, see Marta Heredia Casanova, *El jarabe: Baile tradicional de México* (Jalisco, Mexico: Secretaría de Cultura, Gobierno del Estado de Jalisco, 1999).

16. Carmen Lomas Garza, artist's statement (http://www.carmenlomasgarza.com/): "When waiting passengers see the copper cutout *Baile* it is as if they are looking in through a window of an artist's studio. The artist is painting an image of Jarabe Tapatío dancers from Mexico. The metal cutout was based on a paper cutout that was photographed, digitized, and cut with a high-pressure jet stream of water."

17. Kenneth Baker, "Terminal's Art Has Its Ups and Downs: Some Works Stand Out in Airport's Huge Space," *San Francisco Chronicle*, July 27, 2000, E1.

18. http://www.carmenlomasgarza.com.

19. Garza, interview by Karlstrom.

20. Bernice Steinbaum, a longtime friend of the artist and gallery owner who had represented her work in New York and Miami, correctly advised Garza that her work was underpriced: she should demand more for it, if only to make a living wage. Garza, interview by author.

21. Jesse Hamlin, "Appreciation: Tito Puente Left a Blazing Legacy of Latin Jazz," *San Francisco Chronicle*, June 2, 2000, D2.

EXHIBITION HISTORY

EDUCATION

Master of Art, San Francisco State University, 1981
Master of Education, Juárez-Lincoln Center/Antioch Graduate School of Education, Austin, 1973
Bachelor of Science, Texas A&I University, Kingsville, 1972

AWARDS

2007

Smithsonian Latino Center Legacy Award in the Visual Arts, Washington, DC

2004

Rockefeller Study and Conference Center, Residency Program, Bellagio, Italy

2000

Carter G. Woodson Honor Book, National Council for the Social Studies
Outstanding Achievement, Parent's Guide to Children's Media, Inc.
Outstanding Selection, Parent Council, Ltd.
Pura Belpré Award for Illustration
Skipping Stones Honor Award

1999

Honorable Mention, Américas Award for Children's and Young Adult Literature, Consortium of Latin American Studies Programs (CLASP)

1997

International Reading Association Notable Books for a Global Society Choice
Texas Bluebonnet Award Master List

1996

Américas Award for Children's and Young Adult Literature, Consortium of Latin American Studies Programs (CLASP)
Artistas Activas en la Comunidad Honoree, Bay Area Network of Latinas, San Francisco, CA
Best Seller Award, Children's Book Press, San Francisco, CA
Children's Books of Distinction Award, *Hungry Mind Review*

National Endowment for the Arts/FONCA (Fondo Nacional para la Cultura y las Artes), International Creative Artists' Residency Program, Oaxaca and Mexico City
Pura Belpré Honor Award, Association for Library Service to Children and National Association to Promote Library Services to the Spanish Speaking
Skipping Stones Book Award
Tomás Rivera Mexican American Children's Book Award, Southwest Texas State University, San Marcos

1995

VIDA Artist Award, NBC-TV and *Hispanic* magazine

1994

Djerassi Resident Artists Program, Woodside, CA
Lifetime Achievement Award in Art, National Hispanic Academy of Media Arts and Sciences, Los Angeles, CA

1993

Bay Area Hispanic Heroes and Heroines, Bank of America, San Francisco, CA
Chicanas in the Arts Award, Chusma House Publications and National Association for Chicano Studies, San Jose, CA

1992

Woman Artist of the Year, BAYLAW, San Francisco, CA

1991

Illinois State Visiting Artist for April

1990

American Library Association Notable Book
Best Books of the Year Selection, Library of Congress
Best Books of the Year Selection, *School Library Journal*
California Arts Council Fellowship in Painting
Pura Belpré Honor Award
Texas Bluebonnet Award

1987

National Endowment for the Arts Fellowship in Painting

1986

California Arts Council Artist in Residence Grant, sponsored by the Mexican Museum, San Francisco

1984

California Arts Council Artist in Residence Grant, cosponsored by the Mexican Museum and Real Alternatives Program, San Francisco

1982
California Arts Council Artist in Residence Grant, sponsored by Galería de la Raza/Studio 24, San Francisco

1981
National Endowment for the Arts Fellowship in Printmaking

1979
California Arts Council Artist in Residence Grant, sponsored by Galería de la Raza/Studio 24, San Francisco

MUSEUM COLLECTIONS

Dain Bosworth Company, Minneapolis, MN
Djerassi Resident Artist Program, Woodside, CA
El Paso Museum of Art, El Paso, TX
Federal Reserve Bank, Dallas, TX
Fort Wayne Museum of Art, Fort Wayne, IN
Fresno Unified School District, Fresno, CA
Galería de la Raza/Studio 24, San Francisco, CA
Hirshhorn Museum and Sculpture Garden, Smithsonian Institution, Washington, DC
Jane Voorhees Zimmerli Art Museum, Rutgers University, New Brunswick, NJ
Lang Communications, New York, NY
Library of Congress, Washington, DC
Kaiser Permanente Art Program, Denver, CO
McAllen International Museum, McAllen, TX
McAllen Memorial Library, McAllen, TX
Mexican American Library Project, University of Texas Library, Austin
Mexican Fine Arts Center Museum, Chicago, IL
The Mexican Museum, San Francisco, CA
Mills College Art Gallery, Oakland, CA
Oakland Museum of California, Oakland
San Francisco Arts Commission, City and County of San Francisco, CA
San Francisco General Hospital, San Francisco, CA
San Antonio Museum of Art, San Antonio, TX
San Jose Museum of Art, San Jose, CA
Shields Library, University of California, Davis
Smith College Museum of Art, Smith College, Northampton, MA
Smithsonian American Art Museum, Washington, DC
St. Paul Companies, Minneapolis, MN
Texas Women's University, Denton
Tucson Museum of Art, Tucson, AZ

PUBLIC ART COMMISSIONS

1999
Baile, San Francisco International Airport, San Francisco, CA. Copper metal wall sculpture, 16 x 24 feet. Commissioned by San Francisco International Airport in conjunction with the San Francisco Arts Commission.

1993
Cumpleaños para Barbacoa, Federal Reserve Bank, Dallas, TX. Oil painting. Commissioned by the Federal Reserve Bank.

1984
History of California Water: The Everyday Use of Water, San Francisco Water Department, Millbrae Suburban Facility, Millbrae, CA. Eight acrylic paintings. Commissioned by the City and County of San Francisco Water Department in conjunction with the San Francisco Arts Commission.

SOLO EXHIBITIONS

2009
¡A Viva Voz! Chicana Artist Carmen Lomas Garza, Nettie Lee Benson Latin American Collection, University of Texas, Austin.
In My Family/En mi familia, permanent installation, Austin Children's Museum, Austin, TX.

2007
Carmen Lomas Garza: Paintings and Prints, Mohr Gallery, Community School of Music and Arts at Finn Center, Mountain View, CA.

2004–5
Carmen Lomas Garza: From the Collection of Gilbert Cardenas, Galería América, Institute for Latino Studies, University of Notre Dame, Notre Dame, IN; Fort Wayne Museum of Art, Fort Wayne, IN.

2003
Carmen Lomas Garza: Como la Salvila/Like the Aloe, List Gallery, Swarthmore College, Swarthmore, PA; Resource Library, Gaea Foundation, Washington, DC.
In My Family/En mi familia, Austin Children's Museum, Austin, TX; Kalamazoo Valley Museum, Kalamazoo, MI; Pittsburgh Children's Museum, Pittsburgh, PA; Grand Rapids Children's Museum, Grand Rapids, MI; San Antonio Children's Museum, San Antonio, TX; Children's Discovery Museum, Brownsville, TX; Minnesota Children's Museum, St. Paul, MN.

2001

Carmen Lomas Garza: A Retrospective, San Jose Museum of Art, San Jose, CA; San Antonio Museum of Art, San Antonio, TX; Art Museum of South Texas, South Texas Institute for the Arts, Corpus Christi; Ellen Noël Art Museum of the Permian Basin, Odessa, TX; National Hispanic Cultural Center of New Mexico, Albuquerque; Polk Museum of Art, Lakeland, FL.

1999

Papel Picado: The Paper Cutouts of Carmen Lomas Garza, Galería de la Raza/Studio 24, San Francisco, CA.

1998

Carmen Lomas Garza: Ofrenda para Antonio Lomas: Day of the Dead 1998, Art Museum of South Texas, South Texas Institute for the Arts, Corpus Christi.

1997

Carmen Lomas Garza: Monitos, Kemper Museum of Contemporary Art, Kansas City, MO.

1996

Carmen Lomas Garza: Cuadros de Recuerdos de una Artista Chicana/Paintings of Memories of a Chicana Artist, Steinbaum Krauss Gallery, New York, NY.

1995

Carmen Lomas Garza, Whitney Museum of American Art at Philip Morris, New York, NY.

Directions: Carmen Lomas Garza, Hirshhorn Museum and Sculpture Garden, Smithsonian Institution, Washington, DC.

Los Primos del Río Abajo, Millicent Rogers Museum, Taos, NM.

1994

Día de los Muertos/Ofrenda para Antonio Lomas, Honolulu Academy of Art, Honolulu, HI.

1993

Carmen Lomas Garza/Works, Terrain Gallery, San Francisco, CA.

1992

Homenaje a Tenochtitlán: An Installation for the Day of the Dead, Smith College Museum of Art, Northampton, MA.

1991

Carmen Lomas Garza: Pedacito de Mi Corazón, Laguna Gloria Art Museum, Austin, TX; El Paso Museum of Art, El Paso, TX; Ben P. Bailey Art Gallery, Texas A&I University, Kingsville; Lubbock Fine Arts Center, Lubbock, TX; Mexican Fine Arts Center Museum, Chicago, IL; Laband Art Gallery, Loyola Marymount University, Los Angeles, CA; Oakland Museum of California, Oakland.

The Old and the New, Galería Sin Fronteras, Austin, TX.

Tradition & Investigation, Galería Nueva, Los Angeles, CA.

1990

Carmen Lomas Garza, University Art Gallery, California Polytechnic State University, San Luis Obispo.

Imágenes Familiares, Bank of America, San Francisco, Los Angeles, and Modesto, CA.

1989

Carmen Lomas Garza, Galería Sin Fronteras, Austin, TX.

1988

Carmen Lomas Garza, MARS Gallery, Movimiento Artístico del Río Salado, Phoenix, AZ.

Carmen Lomas Garza, Primitivo Gallery, San Francisco, CA.

1987

Carmen Lomas Garza: Lo Real Maravilloso: The Marvelous/The Real, Mexican Museum, San Francisco, CA.

1985

Carmen Lomas Garza, Galería Posada, Sacramento, CA.

1981

Carmen Lomas Garza, Bon Marché Gallery, Eastern Washington University, Spokane.

Carmen Lomas Garza, Firehouse Gallery, Del Rio Council for the Arts, Del Rio, TX.

1980

Carmen Lomas Garza/Prints and Gouaches, Margo Humphrey/Monotypes, San Francisco Museum of Modern Art, San Francisco, CA.

1978

Carmen Lomas Garza, Frank C. Smith Fine Arts Center, Texas A&I University, Kingsville (with César Martínez).

1977

Carmen Lomas Garza, Mexican Museum, San Francisco, CA.

1975

Carmen Lomas Garza, Trinity University, San Antonio, TX.

1972

Monitos, Estudios Rio Gallery, Mission, TX.

GROUP EXHIBITIONS

2008

20th Century Artists: Graduates of Texas A&I/Texas A&M University–Kingsville, Ben P. Bailey Art Gallery, Texas A&M University–Kingsville.

2007

¡A Viva Voz! Nettie Lee Benson Latin American Collection, University of Texas, Austin.

Big Picture: Provisions for the Arts of Social Change, Nathan Cummings Foundation, New York, NY.

Children Should Be Seen: The Image of the Child in American Picture-Book Art, Katonah Museum of Art, Katonah, NY; Eric Carle Museum of Picture Book Art, Amherst, MA; Los Angeles Public Library, Getty Gallery, Los Angeles, CA.

Pacific Light: California Watercolor Refracted, International Center for the Arts, San Francisco State University, San Francisco, CA; Nordiska Akvarellmuseet (Nordic Watercolor Museum), Skarhämn, Sweden.

2006

Nuestra Cultura Artística: A Celebration of Latino Cultural History, Lubeznik Center for the Arts, Michigan City, IN.

Spirit Healers, Museo de las Americas, Denver, CO.

Texas 100: Selections from the El Paso Museum of Art, El Paso Museum of Art, El Paso, TX.

The Chicano Collection, Downtown Center for the Arts, Oxnard, CA.

Visual Politics: The Art of Engagement, San Jose Museum of Art, San Jose, CA.

Voces Latinas: Works on Paper from 1921–Present, Nevada Museum of Art, Reno, NV.

2005

Celebrating the Permanent Collection, Noyes Museum of Art, Oceanville, NJ.

Cheech Marin Presents the Chicano Collection: Fine Art Prints by Modern Multiples, Plaza de la Raza Cultural Center for the Arts & Education, Los Angeles, CA.

Colecciones: Mexican Art from 50 Private Chicago Collections, Mexican Fine Arts Center Museum, Chicago, IL.

La Lotería: Una Ventana en la Cultura e Historia de México, Sioux City Art Center, Sioux City, IA.

Trazos: Myth and Memory, Galería de La Raza/Studio 24, San Francisco, CA.

2004

Chicano Art for Our Millennium, Mesa Southwest Museum, Mesa, AZ.

Collection Highlights, San Jose Museum of Art, San Jose, CA.

Contested Narratives: Chicana Art from the Permanent Collection, Mexican Museum, San Francisco, CA.

Hispanidad: Selections from the Permanent Collection, National Hispanic Cultural Center, Albuquerque, NM.

Sprint Corporate Art Collection, ExhibitsUSA, Overland Park, KS.

25 Years of Heart and Struggle, Mission Cultural Center for Latino Arts, San Francisco, CA.

Art/Women/California, 1950–2000: Parallels and Intersections, San Jose Museum of Art, San Jose, CA.

In Search of the Dream: The American West, Bruce Museum of Arts and Science, Greenwich, CT.

2001

Chicano Visions: American Painters on the Verge, San Antonio Museum of Art, San Antonio, TX; Smithsonian Art and Industries Building, Washington, DC; National Hispanic Cultural Center, Albuquerque, NM; El Paso Museum of Art, El Paso, TX; Indiana State Museum, Indianapolis; San Diego Museum of Contemporary Art, San Diego, CA; Museum of Art, Fort Lauderdale, FL.

Collecting Our Thoughts: The Community Responds to Art in the Permanent Collection, San Jose Museum of Art, San Jose, CA.

Roundup: Selected Works from Friends of the El Paso Museum of Art, El Paso, TX.

Sculptural Works by Cheryl Coon + Artists' Pages from the Djerassi Resident Artists Program, San Francisco Arts Commission Gallery, San Francisco, CA.

2000

Arte Latino: Treasures from the Smithsonian American Art Museum, Smithsonian American Art Museum, Washington, DC; El Paso Museum of Art, El Paso, TX; Orlando Museum of Art, Orlando, FL; Terra Museum of American Art, Chicago, IL; Palm Springs Desert Museum, Palm Springs, CA; Museum of Fine Arts, Santa Fe, NM; Oakland Museum of California, Oakland.

Chicanos en Mictlán: Día de los Muertos in California, Mexican Museum, San Francisco, CA.

La Luz: Contemporary Latino Art in the United States, National Hispanic Cultural Center, Albuquerque, NM.

Multiplicity: Prints from the Permanent Collection, Mexican Fine Arts Center Museum, Chicago, IL.

Revealing & Concealing Portraits & Identity, Skirball Cultural Center, Los Angeles, CA.

Valle de la Luna: Works by Mexican, Latino and Chicano Artists, Sonoma Valley Museum of Art, Sonoma, CA.

1999

American Spectrum, Smith College Museum of Art, Northampton, MA.

Outward Bound: American Art at the Brink of the Twenty-first Century, Meridian International Center, Washington, DC.

¡Provecho! A Taste of the Permanent Collection, Mexican Fine Arts Center Museum, Chicago, IL.

The Role of Paper/El Papel del Papel, Guadalupe Cultural Arts Center, San Antonio, TX.

1998

Down Under & Over Here: Children's Book Illustration from Australia and America, Cedar Rapids Museum of Art, Cedar Rapids, IA.

Ice House of South Texas, Museo del Barrio, New York, NY.

Then and Now: Terrain's Tenth Year Celebration, Terrain Gallery, San Francisco, CA.

1997

Art that Heals, Center for Visual Art, Metropolitan State College of Denver, CO.

Brave Little Girls, San Francisco Public Library, San Francisco, CA.

Día de los Muertos, 1997, Mexican Museum, San Francisco, CA.

La Guadalupana: Images of Faith and Devotion/Imágenes de Fe y Devoción, Tacoma Art Museum, Tacoma, WA.

Native American Invitational/Indigenous Women Artists, Gilcrease Museum, Tulsa, OK.

Purchase Exhibition, Fort Wayne Museum of Art, Fort Wayne, IN.

Seventh Annual Children's Book Illustrator Show, Sun Gallery, Hayward Area Forum of the Arts, Hayward, CA.

The Hirshhorn Collects/Recent Acquisitions, 1992–1996, Hirshhorn Museum and Sculpture Garden, Smithsonian Institution, Washington, DC.

1996

A Labor of Love, New Museum of Contemporary Art, New York, NY.

De Mujer a Mujer: A Celebration of Latinas by Latina Artists, Austin Museum of Art, Austin, TX.

Feast for the Eyes, Austin Museum of Art–Laguna Gloria, Austin, TX.

Legacy/Legado: A Latino Bicentennial Reflection, Old State House, Hartford, CT.

Seventh Annual Children's Book Illustrator Show, Sun Gallery, Hayward Area Forum of the Arts, Hayward, CA.

1995

A Defiant Legacy: 1970–1995, Galería de la Raza, offsite exhibition at Yerba Buena Center for the Arts, San Francisco, CA.

Fables, Fantasies and Everyday Things: Children's Books by Artists, Whitney Museum of American Art at Champion, Stamford, CT.

Facing Eden/100 Years of Landscape Art in the Bay Area, M. H. de Young Memorial Museum, Fine Arts Museums of San Francisco, CA.

Multicultural Children's Literature, San Francisco International Airport, San Francisco, CA.

Paintings and More: A Chicana Perspective, Art Space Gallery, Fresno City College, Fresno, CA.

Que Viva Tu Recuerdo: Altars and Offerings for Days of the Dead, Oakland Museum of California, Oakland.

Shared Stories: Exploring Cultural Diversity, ExhibitsUSA, Mid-America Arts Alliance, Kansas City, MO.

1994

Multicultural Children's Literature, San Francisco International Airport, San Francisco, CA.

Sor Juana Festival: A Tribute to Mexican Women, Mexican Fine Arts Center Museum, Chicago, IL.

Toma Mi Corazón: La Peña Takes Art to Heart, El Taller Gallery and La Peña, Austin, TX.

Under One Sky: Opening Young Minds with Books, Bedford Gallery, Regional Center for the Arts, Walnut Creek, CA.

1993

Art of the Other Mexico, Mexican Fine Arts Center Museum, Chicago, IL; Museo de Arte Moderno, Mexico City; Museo Regional de Oaxaca, Mexico; Centro Cultural Tijuana, Mexico; Palm Springs Desert Museum, Palm Springs, CA; Museo del Barrio, New York, NY; Center for the Fine Arts, San Francisco, CA.

Chicano Art, Jesse Alonso Gallery, Tucson, AZ.

El Sabor: From Tradition to Innovation, Galería de la Raza/Studio 24, San Francisco, CA.

Filler, Terrain Gallery, San Francisco, CA.

Hispanic Perspectives, Patricia Stewart Gallery, Napa, CA.

In Out of the Cold, Center for the Arts at Yerba Buena Gardens, San Francisco, CA.

La Frontera/The Border: Art about the Mexico/United States Border Experience, Centro Cultural de la Raza and Museum of Contemporary Art, San Diego, CA; Centro Cultural Tijuana, Mexico; Tacoma Art Museum, Tacoma, WA; Scottsdale Center for the Arts, Scottsdale, AZ; Neuberger Museum of Art, State University

of New York, Purchase; San Jose Museum of Art, San Jose, CA.

Mission Gráfica: The Spirit of the Community, Center for the Arts at Yerba Buena Gardens, San Francisco, CA.

The Living Room: Contemporary Artists Re-Interpret Function and the Object in the Living Environment, Terrain Gallery, San Francisco, CA.

1992

Directions in Bay Area Printmaking: 3 Decades, Palo Alto Cultural Center, Palo Alto, CA.

Hospitality House 7th Annual Art Auction, Stephen Wirtz Gallery, San Francisco, CA.

La Reina Cósmica, La Peña, Austin, TX.

Latino Art Show, Concannon Vineyard, Livermore, CA.

Lo Mejor de Lo Nuestro, La Peña, Austin, TX.

Master Prints from the Rutgers Center for Innovative Printmaking: The First 5 Years, Gallery at Bristol-Myers Squibb, Princeton, NJ.

The Chicano Codices: Encountering Art of the Americas, Mexican Museum, San Francisco, CA; Foothills Art Center, Golden, CO; University Art Gallery, California State University, Northridge; La Plaza de la Raza, Los Angeles, CA; Centro Cultural de la Raza, San Diego, CA; Centro de la Raza, Seattle, WA.

1991

Art as a Healing Force, Bolinas Museum, Bolinas, CA.

Behind the Scenes: The Collaborative Process, Berkeley Art Center Association, Berkeley, CA.

Crossing Over/Changing Places, Print Club, Philadelphia, PA (traveling).

Her Story: Narrative Art by Contemporary California Artists, Oakland Museum of California, Oakland.

Los Artistas Chicanos del Valle de Tejas: Narradores de Mitos y Tradiciones, Centro Cultural Tijuana, Mexico.

Mujeres, La Peña, Austin, TX.

Presswork: The Art of Women Printmakers, Lang Communications and National Museum of Women in the Arts, Washington, DC (traveling).

Tejanos, UTSA Art Gallery, University of Texas, San Antonio.

1990

Tejanos: 15 Pintores, 3 Escultores: Artistas Mexicano-Norteamericanos, Instituto Nacional de Bellas Artes and Museo de Arte Alvar y Carmen T. de Carrillo Gil, Mexico City.

Body/Culture: Chicano Figuration, University Art Gallery, Sonoma State University, Rohnert Park, CA (traveling).

Chicano Art: Resistance and Affirmation, 1965–1985, Wight Art Gallery, University of California, Los Angeles;

Denver Art Museum, Denver, CO; Albuquerque Museum, Albuquerque, NM; San Francisco Museum of Modern Art, San Francisco, CA; Fresno Art Museum, Fresno, CA; Tucson Museum of Art, Tucson, AZ; Bronx Museum, Bronx, NY; San Antonio Museum of Art, San Antonio, CA.

Days of Saints and Souls: A Celebration of the Days of the Dead, De Pree Art Center and Gallery, Hope College, Holland, MI.

Printed in America, Walters Hall Gallery, Douglass College, Rutgers University, New Brunswick, NJ.

Visible Truths: Traditional Sources within the Chicano Esthetic, Galería Posada, Sacramento, CA.

1989

Affinities, Jamaica Arts Center, Jamaica, NY.

Ancient Rites/New Perspectives: Día de los Muertos, Mexican Museum, San Francisco, CA.

Ceremony of Memory: New Expressions in Spirituality among Contemporary Hispanic Artists, Center for Contemporary Arts, Santa Fe, NM.

Obras en Papel, Mexican Museum, San Francisco, CA.

Places in the Sun, Gumps Gallery, San Francisco, CA.

¡Raza Sí! Student Union Gallery, University of Texas, Austin.

1988

Affinities: Idioms/Aesthetics/Intents, Jamaica Arts Center, Jamaica, NY.

Artists of Texas A&I University, Ben P. Bailey Art Gallery, Texas A&I University, Kingsville.

Cultural Currents, San Diego Museum of Art, San Diego, CA.

Día de los Muertos, Mexican Fine Arts Center Museum, Chicago, IL.

Mano a Mano: Abstraction/Figuration: 16 Mexican-American and Latin American Painters from the San Francisco Bay Area, Art Museum of Santa Cruz and Mary Porter Sesnon Gallery, University of California, Santa Cruz; Oakland Museum of California, Oakland.

Personal Histories, Through the Flower, Benicia, CA.

1987

Artistas México Americanos de San Francisco, California, Salón de Sorteos, Lotería Nacional, Mexico City.

Connections, San Francisco Arts Commission Gallery, San Francisco, CA.

Hispanic Art in the United States: Thirty Contemporary Painters and Sculptors, Museum of Fine Arts, Houston, TX; Corcoran Gallery of Art, Washington, DC; Lowe Art Museum, Miami, FL; Museum of Fine Arts and Museum of New Mexico, Santa Fe; Centro Cultural

de Arte Contemporáneo, Mexico City; Los Angeles County Museum of Art, Los Angeles, CA; Brooklyn Museum, Brooklyn, NY.

Los Animales del Sol, Art Corridor, Sacred Heart Schools, Menlo Park, CA.

1986

Chicano Expressions: A New View in American Art, INTAR Latin American Gallery, New York, NY.

Crossing Borders/Chicano Artists, San Jose Museum of Art, San Jose, CA.

El Barrio: Premier Espacio de la Identidad Cultural, Centro Cultural Tijuana, Mexico.

Lo del Corazón: Heartbeat of a Culture, Mexican Museum, San Francisco, CA (traveling).

Shrines and Altars, John Michael Kohler Arts Center, Sheboygan, WI.

1985

14th Annual Día de los Muertos Exhibition, Galería de la Raza/Studio 24, San Francisco, CA.

Celebration of Bay Area Art: KQED Special Art Auction, Fuller Goldeen Gallery and John Berggruen Gallery, San Francisco, CA.

¡Mira! The Canadian Club Hispanic Art Tour, Museo del Barrio, New York, NY (traveling).

Reliquaries, Niches and Shrines: A Day of the Dead Exhibition, Mexican Museum, San Francisco, CA.

Women by Women, Galería de la Raza/Studio 24, San Francisco.

1984

Alter Ego, de Saisset Museum, Santa Clara University, Santa Clara, CA.

Heritage of the New Chicano, Olive Hyde Art Gallery, Fremont, CA.

Ofrendas: René Yáñez, Carmen Lomas Garza, Armando Cid, Amalia Mesa-Bains, Galería Posada, Sacramento, CA.

1983

A Través de la Frontera, Centro de Estudios Económicos y Sociales del Tercer Mundo, Mexico City (traveling).

Personal Reflections: Masks by Chicano and Native American Artists in California, Galería Posada, Sacramento, CA.

Prints 1/500: International Printmaking Invitational, Art Gallery, California State College, San Bernardino.

Spectrum: A View of Mexican American Art, Mexican Museum, San Francisco, CA.

1982

Art, Religion, Spirituality, Helen Euphrat Art Gallery, De Anza College, Cupertino, CA.

Cajas y Otras Cosas, Galería de la Raza/Studio 24, San Francisco, CA.

California Bay Area Contemporary Prints, Francis McCray Gallery, Western New Mexico University, Silver City.

Hispanics USA, Ralph Winston Gallery, Lehigh University, Bethlehem, PA.

II Bienal del Grabado de América, Museo Municipal, Maracaibo, Venezuela.

1981

Califas, Mary Porter Sesnon Art Gallery, University of California, Santa Cruz.

Quinta Bienal de San Juan del Grabado Latinoamericano, Instituto de Cultura Puertorriqueña, San Juan, Puerto Rico.

Staying Visible: The Importance of Archives, Helen Euphrat Art Gallery, De Anza College, Cupertino, CA.

Texas Women: A Celebration of History, Texas Foundation for Women's Resources, Austin.

1980

Cinco de Mayo Exhibition, The Cannery, San Francisco, CA.

Fifth Anniversary Exhibit: Los Primeros Cinco Años, Mexican Museum, San Francisco, CA.

Joan Mondale Selections for 1980–81, home of Vice President Walter Mondale, Washington, DC; National Museum of American Art, Smithsonian Institution, Washington, DC.

Mosaic: A Multicultural Art Exhibition, Memorial Union Art Gallery, University of California, Davis.

Self Portraits, Galería de la Raza/Studio 24, San Francisco, CA (curated by Carmen Lomas Garza).

1979

8 Artistas de San Francisco: Paintings and Graphics, Ruben Salazar Library, Sonoma State University, Rohnert Park, CA.

Fire! An Exhibition of 100 Texas Artists, Contemporary Arts Museum, Houston, TX.

Regalos III: Gifts and Acquisitions, Mexican Museum, San Francisco, CA.

¡Que Te Vaya Pretty Nice! Xochil Art and Culture Center, Mission, TX.

1978

Canto al Pueblo: Dále Gas, Corpus Christi State University, Corpus Christi, TX.

Homenaje a Frida Kahlo: Día de los Muertos, Galería de la Raza/Studio 24, San Francisco, CA (curated by Carmen Lomas Garza).

Reflexiones: A Chicano-Latino Art Exhibit, Centro Cultural de la Raza, San Diego, CA.

1977

Ancient Roots/New Visions, Tucson Museum of Art, Tucson, AZ (traveling).

Bay Area Chicano Artists, Fair Oaks Community Center, Redwood City, CA.

Chicanas de Tejas, Chicano Art Gallery, Association for the Advancement of Mexican Americans Art Center, Houston, TX.

Dále Gas: Chicano Art of Texas, Contemporary Arts Museum, Houston, TX.

World Print Competition, 1977, San Francisco Museum of Modern Art, San Francisco, CA (traveling).

1976

2001: A Group Exhibit of Mixed Media, Galería de la Raza, San Francisco, CA.

A Chicana Art Show, Chicana Research and Learning Center, Austin, TX.

Día de los Muertos, Galería de la Raza, San Francisco, CA.

Graduate Student Exhibitions: Dos Pipis y una Panocha, Fine Arts Center, Washington State University, Pullman.

Other Sources: An American Essay, San Francisco Art Institute, San Francisco, CA.

Tejano Artists in Bicentennial America, Electric Tower Display Gallery, Houston Lighting and Power Company, and the Association for the Advancement of Mexican Americans Art Center, Houston, TX (traveling).

1975

Benefit and Art Auction Honoring Amado Peña III, Austin, TX.

Dieciséis de Septiembre, Estudios Rio Gallery, Mission, TX; McAllen Memorial Library, McAllen, TX.

Los Quemados: Artistas Chicanos, Instituto Chicano-TIED and Instituto Cultural Mexicano, San Antonio, TX; La Casa Chicana, Southern Methodist University, Dallas, TX.

May Day Exhibition, Estudios Rio Gallery, Mission, TX.

Valentine Exhibit, Estudios Rio Gallery, Mission, TX.

1974

Celebration Seventy-four, Galería de la Raza, San Antonio, TX.

Christmas Collection, Estudios Rio Gallery, Mission, TX.

1972

Raíces y Retoño: An Exhibition of Pre-Columbian and Contemporary Chicano Art, Juárez-Lincoln Center, St. Edward's University, Austin, TX.

South Texas Artists, University of Texas–Pan American Art Gallery, Edinburg.

1971

Chicano Artists of Texas, Fort Worth National Bank, Fort Worth, TX.

1969

Chicano Art from Texas A&I University, Mexican American Youth Organization (MAYO), First Annual Conference, La Lomita Mission, Mission, TX.

Carmen Lomas Garza, *Día de los Muertos/Ofrenda para Antonio Lomas*, 1989. Black paper cutout, 58 × 102 inches (ten sheets, each 22 × 30 inches). Artist's collection.

Photograph by Wolfgang Dietze.

BIBLIOGRAPHY

ARTICLES, CHAPTERS, AND BOOKS

Acosta, Belinda B. "'The Best of Ours' on Display: Art Exhibit Celebrates Hispanic Art." *Austin American-Statesman*, May 30, 1992, 13.

Alarcón, Francisco. "El Museo Mexicano—Quinto Aniversario." *El Tecolote* (San Francisco) 11, no. 4 (December 1980): 7.

Alba, Victoria. "Artists with a Mission." *Image Magazine* (*San Francisco Examiner*) May 20, 1990, 22–31.

Albright, Thomas. "Photographs That Go 'Tilt.'" *San Francisco Chronicle*, April 23, 1980, 64.

"Altars to the Past." *San Diego Union*, December 10, 1989, E1.

Andrade, Sally J. "Painting a Different Picture." *Washington Post*, December 17, 1995, G7.

Anzaldúa, Gloria. "Chicana Artists: Exploring Nepantla, el Lugar de la Frontera." In *Making Sense: Essays on Art, Science, and Culture*, edited by Robert L. Coleman, Rebecca Brittenham, Scott Campbell, and Stephanie Girard, 55–69. Boston: Houghton Mifflin, 1999.

Army, Mary Montaño. "El Arte: Show Catapults Hispanic to Forefront." *New Mexico Magazine*, July 1988, 37–43.

"Arte: Carmen Lomas Garza." *Magazín* (San Antonio, TX) 1, no. 9 (1973): 57–61.

"Art Exhibit This Month." *Upper Valley Progress* (Mission, TX), September 11, 1975, 7.

Auer, James. "Art Is Ideas, Sheboygan Show Has Lots of Them." *Milwaukee Journal*, May 4, 1986, Entertainment sec., 12.

"Avanzando." *Hispanic* 10, no. 11 (November 1997): 90.

Baker, Kenneth. "Everyday Miracles in Mexican Museum Show." *San Francisco Chronicle*, December 26, 1987, C3.

———. "Terminal's Art Has Its Ups and Downs: Some Works Stand Out in Airport's Huge Space." *San Francisco Chronicle*, July 27, 2000, E1.

"Bank of America Introduces Bilingual Check Series." *Business Wire*, September 17, 1990, K7.

Bejarano, William. "Utah Chicano Forum." *Chismearte* (Los Angeles) 1, no. 1 (Fall 1976): 9–10.

Benjamin, Marc. "Author Urges Children to Have Pride in Culture." *Bakersfield Californian*, March 31, 1992, B4.

Benson, Heidi. "San Jose Museum's Landauer Loves 'The Hunt.'" *San Francisco Chronicle*, April 15, 2001, 38.

"Best Exhibits." *San Francisco Examiner*, December 26, 1993, D6.

Bonetti, David. "Eureka Exhibition Much Improved: Terrific Show of Award Winners in San Jose." *San Francisco Chronicle*, February 1, 2001, E2.

———. "The Hispanic Vision." *San Francisco Examiner*, October 2, 1989, C1.

———. "Welcome Scenes of Everyday Life: Universal Appeal in Chicana Experience." *San Francisco Examiner*, January 14, 1993, C3.

Brazil, Eric. "Bilingual Checks 1st in State." *San Francisco Examiner*, September 17, 1990, A1.

Brown, Betty Ann. "A Community's Self-Portrait." *New Art Examiner* 18 (December 1990): 20–24.

Bruno, Christopher. "Altars Pay Homage to What America Holds Sacrosanct." *Santa Clara* (Santa Clara, CA), April 12, 1984, 15.

Burke, Lynne T. "Chicano Pride and Anger Mix at 'Califas.'" *San Jose Mercury News*, April 12, 1981, The Tab, 34.

———. "Exploring the Hispanic Experience." *Minnesota Parent*, May 1992, 28–29.

———. "Joan Mondale Art Previews in S.F." *San Jose Mercury News*, March 17, 1980, C4.

———. "The Political and the Personal Meet in Latino Art." *San Jose Mercury News*, August 1, 1986, D1.

———. "Portraits of a Culture: Hispanic Artists Make Presence Known in Show." *San Jose Mercury News*, May 6, 1988, E1.

Burnett, Ginny Garrard. "Art and Chicanismo." *Texas Observer*, May 29, 1987, 28–29.

Bustos, Roxann. Review of "Homenaje a Tenochtitlan: An Installation for the Day of the Dead." *Library Journal* 122, no. 20 (December 1997): 170.

Cárdenas de Dwyer, Carlota, ed. *Chicano Voices*. Boston: Houghton Mifflin, 1975.

Cardona, Patricia. "Gana adeptos de Museo Mexicano de San Francisco: Pedro Rodriquez." *Uno Mas Uno* (Mexico City), February 6, 1978, 18.

"Carmen Lomas Garza at the Hirshhorn Museum." *KOAN: Ken Oda's Art Newsletter* (Washington, DC) 4, no. 4 (December 1995): 20.

"The Carmen Lomas Garza Exhibit." *Conner Museum: CM* (Kingsville, TX) 17, no. 17 (Spring 1992): 1.

Carroll, Colleen. *How Artists See Families: Mother, Father, Sister, Brother*. New York: Abbeville Press, 1997.

Chapa, Evey, and Sally Andrade, eds. *La Mujer Chicana: An Annotated Bibliography*. Austin: Chicana Research and Learning Center, 1976.

Chaplik, Dorothy. "Carmen Lomas Garza: The Mexican Fine Arts Center Museum." *Latin American Art* 4, no. 3 (Fall 1992): 89.

Chattopadhyay, Collette. "Storytelling Carmen Lomas Garza: *Pedacito de mi Corazón* at Loyola Marymount University." *Artweek* 23, no. 30 (December 1992), front and back covers.

Cheng, Scarlet. "A Traveling Trove of Latino Riches: Show Pulls Together Pieces that Span Miles, Centuries." *Los Angeles Times*, May 5, 2002, F11.

Christensen, Judith. "Disparate Influences, Shared Attitudes." *Artweek* 19, no. 27 (August 1988): 8.

Clark, William. "Collection of Works Depicts Hispanic Spiritual Ceremonies." *Albuquerque Journal*, July 7, 1989, C1.

———. "National Hispanic Show a 'Dazzler.'" *Albuquerque Journal*, July 29, 1988, C1.

Cohn, Terri. "Stories of an Unspoiled World." *Artweek* 19, no. 2 (January 1988): 5.

Coronado, Teresa. "She Belongs to Texas." *La Prensa* (Austin), September 8, 1989, 2.

Cortez, Constance. "Carmen Lomas-Garza." In *The Oxford Encyclopedia of Latinos and Latinas in the United States*, vol. 3, edited by Suzanne Oboler and Deena J. González, 7–9. New York: Oxford University Press, 2005.

Cotter, Holland. "Carmen Lomas Garza." *New York Times*, July 28, 1995, C21.

Cottingham, Laura C. "Post '68: The Aesthetic Legacies of Black Power, Women's Liberation, and Gay Rights in American Art." *Flash Art* 174 (January–February 1994): 31–34.

Coyatzin, Moyo. "Mano a Mano." *Prelude Magazine* (Carmel-by-the-Sea, CA), April 1988, front cover, 44–45.

Crohn, Jennifer. "What's the Alternative?" *East Bay Guardian* (San Francisco), March 1991, 41.

Crossley, Mimi. "Art: 'Chicanas de Tejas.'" *Houston Post*, March 18, 1977, C3.

———. "Art: 'Tejano Artists.'" *Houston Post*, August 19, 1976, BB7.

———. "Tejano Artists at Houston Lighting & Power Company Exhibit." *Art in America* 65, no. 3 (May–June 1977): 121.

Davalos, Karen Mary. *Exhibiting Mestizaje: Mexican (American) Museums in the Diaspora*. Albuquerque: University of New Mexico Press, 2001.

Davis, Jim. "Memories of Home: Art by Kingsville Native Reflects Chicano Life in South Texas." *Corpus Christi Caller-Times*, November 8, 1991, E6.

Day, Frances Ann. "Carmen Lomas Garza." In *Multicultural Voices in Contemporary Literature: A Resource for Teachers*, 63–64. Portsmouth, NH: Heinemann, 1994.

De Uriarte, Miriam. "Art in Her Heart." *Express* (Berkeley, CA) 15, no. 17 (February 1993): 26–27.

Dingmann, Tracy. "Universal Experience: Paintings of Mexican-American Event Accessible to Wider Audience." *Albuquerque Journal*, April 21, 2002, F1.

"Las direcciones de Carmen Lomas Garza." *Washington Hispanic*, December 1, 1995, 12.

Donohoe, Victoria. "Female Painters, USArtists Benefit Part of Area Exhibits." *Philadelphia Inquirer*, October 12, 2003, L3.

Easton, Jennifer. "Carmen Lomas Garza." In *Interventions and Provocations: Conversations on Art, Culture, and Resistance*, edited by Glenn Harper, 65–76. Albany: State University of New York Press, 1998. Originally published in *Art Papers* 18, no. 3 (May–June 1994): 2–6.

Ennis, Michael. "Arte Magnifico." *Dossier Magazine* (Washington, DC), October 1987, 58.

"Exhibit Features 8 Artists' Work." *Monitor* (McAllen, TX), February 16, 1975, E7.

Farley-Villalobos, Robbie. "Artist's Political Struggle Opens Museum." *El Paso Herald-Post*, December 19, 1991, 3.

———. "Museum President Embarrassed: 'Personal' Survey Shows Public Doesn't Like Current Exhibit." *El Paso Herald-Post*, January 25, 1992, 1.

Ferriss, Susan. "Conquistadors' Progeny Mourn Rape of a Culture: Mexican Museum Exhibitors Recall Tenochtitlan." *San Francisco Examiner*, October 12, 1992, A6.

Fischer, Jack. "Barrio Paintings Mix Nostalgia with Politics: Her Style Appears Naïve, But Its Impact Is Sophisticated." *San Jose Mercury News*, January 2001, E6.

"Five Styles of Chicano Art." *El Grito* (Berkeley, CA) 6, no. 1 (1972): 92.

Flores, Lauro. *The Floating Borderlands: Twenty-five Years of U.S. Hispanic Literature*. Seattle: University of Washington Press, 1998.

Fowler, Carol. "Washington a Capital of Art, Too." *Contra Costa Times* (Walnut Creek, CA), December 17, 1995, TR3.

Frankenstein, Alfred. "An Interesting Ride into the Art of the Third World." *San Francisco Chronicle*, September 26, 1976, 37.

———. "Monotypes and Brilliant Colors." *San Francisco Chronicle*, August 4, 1977, 39.

Freudenheim, Susan. "Ethnic Variety Flows in 'Cultural Currents.'" *San Diego Tribune*, July 27, 1988, D1.

Funk, Kathryn. *Personal Histories*. Benicia, CA: Through the Flower, 1988.

"Garza Brings 'Pedacito De Mi Corazon' Home." *Bulletin: A Newspaper for the Faculty and Staff of Texas A&I University* 2, no. 8 (February 1992): 4.

"Garza, Carmen Lomas." *Book Links*, March 1993, 53.

Garza, Carmen Lomas. "Arte." *Magazín* (San Antonio, TX) 1, no. 9, 57–61.

———. "Altares: Arte Espiritual del Hogar." *Hojas: A Chicano Journal of Education* (Juárez-Lincoln University, Austin), 1976, 105–11.

———. "A Critical Agenda for the 1990s: Hopes and Fears." In *Worlds in Collision: Dialogues on Multicultural Art Issues*, edited by Carlos Villa and Regan Louie Villa, 218–21. San Francisco: International Scholars Publications, 1994.

———. "Earache Treatment." *Harper's Magazine*, September 1994, 35.

———. "Entrevista con Carmen Lomas Garza." By Olivia Evey Chapa. *Tejidos: A Bilingual Journal for the Stimulation of Chicano Creativity and Criticism* 3, no. 4 (Winter 1976): front cover, 3, 4, 9, 13, 18, 22–45.

———. *Family Pictures/Cuadros de familia*. San Francisco: Children's Book Press, 1990.

———. *In My Family/En mi familia*. San Francisco: Children's Book Press, 1996.

———. "Interview: Carmen Lomas Garza." By Jennifer Easton. *Art Papers* (Atlanta) 18, no. 3 (May/June 1994): 2–6.

———. "An Interview with Carmen Lomas Garza." By Susan Gwynne. *In the Galleries*, KPFA radio, March 2, 1993.

———. *Magic Windows/Ventanas mágicas*. San Francisco: Children's Book Press, 1999.

———. *Making Magic Windows: Creating Papel Picado/ Cut-Paper Art with Carmen Lomas Garza*. San Francisco: Children's Book Press, 1999.

———. "Oral History Interview with Carmen Lomas Garza." By Paul J. Karlstrom. San Francisco, April 10–May 27, 1997. Transcript, Smithsonian Archives of American Art, Washington, DC, http://www .aaa.si.edu/collections/oralhistories/transcripts/ Garza97.htm.

———. *Papel Picado/Paper Cutout Techniques*. Mesa, AZ: Xicanindio Arts Coalition, 1984.

———. "Sandía/Watermelon." *Harper's Magazine*, September 1987, 30.

———. "Table Llena." *Tecolote Literary Magazine* (San Francisco) 11, no. 10 (July 1981): 5.

———. "Taking from the Past, Adjusting It and Creating New: An Interview with Carmen Lomas Garza." By Paul J. Karlstrom. *Archives of American Art Journal* 42, no. 3–4 (2002): 27–47.

Garza, Carmen Lomas, and Amalia Mesa-Bains. *A Piece of My Heart/Pedacito de mi corazón: The Art of Carmen Lomas Garza*. New York: New Press, 1994.

Garza de Cortes, Oralia. Review of "Magic Windows/ Ventanas Mágicas." *Austin American-Statesman*, November 7, 1999, K7.

Garza, Mary Jane. "Carmen Lomas Garza Becomes First Chicana to Exhibit at the Smithsonian." *La Peña Newsletter: Latino Arts in Austin*, December 1995– January 1996, 3.

———. "Healing Spirits: The Growing Acceptance of Alternative Medicine Enhances the Popularity of Curanderismo." *Hispanic Magazine*, June 1998, 32.

Gaspar de Alba, Alicia. *Chicano Art Inside/Outside the Master's House: Cultural Politics and the CARA Exhibition*. Austin: University of Texas Press, 1998.

George, Ron. "Art Grad Garza Returns to A&I in Triumph." *Corpus Christi Caller-Times*, February 14, 1992, F10.

Gibson, Christopher. "Papel Picado: Three Artists Help Revive Hispanic Ephemeral Arts." *Tradición Revista: Journal of Contemporary & Traditional Spanish Colonial Art & Culture* 7, no. 3 (Fall 2002): 24–28.

Glasscock, Sarah. *American Communities across Time/ Communities across America Today*. Washington, DC: National Geographic Reading Expeditions, 2001.

Goddard, Dan R. "Art Center's Visions Reflect City's Makeup." *San Antonio Express-News*, November 18, 1998, G12.

———. "S. A. Artist Opens 'Historic' Corpus Christi Exhibit." *San Antonio Express-News*, October 8, 1998, F4.

Goldman, Shifra M. "Califas en Santa Cruz, Primera Parte." *La Opinión* (Los Angeles), January 31, 1982, 8.

———. "Califas en Santa Cruz, Segunda Parte." *La Opinión* (Los Angeles), February 7, 1982, 8.

———. "Homogenizing Hispanic Art." *New Art Examiner* 15, no. 1–6 (September 1987): 30–33.

———. "Supervivencia y prosperidad del arte chicano en Texas: Nueva revisión." *Comunidad* (*La Opinión*, Los

Angeles) September 1980, 3. Reprinted as "Chicano Art Alive and Well in Texas: A 1981 Update." *Revista Chicano-Riqueña* 9, no. 1 (Winter 1981): 34–40.

Goldman, Shifra M., and Tomás Ybarra-Frausto. *Arte Chicano: A Comprehensive Annotated Bibliography of Chicano Art, 1965–81.* Berkeley: Chicano Studies Library Publications Unit, University of California, 1985.

———. "Mujeres de California: Latin American Women Artists." In *Yesterday and Tomorrow: California Women Artists,* edited by Sylvia Moore, 202–27. New York: Midmarch Arts Press, 1989.

Golonu, Berin. "Conversations with the Leaders of Latino Arts Organizations in the Bay Area." *Artweek* 34, no. 3 (April 2003): 13–14.

———. "Dispatches: San Francisco International Airport." *Sculpture* 20, no. 4 (May 2001): 76–78.

Goodwin, Ben. "Alice Artist's Memory of a Vision Is on Display at A&I." *Corpus Christi Caller-Times,* March 5, 1992, B2.

Gordon, Allan M. "A Mosaic of Cultures and Forms." *Artweek* 11, no. 4 (February 1980), 6.

Graham, Henry. "The Bandera Expressway." *Eagle Bone Whistle* (San Antonio, TX) 1, no. 11 (Pisces, 1971): 3.

"A Grand Hispanic Art Show." *Vista* (*Corpus Christi Caller-Times*), April 5, 1987, 20–21.

Guerra-Garza, Victor, ed. "Semillas: Carmen Lomas Garza." *Hojas: A Chicano Journal of Education* (Juárez-Lincoln University, Austin), 1976, 47–51.

Guest, E. "Bay City Best: Top Picks for the Coming Week." *San Francisco Examiner Magazine,* August 7, 1994, 12.

Hedges, Elaine, and Ingrid Wendt. *In Her Own Image: Women Working in the Arts.* Old Westbury, NY: Feminist Press, 1980.

Heller, Nancy. *Women Artists: An Illustrated History.* New York: Abbeville Press, 1997.

Hess, Elizabeth. "Affinity Group." *Village Voice,* December 27, 1988, 100.

Heyes, Eileen. "An Oasis of Their Own." *Los Angeles Times,* July 29, 1990, BR8.

"Hirshhorn inaugura muestra de artista chicana." *La Nación* (Buenos Aires), November 17, 1995, B1.

"Hispanic Art in the United States." *Art in America* 1988, 49.

Hispanic Magazine. "1995 VIDA Award Recipients." *Hispanic Magazine* 8, no. 5 (July 1995): 30.

Holg, Garrett. "Ancient and Modern Mexico Come Together in Exhibit." *Chicago Sun-Times,* August 22, 1993, 8.

Horiuchi, Katsuaki. "Chikano no sekatsu o egaky Carmen Lomas Garza/Carmen Lomas Garza Who Depicts the Life of Chicanos." Publication and radio interview. *NHK Radio Spain-go Koza/NHK Radio Spanish Course,* American-no Hispanic to Spain-go/American Hispanics and Their Spanish Language, 78–83.

Hurley, Anne. "Galería de la Raza Turns 20." *San Francisco Bay Guardian,* August 29, 1990, 47.

Johnstone, Mark, and Leslie Aboud Holzman. *Epicenter: San Francisco Bay Area Art Now.* San Francisco: Chronicle Books, 2002.

Jones, Joyce. "All in the Familia." *Washington Post,* December 8, 1995, 57.

Kutner, Janet. "Art with Roots: Unusual Elements Convey Artists' Spiritual and Hispanic Heritage." *Dallas Morning News,* February 17, 1990, C1.

Lazo, Luz. "A Burst of Color and Pride: Carmen Lomas Garza's Artwork Celebrates Her Family's Mexican Culture." *Washington Post,* January 7, 2004, C14.

Lewis, Valerie. "A Celebration of Family." *San Francisco Chronicle,* July 29, 1990, 9.

"Library Tea Set Today." *Kingsville (TX) Record,* October 1993, 1.

"Lifebeat of a Culture: Artist Paints Positive Side of the American Chicano." *Corpus Christi Caller-Times,* October 12, 2001, E14.

Lippard, Lucy R. *Mixed Blessings: New Art in a Multicultural America.* New York: Pantheon Books, 1990.

———. "Report from Houston: Texas Red Hots." *Art in America* 67, no. 1–4 (July–August 1979): 30–31.

"Local Artist Honored." *Kingsville (TX) Record,* March 24, 1991, A8.

Lomelí, Francisco. *Handbook of Hispanic Cultures in the United States: Literature and Art.* Houston: Arte Público, 1993.

Longoria, Arturo, with Aida Barrera. "Los Tejanos: The Mexican Texans, When . . . Where. . . How." *Texas Highways* 40, no. 9 (September 1993): 53.

Lowe, Charlotte. "Chicano Art Shares Strong Heartbeat." *Tucson Citizen,* February 4, 1993, Calendar sec., 11.

Maclay, Catherine. "New World, New Gallery, New Visions." *San Jose Mercury News,* October 22, 1993, 59.

———. "Windows on the World She Left Behind." *San Jose Mercury News,* January 15, 1993, 45.

Manaster, Jane. Review of "In My Family/En Mi Família." *Austin American-Statesman,* September 1, 1996, D9.

Marquis, Anne-Louise. "Carmen Lomas Garza: Hirshhorn Exhibition Features Work by Mexican American Artist." *Smithsonian* 1, no. 2 (Fall/Winter 1995): 4–5.

"The Marvelous, The Real/Lo Real Maravilloso." *Cambio* (San Francisco), January 1988, 14–15.

Matthews, Lydia. "Stories History Didn't Tell Us." *Artweek*, February 14, 1991, 1, 15–17, 22.

McBride, Elizabeth. "Hispanic Art in the United States." *Artspace: Southwestern Contemporary Arts Quarterly* 2, no. 4 (Fall 1987): 30–34.

McCombie, Mel. "Hispanic Art in the United States." *ARTnews* 86 (September 1987): 156.

———. "Hispanic Exhibition Illustrates Culture, Artistic Power." *Austin American-Statesman*, May 7, 1987, G3.

———. "Surveying the Range." *Artweek* 18, no. 22 (June 1987): 9.

McCoy, Martha. "Art for Democracy's Sake." *Public Art Review*, no. 17 (Fall/Winter 1997): 4–9.

Medley, Yvonne J. "Cutting Up with Carmen." *Washington Times*, January 18, 1996, M3.

Meek, Sharon. "Making Memories, Monitos Style." *School Arts* 94, no. 8 (April 1995): 26–27.

Mejias-Rentas, Antonio. "Art at Last." *Hispanic Link Weekly Report* 13, no. 45 (November 13, 1995): 8.

———. "Piercing Images of Life." *Hispanic*, April 1988, 34–41.

Mesa-Bains, Amalia. "Contemporary Chicano & Latino Art." *Visions Art Magazine* (Los Angeles), September 1989.

"Mexican-American Art Exhibition Opens." *Kingsville (TX) Record*, November 1995, B2.

Milanese, Anna Marisa. "In Question: Carmen Lomas Garza." *Silicon Valley* (*San Jose Mercury News*), October 15, 2000, 4.

Miller, Lauraine. "Drawing on the Past to Make an Impression: 'Chicana' Artist Seeks to Root Out Bias." *Houston Chronicle*, March 15, 1992, D1.

Moore, Sylvia, ed. *Yesterday and Tomorrow: California Women Artists*. New York: Middlemarch Arts Press, 1989.

Moreno, Jose Adan. "Carmen Lomas Garza: Traditional & Untraditional." *Caminos* (Los Angeles) 5, no. 10 (November 1984): 44–45, 53.

Moser, Charlotte. "Barrio to Museum." *Houston Chronicle*, August 21, 1977, 15.

Moure, Nancy Dustin Wall. *California Art: 450 Years of Painting and Other Media*, 473–74. Los Angeles: Dustin Publications, 1998.

Moya, Henry. "El Arte del Otro México." *La Raza* (Los Angeles) 1, no. 2 (September 1993): 12–13.

"New Show at Estudios Rio." *Valley Town Crier* (McAllen, TX), October 25, 1972, 18.

Noriega, Chon A. "Art Official Histories." *Aztlán* 23, no. 1 (Spring 1998): 1–12.

"Noted Artist Exhibits Here." *Kingsville (TX) Record*, February 1992, A5.

Oleson, J. R. "Gallery Space Fits La Peña." *Austin American-Statesman*, June 6, 1992, 13–14.

———. "Lomas Garza Tells Own Stories." *Austin American-Statesman*, November 9, 1991, 13.

Oliva-Hennelly, Maria. "Libro cuenta algunas creencias tradicionales de la gente hispana." *Santa Fe New Mexican*, December 29, 1997, A10.

Ollman, Leah. "Artists Build Shrines to Personal and Cultural Pasts." *Los Angeles Times* (San Diego County edition), December 14, 1989, 1, 11.

———. "'Cultural Currents' Sends Message about American Art." *Los Angeles Times*, San Diego County edition, July 11, 1988, 1, 7.

"La onda artística de Carmen Lomas Garza." *Magazín* (San Antonio, TX) 1, no. 2 (November 1971): 29–36.

Peterson, Keri. "Former A&I Student Returns for Art Exhibit." *South Texan* (San Antonio) 67, no. 17 (February 1992): 1, 5.

Pierce, P. J. *"Let Me Tell You What I've Learned": Texas Wisewomen Speak*. Includes an interview with Garza. Austin: University of Texas Press, 2002.

Pincus, Robert L. "Museum of Art Exhibit Is an Ethnic Mix." *San Diego Union*, July 21, 1988, D1.

Pinedo, María. "Día de los Muertos." *San Francisco Odalisque*, November 23–December 15, 1976, 13.

Pritiken, Renny, and René de Guzman. "In Out of the Cold." *Performing Arts* (Yerba Buena Center for the Arts) 6, no. 10 (October 1993): 4–6.

"Profile." *Intercambios Femeniles: The National Network of Hispanic Women* 2, no. 2 (Spring/Summer 1984): 7.

Pulkka, Wesley. "Painter Connects with Culture through Art." *Albuquerque Journal*, April 1995, G3.

Quirarte, Jacinto. "New Show Overlooks Hispanic Artists' Roots." *Santa Fe Reporter*, August 3, 1988, 21–22.

Ramirez, Jesus. "Colegio Jacinto Treviño." *La Voz Chicana* (San Juan, TX) 2, no. 13, (1970): 1, 6.

"Recortes." *Vista en L.A.* 1, 3, no. 4 (July 1995): 5.

Richard, Paul. "The Colors of Struggle: The Politicized Palette of 'Chicano Art.'" *Washington Post*, May 10, 1992, G1.

———. "Tejana Nostalgia: Lomas Garza's Colorful, Festive Barrio Lacks Bitter Realities." *Washington Post*, December 3, 1995, G5.

Richbourg, Diane. "Paint by Memory: Artist Gains Success Painting Images from Youth in Kingsville." *Corpus Christi Caller-Times*, November 25, 1995, E7.

Rindfleisch, Jan, ed. *Art, Religion, Spirituality*. Cupertino, CA: Foothill–De Anza Community College, 1982.

————. *Faces in the Greater San Francisco Bay Area, 1984.* Cupertino, CA: Foothill–De Anza Community College, 1984.

————. *Staying Visible: The Importance of Archives.* Cupertino, CA: Foothill–De Anza Community College, 1981.

Rockstroh, Dennis. "Modern Artists Give Visualization to Chicano Roots." *San Jose Mercury News*, December 12, 1984, Weekly part 2.

Rodríguez y Rodríguez, Jesús. *Artistas México Americanos de San Francisco, California.* Mexico City: Lotería Nacional para la Asistencia Publica, 1987.

Rubinstein, Charlotte Streifer. *American Women Artists: From Early Indian Times to the Present.* New York: Avon Books, 1982.

Salas, Abel. "Ofrenda de Arte: Carmen Lomas Garza Expresses Her Love of Culture through Her Artwork." *Hispanic* 11, no. 12 (December 1998): 32–33.

Saldívar, José David. *Border Matters: Remapping American Cultural Studies.* Berkeley: University of California Press, 1997.

"San Antonio Site for National Symposium on Mexican American Art." *Chicano Times* (San Antonio, TX) 4, no. 30 (November 1973): 5.

Sánchez Fonseca, Marcela. "Color y composición en la obra de Carmen Lomas Garza: Artista detalla tradiciones y culturas latinas en el Hirshhorn." *El Tiempo Latino* (Washington, DC) 6, no. 3 (January 19, 1996): B1.

Sandoval, Ricardo. "B of A Introduces Bilingual Checks." *Orange County (CA) Register*, September 17, 1990, E1.

Santiago, Chiori. "In Memory's Abode." *Museum of California Magazine* (Oakland Museum of California) 17, no. 1 (Winter 1993): front inside cover, 4–7.

————. "Mano a Mano: We Have Come to Excel." *Museum of California Magazine* (Oakland Museum of California) 12, no. 5 (March/April 1989): 8–13, back cover.

————. "The Mexican Museum." *Latin American Art* 2, no. 4 (Fall 1990): 95–98.

————. "Se Renueva el Museo Mexicano." *MAS* (New York), November/December 1991, 98.

Santos-Garza, Venessa. "Art Museum's Family Fun Day Entertains Hundreds: Artist Garza Happy to See All Ages Enjoying Her Works." *Corpus Christi Caller-Times*, October 15, 2000, B1.

"Scenes from Su Vida, Triunfos/Successes." *Latin Magazine* (Chicago), Fall 1996, 10.

Seidler, Lucian. "Artists of the Mission." *Nob Hill Gazette* (San Francisco), October 1981, 12–13, 17.

Shaw-Eagle, Joanna. "Rich Heritage Fills Joyful Pictures from Childhood." *Washington Times*, December 17, 1995, D1.

Silva, Elda. "Artists Explore Role of Paper." *San Antonio Express-News*, May 5, 2000, F1.

————. "Child's Eye View: Illustrations Reflect Hispanic Family Life." *San Antonio Express-News*, October 8, 1996, D1.

————. "Curing 'Cultural Myopia': Con Safo Group Helped Bring Chicano Artists' Work into Wider View." *San Antonio Express-News*, August 23, 1998, H1.

————. "Family Pictures: Artist Shares Vivid Gift of Remembrance of La Familia." *San Antonio Express-News*, May 27, 2001, H1.

Silverman, Andrea. "¡MIRA! El Museo del Barrio." *ARTnews* 85, no. 5 (May 1986): 136–37.

Simmons, Jeff. "Artist, Activist, Educator: Carmen Lomas Garza in Profile." *Hispanic Outlook in Higher Education* 10, no. 23 (August 11, 2000): 13.

Smith, Craig. "El arte de los 'monitos.'" *Santa Fe New Mexican*, May 27, 2002, B8.

————. "Painted from Memory." *Santa Fe New Mexican*, May 24, 2002, 55.

"Smithsonian Highlights." *Smithsonian* 26, no. 9 (December 1995): 34.

Snow, K. Mitchell. "Carmen Lomas Garza: Hirshhorn Museum." *ArtNexus* 20 (April–June 1996): 124–25.

Snow, Shauna. "Deep in the Heart of Chicana Art." *Los Angeles Times*, November 7, 1992, F1.

Somlo, Patty. "Under the Hispanic Umbrella." *San Francisco Sunday Examiner and Chronicle*, January 10, 1988, 7.

Sorrell, Victor Alejandro. "Citings from a Brave New World: The Art of the Other Mexico." *New Art Examiner*, May 1994, 28–32, 56–57.

Sperling Cockroft, Eva. "Chicano Identities." *Art in America* 80, no. 6 (June 1992): 85–93.

Stanush, Barbara. "Only in Wild Horse Desert Would You Find King Ranch." *San Antonio Express-News*, May 2, 1992, ED2.

"State of the Art: A Piece of My Heart/Pedacito de mi Corazon." *Texas Monthly* 22, no. 6 (June 1994): 80.

Stutzin, Leo. "Pieces of a Huge Heart." *Modesto (CA) Bee*, March 7, 1993, F9.

Sussman, M. Hal. "Hispanic Art in the United States." *Southwest Art* 16, no. 12 (May 1987): 83–86.

Szilagyi, Pete. "Art from the Heart: Carmen Lomas Garza's Work Depicts Childhood Memories." *Austin American-Statesman*, October 26, 1991, 1.

Tamblyn, Christine. "Women Recording Themselves." *Artweek* 19, no. 15 (April 1988): 5.

Tanguma, Leo. "¡Mira!" *La Voz Hispana de Colorado*, no. 6 (February 4, 1987): 12.

Tanner, Marcia. "Expressions of Culture: Shows Explore Latin, Black Experience." *San Francisco Chronicle*, February 21, 1993, Datebook 54.

Tibol, Raquel. "La exposición chicana en el MAM." *Proceso* (Mexico City), November 22, 1993, 52–53.

Torres, Esteban. "Exposiciones." *El Sol de México* (Mexico City), November 10, 1993, D5.

"Transcending the Myths of Curanderismo." *Intercambios Femeniles: The National Network of Hispanic Women* 2, no. 4 (Winter 1985): 19.

"Two Children's Books Exhibits Unveiled at Reception." *Diablo Arts: Regional Center for the Arts Magazine* (Walnut Creek, CA), September–November 1994, 35.

Vabelli, Jill. "Let's Go South of the Border!" *Instructor* (Cleveland) 100, no. 3 (October 1990): 82.

Valdéz, Armando. *El Calendario Chicano 1975*. Hayward, CA: Southwest Network, 1975.

"Valentine Exhibit Opens." *Upper Valley Progress* (Mission, TX), February 20, 1975, 5.

Van Proyen, Mark. "Carmen Lomas Garza at San Jose Museum of Art." *Art in America* 90, no. 1 (January 2002): 119–20.

———. "To Touch Both Soul and Body." *Artweek* 22 (April 11, 1991): 11–12.

Velasco, Robert, II. Letter to the editor. *Washington Post*, December 13, 1995, A28.

Venant, Elizabeth. "'Hispanic Art' Sparks Ethnic Pride." *Los Angeles Times*, March 15, 1989, sec. 6, 1.

Vigil, Evangelina. "Woman of Her Word: Hispanic Women Write." *Revista Chicano-Riqueña* 11, no. 3–4 (1983): 77–81.

Walkup, Nancy. "Carmen Lomas Garza: A Universal Tribute to Family, Heritage, and Community." *School Arts* 97, no. 1 (September 1997): 27–29.

Walsh, Brendan. "Artistic Endeavors: Art Museum of South Texas Offers Culturally Diverse Exhibits, Lectures." *Corpus Christi Caller-Times*, August 24, 2001, 7.

Wasserman, Abby. "The Art of Narrative." *Museum of California Magazine* (Oakland Museum of California) 15, no. 1 (Winter 1991): front cover, 24–28.

Wilson, Megan. "Art in Flight." *Public Art Review*, no. 26 (Spring/Summer 2002): 22–29.

Wilson, William. "Chicano Show Mixes Advocacy, Aesthetics." *Los Angeles Times*, September 12, 1990, 1.

Woodard, Josef. "Not So Naive After All." *Artweek* 22, no. 14 (April 1991): 9–10.

Yankes, Bill. "Latino Art Exhibition a Colorful Milestone; Artist Chides Museum." *Los Angeles Times*, March 23, 1989, 1.

Ybarra-Frausto, Tomás. "Carmen Lomas Garza." *Imagine* (Boston) 3, no. 1–2 (Summer–Winter 1986): 129–32.

Yerba, Patricia Velazquez. "Vinieron del otro lado: Veinte artistas chicanos expondrán en el MAM." *El Universal* (Mexico City), November 9, 1993, 1, 4.

Young, Susan. "Art from the Heart." *Oakland Tribune*, January 16, 1993, D1.

Zamudio-Taylor, Victor, and Carmen Lomas Garza. "Carmen Lomas Garza." *Whitney Museum of American Art: Summer Calendar*, June–August 1995.

EXHIBITION CATALOGS

Arte Latino: Treasures from the Smithsonian American Art Museum. Curated by Jonathan Yorba. New York: Watson-Guptill; Washington, DC: Smithsonian American Art Museum, 2001.

Los Artistas Chicanos del Valle de Tejas: Narradores de Mitos y Tradiciones. Curated by Gilberto Cárdenas and Amalia Malagamba for VII Festival Internacional de la Raza. Tijuana, Mexico: Centro Cultural Tijuana, 1991.

Artistas México Americanos de San Francisco, California. Mexico City: Salón de Sorteos, Lotería Nacional, 1987.

Art of the Other Mexico: Sources and Meanings. Chicago: Mexican Fine Arts Center Museum, 1993.

Art/Women/California, 1950–2000: Parallels and Intersections. Edited by Diana Burgess Fuller and Daniela Salvioni. Berkeley: University of California Press, 2002.

Body/Culture: Chicano Figuration. Curated by Richard J. Kubiak and Elizabeth Partch. Rohnert Park, CA: University Art Gallery, Sonoma State University, 1990.

Carmen Lomas Garza. Washington, DC: Hirshhorn Museum and Sculpture Garden, Smithsonian Institution, 1995.

Carmen Lomas Garza. Curated by Terezita Romo. Sacramento: Galería Posada, 1985.

Carmen Lomas Garza. Curated by Victor Zamudio Taylor. New York: Whitney Museum of American Art at Philip Morris, 1995.

Carmen Lomas Garza: Como la Salvila/Like the Aloe. Swarthmore, PA: List Gallery, Swarthmore College.

Carmen Lomas Garza: Lo Real Maravilloso: The Marvelous/The Real. Curated by Tomás Ybarra-Frausto. Text by Terezita Romo and Tomás Ybarra-Frausto. San Francisco: Mexican Museum, 1987.

Carmen Lomas Garza: Pedacito de Mi Corazón. Curated by Peter Mears. Austin: Laguna Gloria Art Museum, 1991.

Carmen Lomas Garza/Prints and Gouaches, Margo Humphrey/Monotypes. San Francisco: San Francisco Museum of Modern Art, 1980.

Ceremony of Memory: New Expressions in Spirituality among Contemporary Hispanic Artists. Curated by Amalia Mesa-Bains. Santa Fe, NM: Center for Contemporary Arts, 1988.

Chartle Papers. Curated by Amalia Mesa-Bains. Houston: Museum of Fine Arts, 1987.

Chicano Art: Resistance and Affirmation, 1965–1985. Edited by Richard Griswold del Castillo, Teresa McKenna, and Yvonne Yarbro-Bejarano. Los Angeles: Wight Art Gallery, University of California, 1990.

The Chicano Codices: Encountering Art of the Americas. Curated by Marcos Sánchez-Tranquilino. San Francisco: Mexican Museum, 1992.

Chicano Expressions: A New View in American Art. Curated by Inverna Lockpez, Tomás Ybarra-Frausto, Judith Baca, and Kay Turner. New York: INTAR Latin American Gallery, 1986.

Chicanos en Mictlán: Día de los Muertos en California. Curated by Terezita Romo. San Francisco: Mexican Museum, 2000.

Chicano Visions: American Painters on the Verge. Boston: Little, Brown, 2002.

Cultural Currents. Curated by Mary Stofflet. San Diego: San Diego Museum of Art, 1988.

Dále Gas: Chicano Art of Texas. Curated by Santos Martinez Jr. Houston: Contemporary Arts Museum, 1977.

Directions: Carmen Lomas Garza. Curated by Anne-Louise Marquis. Washington, DC: Hirshhorn Museum and Sculpture Garden, Smithsonian Institution, 1995.

Fire! An Exhibition of 100 Texas Artists. Curated by James Surls. Houston: Contemporary Arts Museum, 1979.

From the Inside Out: Perspectives on Mexican and Mexican-American Folk Art. Edited by Karana Hattersley-Drayton, Joyce Bishop, and Tomás Ybarra-Frausto. San Francisco: Mexican Museum, 1989.

La Frontera/The Border. Curated by Patricio Chavez and Madeleine Grynsztejn. San Diego: Centro Cultural de la Raza and Museum of Contemporary Art San Diego, 1993.

Her Story: Narrative Art by Contemporary California Artists. Curated by Therese Heyman. Oakland, CA: Oakland Museum of California, 1991.

Hispanic Art in the United States: Thirty Contemporary Painters and Sculptors. Curated by John Beardsley and Jane Livingston. Houston: Museum of Fine Arts; New York: Abbeville Press, 1987.

Homenaje a Frida Kahlo. Text by Amalia Mesa-Bains, Carmen Lomas Garza, and María Pinedo. San Francisco: Galería de la Raza/Studio 24, 1978.

Homenaje a Tenochtitlán: An Installation for the Day of the Dead, by Carmen Lomas Garza. Curated by Linda Muehlig. Text by Amalia Mesa-Bains. Northampton, MA: Smith College Museum of Art, 1992.

In Out of the Cold: Inaugural Exhibition for Center for the Arts at Yerba Buena Gardens. Curated by Renny Pritikin and René de Guzman. San Francisco: Center for the Arts at Yerba Buena Gardens, 1993.

Lo del Corazón: Heartbeat of a Culture. Curated by Amalia Mesa-Bains and Tomás Ybarra-Frausto. San Francisco: Mexican Museum, 1986.

Mano a Mano: Abstraction/Figuration: 16 Mexican-American and Latin American Painters from the San Francisco Bay Area. Curated by Rolando Castellón. Santa Cruz, CA: Art Museum of Santa Cruz County and University of California, Santa Cruz, 1988.

Master Prints from the Rutgers Center for Innovative Printmaking: The First 5 Years. Curated by Judith K. Brodsky. Princeton, NJ: Gallery at Bristol-Myers Squibb, 1992.

Memoria, 3er Festival Internacional de la Raza: El barrio, Primer Espacio de la Identidad Cultural: CREA, '86. Mexico City: CREA, 1987.

¡Mira! The Canadian Club Hispanic Art Tour. Detroit: Hiram Walker, 1985.

Ofrendas: René Yáñez, Carmen Lomas Garza, Armando Cid, Amalia Mesa-Bains. Curated by Tomás Ybarra-Frausto. Sacramento: Galería Posada, 1984.

Personal Reflections: Masks by Chicano and Native American Artists in California. Curated by Terezita Romo. Sacramento: Galería Posada, 1983.

Presswork: The Art of Women Printmakers. Edited by Trudy Victoria Hansen and Eleanor Heartney. Washington, DC: Lang Communications, 1991.

Prints 1/500: International Printmaking Invitational. Curated by Connor Everts. San Bernardino: California State College, 1983.

The Road to Aztlan: Art from a Mythic Homeland. Curated by Virginia M. Fields and Victor Zamudio-Taylor. Los Angeles: Los Angeles County Museum of Art, 2001.

The Role of Paper: Affirmation and Identity in Chicano and Boricua Art/El Papel del Papel: Afirmación e Identidad en la Obra Boricua y Chicana. Curated by Pedro A. Rodríguez. San Antonio, TX: Guadalupe Cultural Arts Center, 1998.

Staying Visible: The Importance of Archives. Curated by Jan Rindfleisch. Cupertino, CA: Foothill–De Anza Community College, 1981.

Tejanos: 15 Pintores, 3 Escultores: Artistas Mexicano-Norteamericanos. Curated by Jacinto Quirarte. Mexico City: Instituto Nacional de Bellas Artes and Museo de Arte Alvar y Carmen T. de Carrillo Gil, 1990.

Vice President's House. Curated by Mary Lou Friedman. Washington, DC: Vice President's House, 1980.

What We Are . . . Now: José Montoya, José, María Vita Pinedo, and Carmen Lomas Garza. San Francisco: Galería de la Raza/Studio 24, ca. 1977–1981.

SELECTED PUBLICATIONS CONTAINING GARZA'S ARTWORK

El Grito: A Journal of Contemporary Mexican-American Thought 4 (1971), front cover and 70–73.

Hembra: Hermanas en movimiento brotando raíces de Aztlán (University of Texas, Austin), Spring 1976, front cover.

Intercambios, Spring 1993, inside cover.

Tin Tan (San Francisco) 2, no. 5 (June 1977), inside front and back cover.

VIDEOS AND FILMS

Brookman, Philip, and Amy Brookman. *Mi Otro Yo: My Other Self.* Videotape. Bethesda, MD, 1987.

Celebrate a World of Difference. Videotape. Glenview, IL: Scott Foresman, 1994.

Chicano! History of the Mexican American Civil Rights Movement. Documentary film. Austin: National Latino Communications Center and Galan Productions, 1996.

Garza, Carmen Lomas. Lecture for Visiting Artist Series "What Follows." Video for student use. Boulder: University of Colorado, 1994.

Garza, Carmen Lomas, and Elizabeth Sher. *Homenaje a Tenochtitlan: An Installation for the Day of the Dead.* DVD and VHS. Berkeley, CA: I.V. Studios, 1992.

———. *Interviews with Artists, Program 2.* DVD and VHS. Berkeley, CA: I.V. Studios, 1984.

Guilbault, Rose. "Channel 7 Salutes Hispanic Achievers." Videotape. KGO TV, Channel 7, CBS, San Francisco, September 1988.

Kong, Luis. *En Camino #312: Latino Artists/Artistas Latinos.* Videotape. Rohnert Park, CA: KRCB/Channel 22, 1989.

Live Interactive Interview with Carmen Lomas Garza. Videotape. Scottsdale, AZ: Educational Management Group, 1996.

Maldonado, Betty. *Hispanic Artists in the United States: The Texas Connection.* Videotape. Houston: De Colores Productions, 1988.

Rodríquez, Laura. "Aqui y Ahora/Female Creators: A Profile of Carmen Lomas Garza." Videotape. Oakland, CA: KTVU/Channel 2, 1982.

Sher, Elizabeth. *Carmen Lomas Garza: Pintora de Monitos.* Videotape. San Francisco: I.V. Studios, 1983.

———. *W x W, Women by Women: An Evening of Exchange: Galería de la Raza/Studio 24, May 29, 1985.* Videotape. Berkeley, CA: I.V. Studios, 1985.

Steinbaum, Bernice. *Cuadros de Recuerdos de una Artista Chicana.* Videotape. New York: Steinbaum Krauss Gallery, 1996.

OTHER MEDIA

"Carmen Lomas Garza, Chicana Artist" (artist's website), http://www.carmenlomasgarza.com.

INDEX